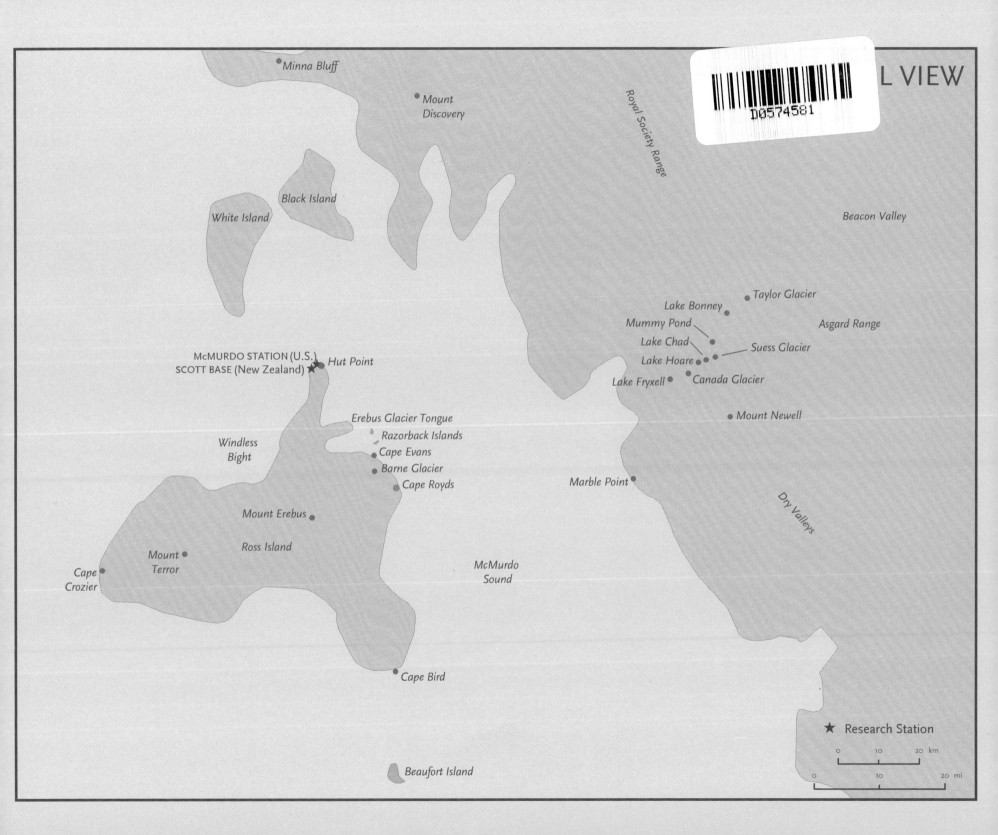

Minna Bluff

Mount
Discovery

Royal Society Range

Black Island

White Island

Beacon Valley

Taylor Glacier

Lake Bonney

Mummy Pond

Asgard Range

Lake Chad

Suess Glacier

Lake Hoare

McMURDO STATION (U.S.)
SCOTT BASE (New Zealand)

Hut Point

Lake Fryxell

Canada Glacier

Mount Newell

Erebus Glacier Tongue

Windless
Bight

Razorback Islands

Cape Evans

Barne Glacier

Cape Royds

Marble Point

Mount Erebus

Ross Island

Dry Valleys

Mount
Terror

McMurdo
Sound

Cape
Crozier

Cape Bird

★ Research Station

0 10 20 km

Beaufort Island

0 10 20 mi

wondrous cold

AN ANTARCTIC JOURNEY

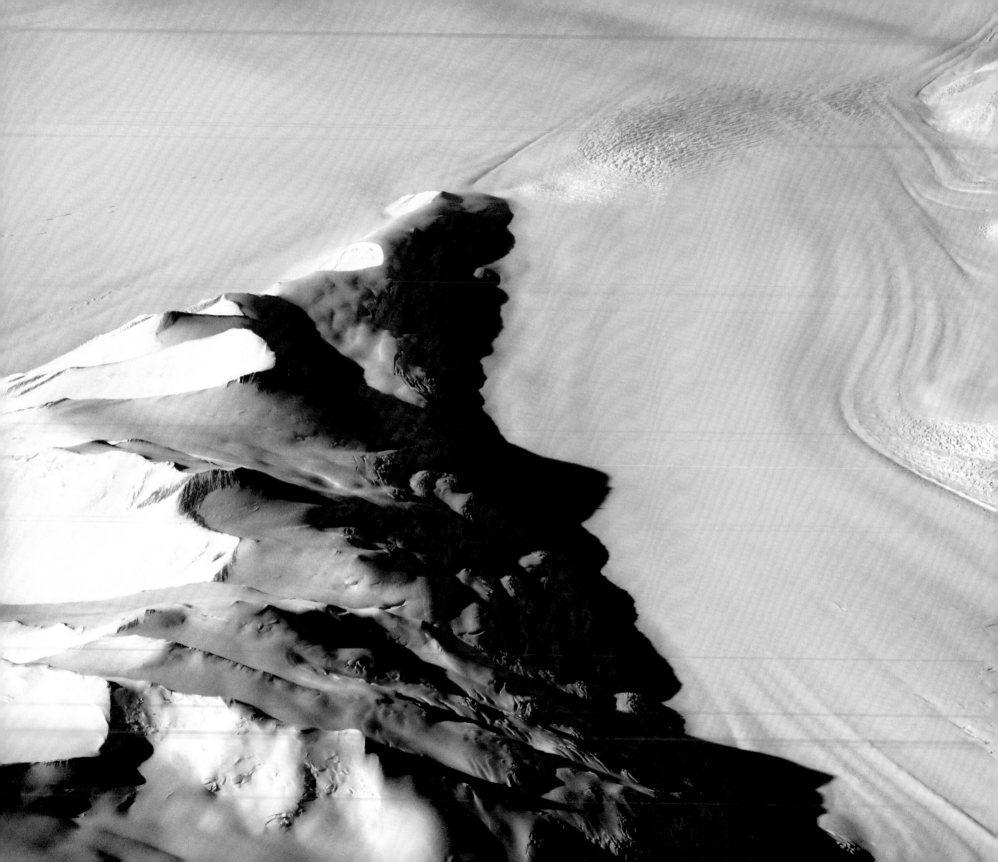

wondrous cold

AN ANTARCTIC JOURNEY

Joan Myers

Smithsonian Institution Traveling Exhibition Service
Washington, D.C.
in association with Smithsonian Books
New York and Washington, D.C.

 Smithsonian Institution

For my grandchildren, Misia and Izaak, the next generation of explorers

Published on the occasion of the exhibition *Wondrous Cold: An Antarctic Journey,* organized by the Smithsonian Institution Traveling Exhibition Service and opening at the Smithsonian's National Museum of Natural History in May 2006.

11 10 09 08 07 06 5 4 3 2 1

Text and photographs © 2006 Joan Myers
Science sidebars © 2006 Sandra Blakeslee

Distributed by HarperCollins Publishers, 1000 Keystone Park, Scranton, PA 18512-4621

The book and the exhibition have been made possible through the generous support of Quark Expeditions.

Library of Congress Cataloging-in-Publication Data
Myers, Joan, 1944–
 Wondrous cold : an Antarctic journey / Joan Myers.
 p. cm.
 ISBN-13: 978-1-58834-238-6 (hardcover : alk. paper)
 ISBN-10: 1-58834-238-7 (hardcover : alk. paper)
 1. Antarctica—Pictorial works. 2. Antarctica—Description and travel.
3. Myers, Joan, 1944– —Travel—Antarctica. I. Title.
G860.M98 2006
919.8'904—dc22 2005024831

♾ The paper used in this publication meets the minimum requirements of the American National Standard for Information Sciences—Permanence of Paper for Printed Library Materials, ANSI Z39.48-1992.

Front cover: Iceberg, Crystal Sound
Endpapers: Map design by Jessica Walker, National Science Foundation. Satellite image map of Antarctica and point location data courtesy U.S. Geological Survey; world boundary data courtesy ESRI, Inc.
Frontispiece: Aerial view of the Transantarctic Mountains

For permission to reproduce photographs appearing in this book, please correspond directly with the author, who may be reached at www.joanmyers.com.

Manufactured in Singapore

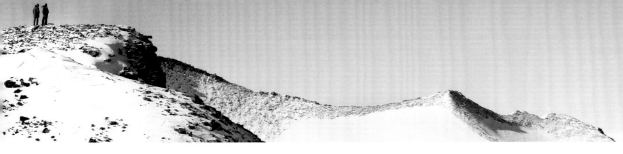

Contents

Foreword

ANTARCTICA IS A LAND OF EXTREMES: coldest, windiest, highest, driest. The place Joan Myers calls the "most hostile continent on Earth" nearly defies capture by film or words. In *Wondrous Cold*, Myers achieves both. Her exquisite photographs of landscapes, wildlife, and the abandoned huts of early explorers are juxtaposed with glimpses of scientists who seek to understand Antarctica's past and future and the support staff who facilitate their work. Her thoughtful and intimate writings provide a warm introduction to the people and places of this harsh yet surprisingly fragile environment.

SITES first met Joan in 1986 when she brought her unique perspective on the Santa Fe Trail to us. Several years later, we were honored to once again take her personal vision to museums across the nation as we toured her poignant photographic essay on Japanese American internment camps. In retrospect, Joan's talent for combining the stories of individuals with landscapes alternately beautiful and desolate surely prepared her for the physical, technical, and emotional challenges of Antarctica.

We are deeply grateful to Quark Expeditions for sharing our vision of reaching Americans wherever they live, work, and play through engaging exhibitions. *Wondrous Cold* takes its place among the panoply of rich and varied topics presented by the Smithsonian Institution Traveling Exhibition Service. Thank you for joining us on this marvelous voyage of discovery.

Anna R. Cohn
Director
Smithsonian Institution
Traveling Exhibition Service

Foreword

IN HER EXTRAORDINARY PHOTOGRAPHY, Joan Myers captures the essence of Antarctica. Her work documents three converging dimensions: the haunting beauty; the unusual creatures that flourish in a seemingly inhospitable environment; and, perhaps most powerfully, the spirit of curiosity and perseverance that drew past explorers and continues to attract remarkable people to the White Continent.

At Quark Expeditions, we understand that spirit. Since our first expedition 15 years ago, we have become a leader in polar adventure, making travel in Antarctica accessible to all who dream of setting foot there. As we continue to develop new expeditions to a corner of the world that is still relatively unexplored, we also work to ensure the continent's environmental sanctity for future generations.

Wondrous Cold pays tribute to the boldness and dedication of pioneers from around the globe who strive to keep Antarctica a place that transcends political boundaries. In our own pioneering journeys—from the first circumnavigation of the continent to each new landing on previously unexplored shores—we try to uphold the same respectful relationship between nature and humanity that Joan Myers so clearly values.

Quark Expeditions is extremely proud to sponsor *Wondrous Cold* in collaboration with the Smithsonian Institution Traveling Exhibition Service. We offer our congratulations to the museums around the country that are hosting the traveling exhibition—and our sincere hope that visitors will be as moved and captivated by these dramatic images as we have been.

Patrick Shaw
President & CEO
Quark Expeditions, Inc.

Remains of observatory used by a German expedition to view the 1882 Transit of Venus, Moltke Harbor, South Georgia

Whale bones, South Georgia

And now there came both mist and snow,
And it grew wondrous cold:
And ice, mast-high, came floating by,
As green as emerald.

SAMUEL TAYLOR COLERIDGE
The Rime of the Ancient Mariner

Prologue: At the Mercy of the Storm, 2001

THE SHIP'S CAPTAIN HAS DECIDED it's better to ride out the storm 20 miles off the sub-Antarctic island of South Georgia rather than risk running aground or hitting an iceberg.

At night, sleep is impossible. The roll of the ship is so extreme that I slide backwards and forwards on my bed, alternately striking my head on the headboard and then sliding downward until my feet are pushed to the bottom bed rail. In the cabin, anything not attached crashes to the floor. A chair pulls loose from its restraints, slides against my bunk, and then flies across the room, smashing into the cabin door. On the next roll, it's back with even more force to strike my bed. So the time passes.

Today is even rougher. All doors to the outside decks have been sealed shut. Winds are blowing gale force 12, hurricane strength, over 85 knots with higher gusts, and causing the ship to roll some 45 degrees side to side. I feel the hesitation at the top of each roll and wonder if the boat will right itself. If something were to go wrong with the engine or a propeller, what would happen? No airplanes nor helicopters fly here; no other boats are nearby. We are in a raging storm some 800 miles from the nearest possible assistance.

There's nowhere to go, little to do. We're in a state of suspended animation. The crew has covered the portholes, so my cabin is dark. I put on half a patch of scopolamine, so I'm not feeling queasy, but I have no desire to eat. In the lounge, a deck below my cabin, every roll of the waves puts the sealed portholes under water. It's like peering into an aquarium. I expect to see fish or maybe a mythical sea creature.

I make my way inside the ship to the bridge, hanging onto railings and moving carefully up the stairs between rolls. From here the sea appears alive and malevolent. Waves are over 40 feet high. They wash completely over the bow and crash against the windows of the bridge. Water, light, and air are frothed together in a mixture too thick to breathe.

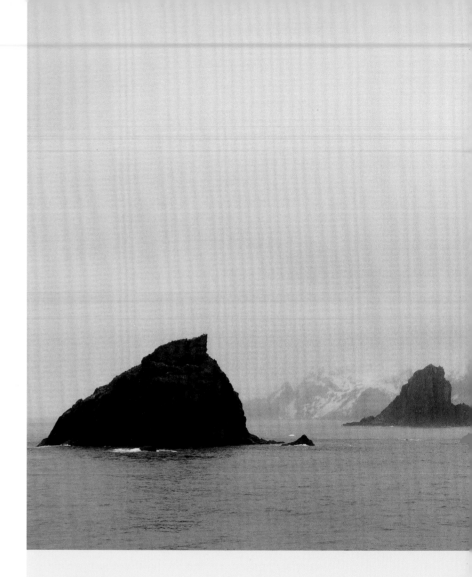

Elephant Island

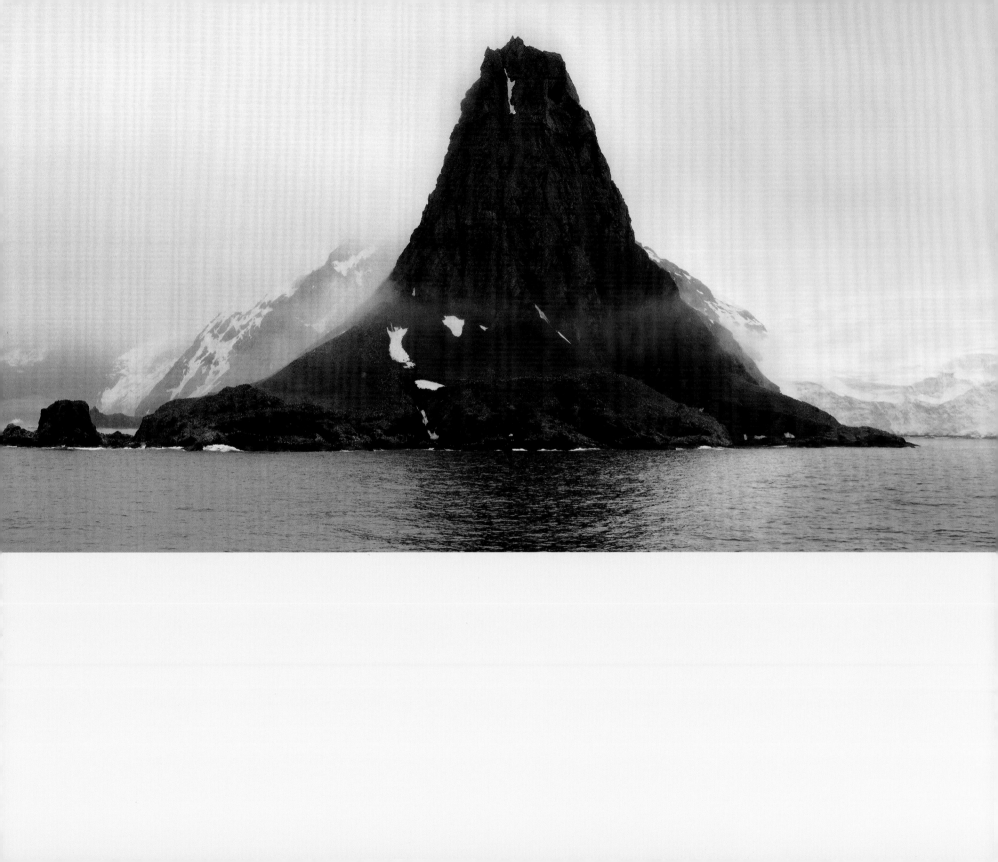

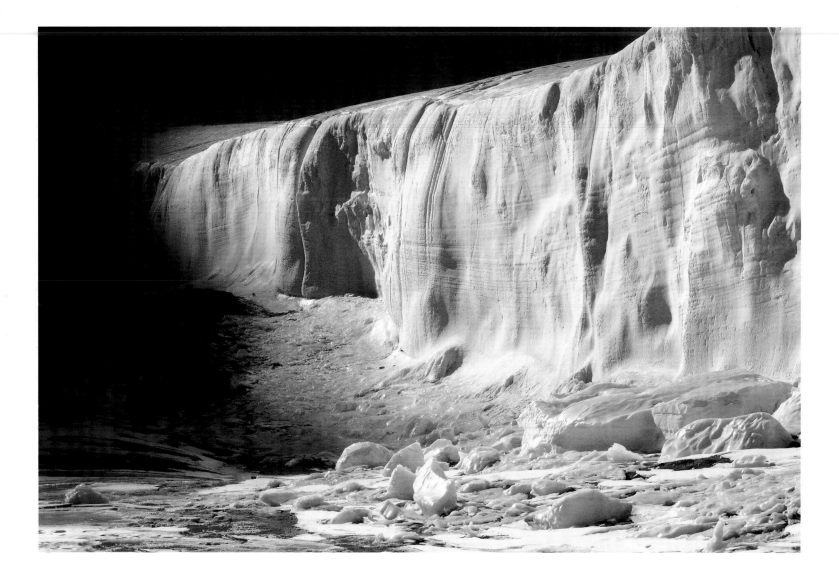

This passage on the Southern Ocean from the tip of South America to Antarctica is like shutting myself in a rocket capsule, strapping myself down, and blasting away. There is no ground beneath my feet. The motion is violent and disorienting. Time no longer divides my days into comfortable episodes of work and play. With little to see besides the confusion of waves and sky, the journey is exhilarating but terrifying. I wonder apprehensively if I'll remain on this wind-lashed sea forever.

I've come to remote South Georgia and to the Antarctic Peninsula farther south, curious about a part of the planet vividly described in the journals of Robert Falcon Scott and Ernest Henry Shackleton, great expedition leaders from the "heroic era" of Antarctic exploration. Since I'm a photographer, I know their stories especially through the images of their expedition photographers, Herbert Ponting and Frank Hurley. During his failed 1910–12 *Terra Nova* attempt to be the first to reach the South Pole, Scott established his

base thousands of miles from South Georgia, on the other side of the continent. Shackleton began his ill-fated 1914–16 expedition on the *Endurance* from the Grytviken whaling station on South Georgia, still 20 long miles away from us. South Georgia is one of the few places in the world still not reachable by aircraft, so I'm arriving by storm-tossed ship in time-honored fashion.

Why Antarctica? I've never liked cold weather. After a childhood in the alternately frigid and steamy Midwest, I happily moved to California and then to New Mexico, where I love the desert summers and try to be somewhere else much of the winter. But when I was a child, I was surrounded by exploration books. My mother was an inveterate armchair traveler. Polar disasters were second only to South Sea mutineers. When my youngest sibling left for college, my mother sold the family house, moved to California, and began to travel. A semi-circumnavigation of Antarctica in the 1970s was her favorite trip. Her house has a wall of faded color photographs of penguins, albatross, and elephant seals from that journey. So, the subliminal message eventually proved stronger than my common sense.

The final impetus came when I visited the British Museum in London years ago. In the manuscript room I came across Scott's diary. Among so many elegant and beautiful manuscripts, I was mesmerized by the small pencil-written journal that he took with him to the South Pole. Scott continued to write in it during those final dreadful days in 1912 before he and his companions froze to death, only 11 miles from the supply depot that would have saved them. I imagined the discipline required to write neatly within the lines and margins with half-frozen fingers while hunger, extreme cold, and fear prowled the tent. I suddenly needed to see this continent where men would choose death over defeat in pursuit of their dreams.

I hang onto the ship's rails with both hands and think about Shackleton's open-boat journey across this ocean. After the *Endurance* was beset and eventually crushed by the pack ice in the Weddell Sea, Shackleton and his 27-man crew made their way in three small boats to Elephant Island. From there, six men set out in the

The real voyage of discovery consists not in seeing new landscapes, but in having new eyes.

MARCEL PROUST

Twenty years from now you will be more disappointed by the things you did not do, than by the things you did do. So, throw off the bowlines. Sail away from the safe harbor. Catch the trade winds in your sails. Explore. Dream. Discover.

MARK TWAIN

Suess Glacier, Lake Hoare, Dry Valleys

Gentoo penguin, Neko Harbor

PAGES 12–13
Gold Harbor, South Georgia

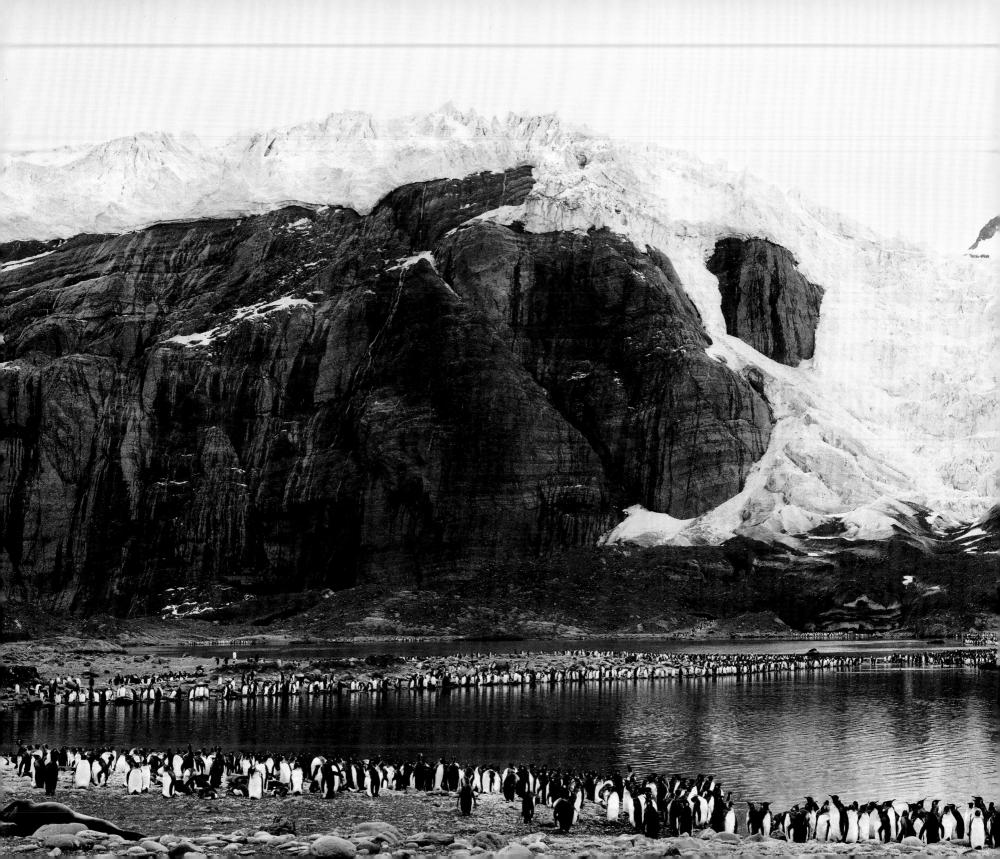

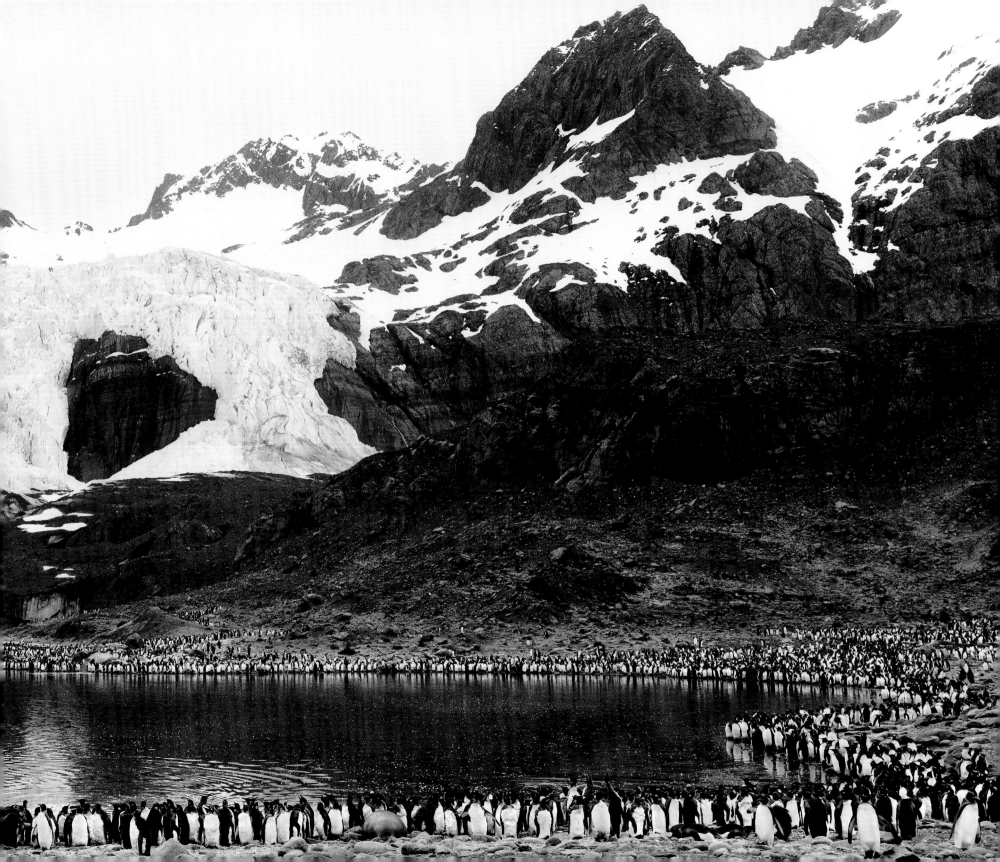

Islands have always fascinated the human mind. Perhaps it is the instinctive response of man, the land animal, welcoming a brief intrusion of earth in the vast, overwhelming expanse of sea.

RACHEL CARSON

All torment, trouble, wonder, and amazement Inhabits here. Some heavenly power guide us Out of this fearful country!

WILLIAM SHAKESPEARE
The Tempest

James Caird, a small dinghy, for the 16-day trip across these waters for South Georgia. This was discomfort of a whole different sort. The men had little to eat, no dry clothes, and only a sextant with which to take sightings. How did they make it? How did they find South Georgia? Why didn't they capsize or die of exposure? Once they reached South Georgia, how did three of those men manage to cross the rugged, glacier-draped center of the island to the whaling stations on the other side?

As the wind finally decreases, our captain slowly heads into Cumberland Bay and Grytviken whaling station. With the sun tentatively poking through the storm clouds, the island is majestic with its sharp white peaks rising above the still-foaming sea. It's touch-and-go as we hit enormous waves broadside, but finally the captain drops anchor and we go ashore. I am relieved to finally step on a surface that doesn't heave and rock.

Only a few people live on the island—a couple who runs the museum during the summer months and a few British soldiers garrisoned here since the Falklands War. Most of the buildings are well beyond occupancy. Whales were taken and processed here until the mid-1960s. The station's buildings are slowly being pulverized into the landscape, helped along by storms like ours that turn corrugated metal into airborne missiles.

Shackleton is buried in Grytviken. After his return to England in 1917, he dreamed, once again, of heading south. In 1921, with several of his old *Endurance* companions but with no specific goal, he once again voyaged to South Georgia. He spent one day ashore, returned to his cabin, and died of a heart attack at age 47. His wife, receiving a cable of his death, ordered the ship to return to South Georgia to bury him in the place he most loved. His gravestone is the most prominent in the small whaling station cemetery.

The next morning, we put in at Gold Harbor on a beach covered by elephant and fur seals and some 20,000 king penguins. The penguins are indeed regal creatures, nearly three feet tall and elegantly "dressed" in black and white with bright yellow patches on the sides of their heads and under their chins and beaks. They

stand quietly at attention or throw back their heads in a trumpeting courtship ritual.

I brave a long line of aggressive fur seals and walk up the beach toward the head of Bertrab Glacier, which drips down like runny frosting from the mountains to form a long freshwater lake at its base. King penguins in the thousands ring the lake. I gasp in disbelief at the scale of the scene and then quickly set up my panorama camera. This island of air, water, and spirits is straight out of *The Tempest*.

Once more at sea, we circle a jade-green iceberg. Layers of sediment stripe its base. On one side it sports the turrets of a fantastical castle. I manage to snap a couple of photographs before the fog closes in, just to prove I didn't dream it.

When I return home, I develop negatives and print pictures. I quickly realize that, despite the jade-green iceberg and the penguins at Gold Harbor, my images are primarily about human life in Antarctica. While my fellow travelers spent their time in penguin rookeries, I concentrated on human structures and activity, trying to understand why people are drawn to such an unfriendly, uninhabitable place.

To be in Antarctica is to see our planet at its most elemental and unforgiving. Nobody has ever lived here permanently and found a way to survive its harsh climate and uncompromising terrain. It's a continent without an oral history. This book is the story of my journey to a world as mysterious and amazing as an unknown planet in a distant galaxy.

Stromness whaling station
(abandoned), South Georgia

PAGES 16–17
Remains of hut from 1901–03
Nordenskjöld expedition,
Paulet Island

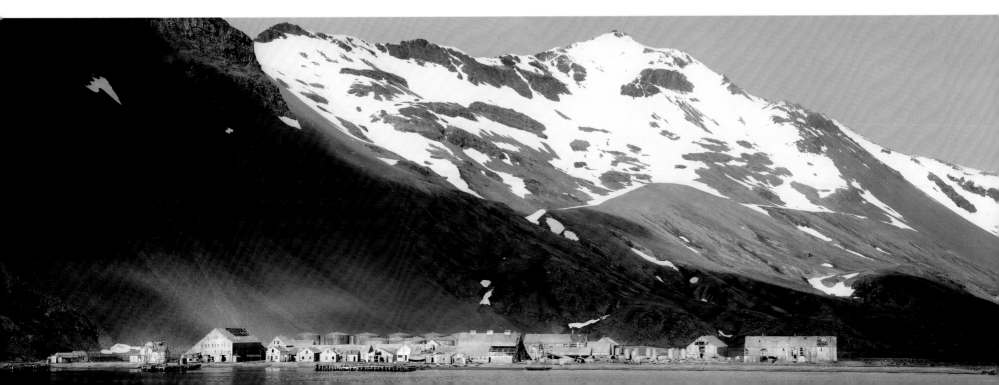

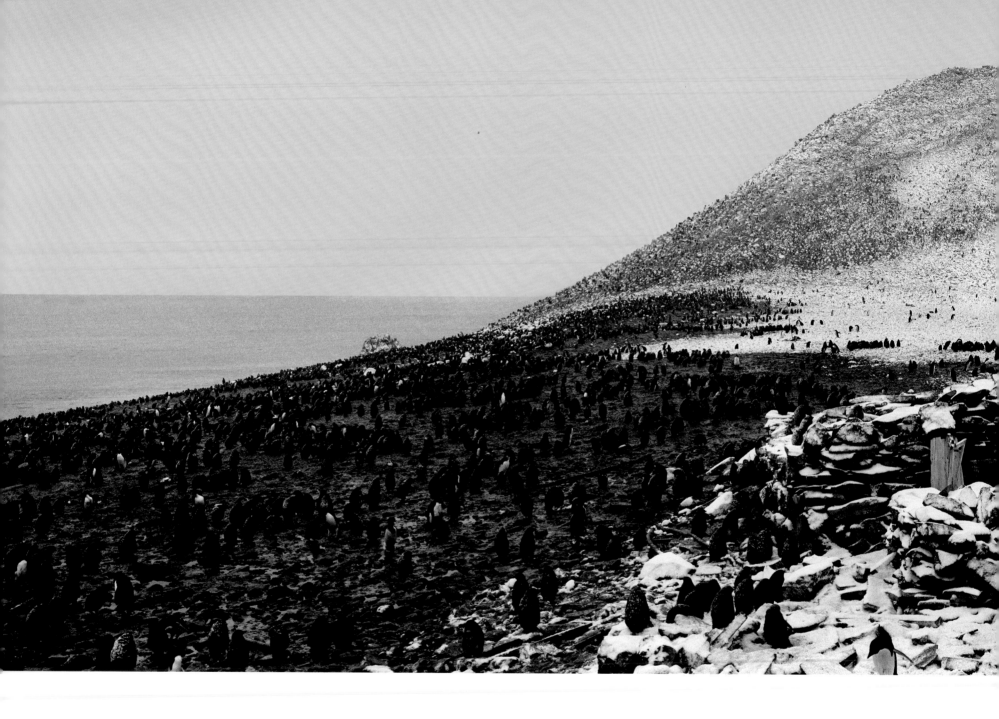

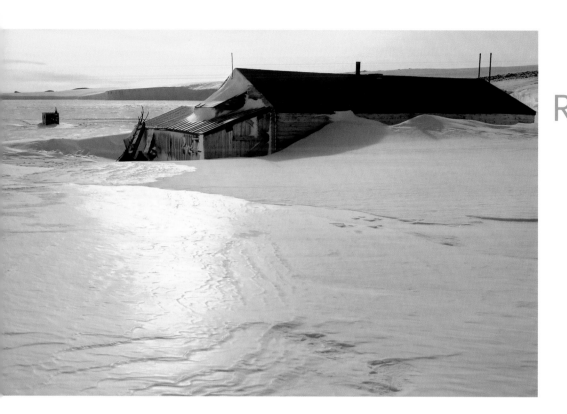

Scott's hut, Cape Evans

Leaving the Planet

OCTOBER 4, 2002, ALBUQUERQUE, NEW MEXICO

Robert falcon scott, the most renowned of all Antarctic explorers, said that the hardest part of an expedition is the preparation. As I sit in the Albuquerque airport waiting to begin the 24 hours of flying that will take me from home to Phoenix, Dallas, Los Angeles, Auckland, and finally Christchurch for a brief stopover before the flight to Antarctica, I feel numb. The last few months have been a blur.

I've heard that the world is divided into two kinds of people—those who would die rather than go to Antarctica and a considerably smaller group that would kill to return. My stormy trip to South Georgia and the Antarctic Peninsula a year earlier left me with an intense longing to return. The craving was so powerful that eventually I ignored all my qualms about the cold and the rigors of travel and applied for an Antarctic Artists and Writers Program grant from the National Science Foundation (NSF).

NSF, which is responsible for all the American scientific work in Antarctica, funds a handful of writers and artists every year, starting with photographer Eliot Porter in 1975. To my delight, I was selected to photograph Antarctica and the human activity that takes place there. In return for round-trip transportation, room and board, polar clothing (on loan), and logistical support for my project, I must produce, in the words of the Foundation, a significant body of work "that [will] increase understanding of the Antarctic and help document America's antarctic heritage."

To pass the rigorous physical standards that NSF requires of everyone at McMurdo Station, Antarctica's primary U.S. research post, I needed dental exams, blood tests, an EKG and treadmill tests, a mammogram, and a complete physical. It took several months to arrange and complete them all. I constantly worried that such a thorough examination of my aging body would reveal a deadly condition that would prevent me from going. Somehow I passed.

To prepare photographically, I sorted camera gear, learned software for the digital camera I had barely used, and ordered new lenses. I bought an extra battery pack for my digital camera and flash, but forgot to order the necessary cables. Every day I received e-mails and phone messages about hard-to-get permits for specially protected areas and what clothes to bring. And the expenses! I finally gave up worrying and simply put what I needed on my Visa card, hoping that it would somehow take care of itself in my absence.

Now, after agonizing every moment about details, I suddenly have nothing left to do. It's an empty moment, a void. For the first time I'm aware of how strange it feels to be departing for four months of work in Antarctica.

In traveling to McMurdo Station, I leave much behind: my loving and supportive husband, Bernie, grown kids with a grandchild on the way, aging parents, my business, a recently remodeled and very comfortable house, and friends who think I'm either lucky or crazy. I'm not just leaving all I hold dear. I'm not just leaving the country. Sitting in the airport in Albuquerque, I realize I am leaving the planet behind.

WOMEN IN ANTARCTICA

The first woman did not step ashore on the Antarctic continent until 1935, when Caroline Mikkelsen, wife of a Norwegian whaling captain, accompanied her husband on one of his voyages to the Antarctic. She went ashore briefly with her husband near present-day Davis Station.

The first women to actually live on the continent were Edith Ronne, wife of the Norwegian-American explorer Finn Ronne, and Jennie Darlington, who had just married Harry Darlington, chief pilot on Ronne's 1946–48 Antarctic research expedition. After the long winter of 1947 at Stonington Island, Jennie Darlington wrote, "Taking everything into consideration, I do not think women belong in the Antarctic."

The U.S. Navy, which established McMurdo as a military outpost in 1956 and ran the Antarctic research stations, felt the same way and refused to transport women. NSF refused to let them work "on the Ice." The restrictions were lifted in 1969 and, for many years now, most bases have seen women working on equal terms with men. At McMurdo, women make up about 35 percent of the population— as doctors, scientists, administrators, technicians, and support staff.

Heading South

OCTOBER 5, CHRISTCHURCH, NEW ZEALAND, 74°F

MEET A NUMBER OF FELLOW TRAVELERS on the flight from Auckland, all instantly recognizable by their bright pink U.S. Antarctic Program luggage tags with penguin insignia.

I don't encounter any scientists, but speak with electricians, heavy-equipment drivers, janitors, and kitchen staff. Many are women, and most everyone is young, in their 20s and 30s. They have an open look, a willingness to tackle new experiences and make the best of them. It's a look I first noticed when I photographed pilgrims walking the Camino de Santiago in northern Spain. A pilgrimage also involves leaving one's home to embark on a long journey on an unfamiliar path with an uncertain outcome. Going to Antarctica apparently encourages a readiness to take whatever comes along and an excitement about life that you rarely experience in your daily routine. You have to be willing to forget the patterns that make you feel comfortable.

Since I'm beginning to feel anxious about my upcoming flight, I go shopping and buy a jade Maori pendant to wear for good luck. Then I take a bus over to the Clothing Distribution Center (or CDC—everyone in the U.S. Antarctic Program uses acronyms, a relic of its military history) for my polar clothing issue. The women head to the right and the men to the left, where we each pick up two duffel bags of ECW (extreme cold weather) gear. The goal is to try everything on to make sure it fits and repack what we're taking to McMurdo. Before departure we'll drag our two checked bags to the scales to be weighed and packed on a pallet. With very little room by our seats, we'll hand-carry only a few necessities.

Sounds easy. It isn't. I can't figure out how to put on some of the clothes, like the bib overalls. Someone is going to have to show me how to fasten the clasps, or I'll lose my pants the first time I wear them. Another mysterious but wonderful piece of clothing is a fleece body suit that would make Catwoman jealous. There are also many pairs of gloves (most of them unsuitable for photography since they're so stiff), six pairs of gigantic wool socks, long underwear, several jackets, balaclavas, hats, goggles, and insulated white rubber shoes called bunny boots. Many women try everything on, repack, and are out in half an hour. Two hours later I'm still wondering how many gloves I really need.

CLOTHING

Hypothermia occurs when the body loses heat faster than it can produce it. If skin gets wet, it freezes 24 times faster than dry flesh. Hence the trick to survival in Antarctica is to clothe yourself in materials that keep you warm and dry. Today that means Gortex, polypropylene, fleece, and other light materials that can be layered to trap warm air next to the body and wick away moisture. Some early explorers used cotton, wool, and reindeer fur. They suffered terribly. Others imitated the Inuit, wearing all-fur clothing and a kind of reed that wicked moisture out of their boots. Wolverine fur was a favorite material to line hoods and parkas. For still unexplained reasons, frozen breath and moisture falling on wolverine hairs can be brushed away with ease.
—Sandra Blakeslee (hereafter S.B.)

Stromness whaling station (abandoned), South Georgia

When I finally finish and am walking back to my hotel, I run into a woman who sympathetically helped me with some of my stranger gear at the CDC. Ann Dalvera lives in Durango, Colorado, and works as a U.S. Forest Service wilderness ranger when she isn't down on the ice. This will be her seventh season there. This year she's running the waste management division at McMurdo and driving forklifts. We share a vegetarian Indian meal as she tells me about the season she helped set up a field camp to study the movement of ice streams, and another when she worked at Siple Dome. I don't find out until several days later that she was a member of the first all-women expedition to ski to the South Pole.

I took every care to guard against cold myself. In zero weather I wore four pairs of thick woolen socks, and one pair of heavy goat-hair ski-socks; I wrapped dried saenne grass round these, and over all wore a pair of finnesko, or Norwegian moccasins, made from the leg fur of reindeer. I wore two suits of thick "Wolsey" woollen underwear; thick corduroy breeches and puttees; a heavy woollen guernsey, a thick woollen coat and a flannel-lined leather coat; a woollen wrapper and a seal-skin fur helmet. On my hands I wore a pair of woollen gloves, a pair of thick woollen, and thick dog-fur mits reaching almost to the elbows. . . . When working the camera, I would remove both pairs of mits until my hands began to chill in the woollen gloves; then bury them again in the warm fur, and beat them together until they glowed again. But my fingers often became so numbed that I had to nurse them back to life by thrusting my hands inside my clothing, in contact with the warm flesh.

HERBERT G. PONTING
The Great White South, 1923

My favorite thing is to go where I've never been . . .

DIANE ARBUS

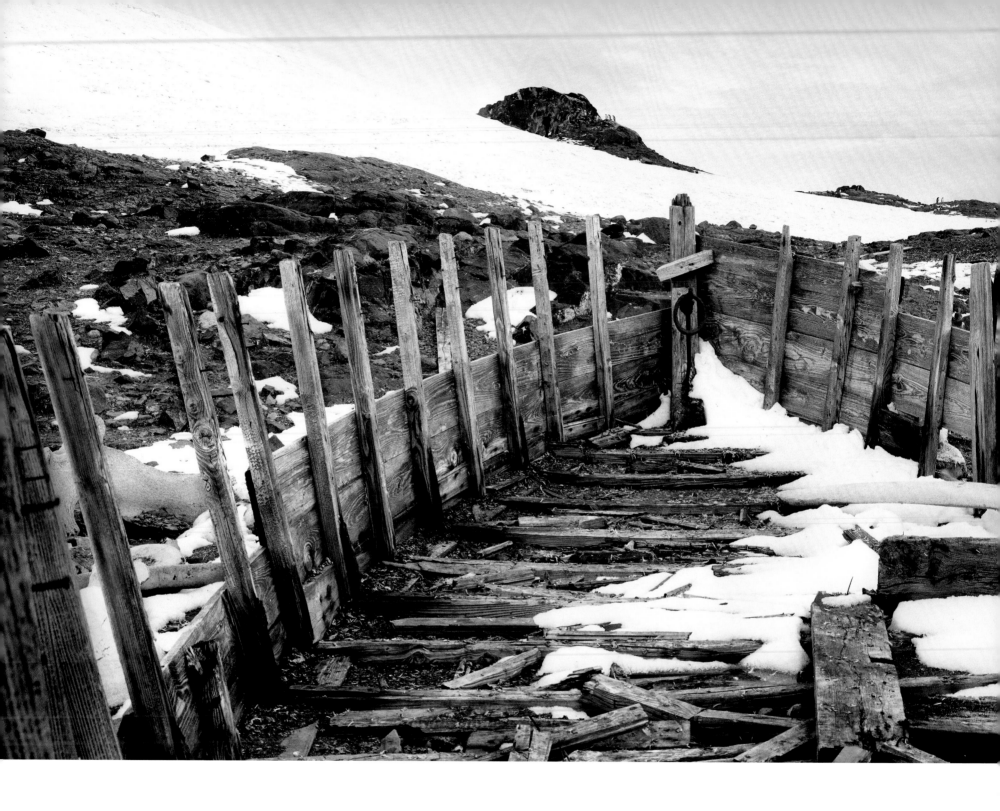

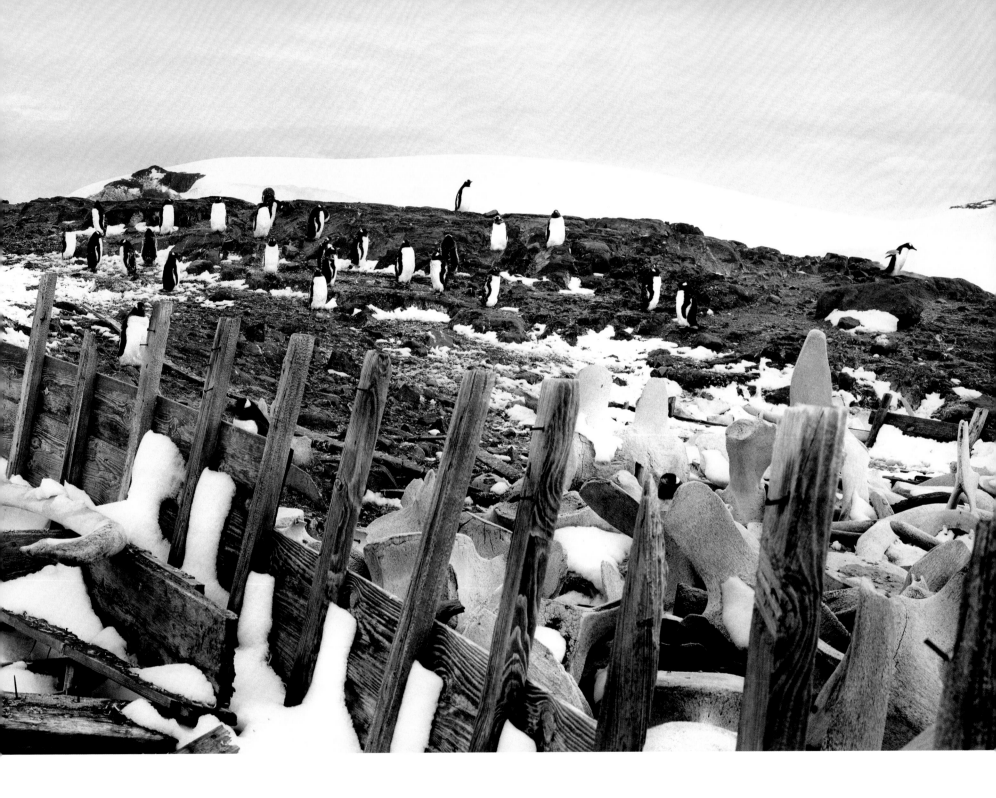

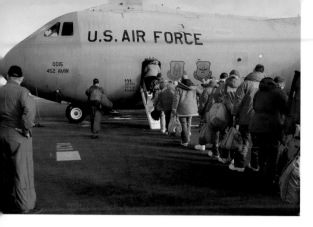

An Alien Landscape

OCTOBER 8, MCMURDO STATION, −21°F, WIND CHILL −45°F

I T'S BEEN A LONG DAY, but I made it!

At 6 AM we report with our luggage to Christchurch's Antarctic air terminal and put on our cold-weather clothes (warm underwear, bib overalls, bunny boots, bear-paw mittens, and parka). We're dressed for the worst the Antarctic has to offer. Since it's nearly 80°F in Christchurch, we're ridiculously uncomfortable, but nobody complains. At least we're appropriately dressed when we arrive. (Since there's nowhere to land between here and McMurdo, our parkas and bunny boots are unlikely to save us in case of mechanical problems.)

We proceed to the gate, present our passports, get boarding tags to hang around our necks, and hoist our bags onto the scales. The C-141 is an aging, clunky-looking plane, a staple of the military's movement of personnel and cargo all over the world since the late 1950s. We climb up a short flight of steep stairs and are fastened, one at a time, into webbed sling-like seats in two long facing rows. The women are loaded last, near the cockpit and the minimal bathroom. (The guys use a bucket in the back.) There are nearly 100 of us altogether along with tons of cargo in the rear.

There are no windows on the plane, so I can't see what's below us. I beg to get a few shots, so the pilot invites me into the cockpit as we begin flying over the Antarctic continent. The view is of another world—the tips of grim mountains draped with glaciers poking through a wooly white blanket. The ice goes on and on, as far as I can see. No roads, no structures or vegetation, nothing but an immense empty continent. It is alien, Other, beyond the known or imagined. How do I fit this landscape in a picture frame? It would be easier to photograph heaven or hell. They, at least, would have human inhabitants to provide scale.

After a five-and-a-half-hour flight, we land smoothly on an ice runway. The doors open, and light floods in. I put on my goggles and step out into more space and sky than I have ever seen. The ice crunches beneath my boots. Distant mountains are edged crisply in the brilliant sunlight. I breathe the cold and light into my whole body. I am surrounded by people but feel terribly alone.

Boarding a C-141

Aerial view of Minna Bluff

THE BASICS

Antarctica is the coldest, windiest, highest (on average), and driest place on Earth.

Area: Fifth largest continent at 5.4 million square miles, slightly less than 1.5 times the size of the United States.

Coastline: 11,165 miles.

Composition: 98% thick continental ice sheet, 2% barren rock, 0% arable land.

Highest point: Vinson Massif, 16,066 feet.

Lowest point: Bentley Subglacial Trench, −8,382 feet.

Floating ice shelves make up 11% of the continent.

Antarctic ice constitutes about 80% of the world's freshwater.

—S.B.

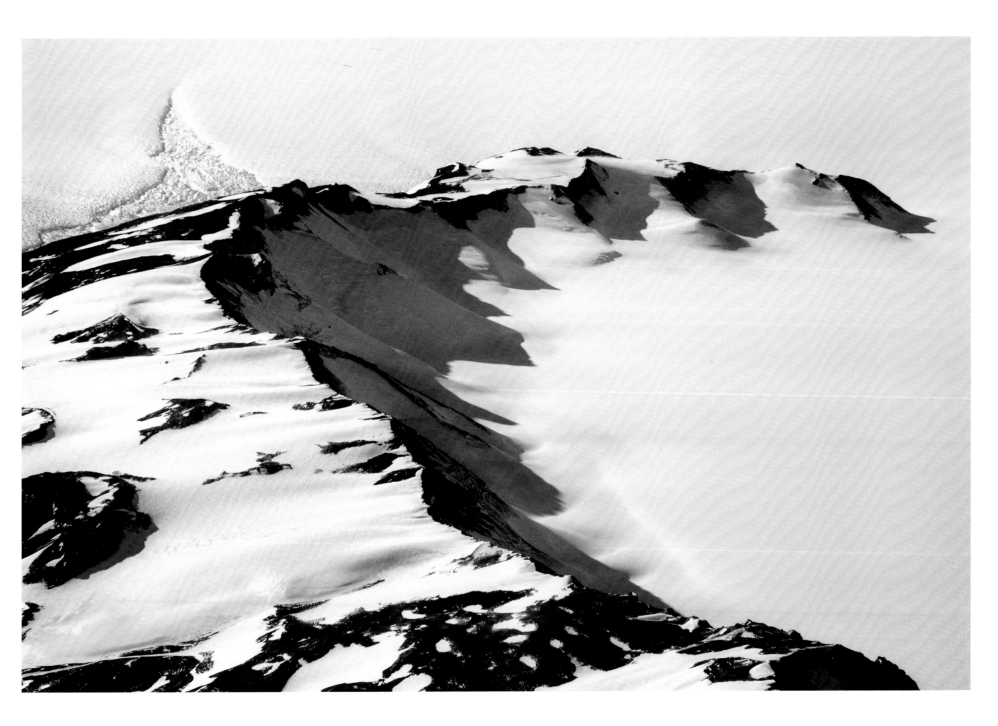

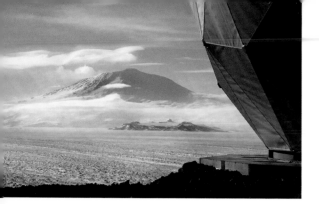

Communications antenna for McMurdo Station, Black Island. McMurdo is a small speck on Ross Island, 50 miles away across the sea ice. Above it towers Mount Erebus.

Overview of McMurdo Station with Observation Hill

A PLACE FOR SCIENCE

Antarctica is a continent devoted to science. The United States has three Antarctic bases, all run by NSF: McMurdo Station, Amundsen-Scott South Pole Station, and Palmer Station on the Antarctic Peninsula. Currently 27 other countries have active scientific research programs with more than 40 stations operating year-round.

Antarctica is also the most peaceful continent on our planet. In 1961 the first Antarctic Treaty took effect among the 12 nations active in the Antarctic during the 1957–58 International Geophysical Year. Its primary purpose was to ensure "in the interests of all mankind that Antarctica shall continue forever to be used exclusively for peaceful purposes." To this end it prohibits military and nuclear activity, promotes scientific research, and holds all territorial claims in abeyance. An additional 21 nations now accede to the treaty and its related agreements, collectively called the Antarctic Treaty System.

Making a Home

OCTOBER 11, MCMURDO STATION, −23°F, WIND CHILL −44°F

ANTARCTICA IS THE COLDEST CONTINENT on the planet, with winter temperatures in the center of the continent reaching a formidable −128°F. When I first stepped off the plane onto the sea ice, the wind chill was −50°F. But it's so dry you don't feel cold as long as you're warmly dressed and keep moving. Highs here at McMurdo are now often above zero, but the wind blows most days, and it hasn't reached 20°F yet.

McMurdo is the metropolis of Antarctica, the largest research station of any nation on the continent. It's also the logistics hub for the South Pole Station and numerous field camps. Planes and helicopters land and depart; heavy equipment operates 24 hours a day. But it's still a very small town. You can walk to the end of it in any direction in a few minutes. It's impossible to get lost . . . except, maybe, in a blizzard.

I come at a good time, since people are just beginning to fly in for the austral summer season, October to February. So far they're mainly support folks—electricians, heavy-equipment drivers, office staff. Over the next month or so, some 200 people will arrive every week, and eventually about a thousand people will live and work at the station.

I look out my office window in Crary Lab, a large split-level science building. The sky is blue and perfectly clear, the view unfamiliar and disorienting. Below me is the sea-ice runway, where our C-141 landed a few days ago. Aside from a few small vehicles and huts, the vista is of an unbroken white, flat expanse of ice rimmed on the far side by the Royal Society Range, a spectacularly beautiful range of mountains. It's a line of peaks like no other, a line so specific in its contours that it distinguishes this place from anywhere else on the planet. Mount Discovery, the range's highest peak, is straight across from me with its slightly rounded top covered in snow. To the left is Black Island, where the communications antennas for McMurdo are located. Farther still, just out of view from this window, is White Island.

At home, from my dining room windows in Santa Fe, I can see the Jemez Mountains, a similar mountain range about the same distance away. It's what lies in between that makes the difference. In New Mexico, juniper and piñon trees stud low hills, along with mountain mahogany, cholla, and chamisa. Rabbits and coyotes roam at will, and ravens do regular flyovers. Thousands of years of human occupation have marked the land with pottery shards, petroglyphs, and pueblo dwellings, as well as the less-aesthetic trappings of modern America.

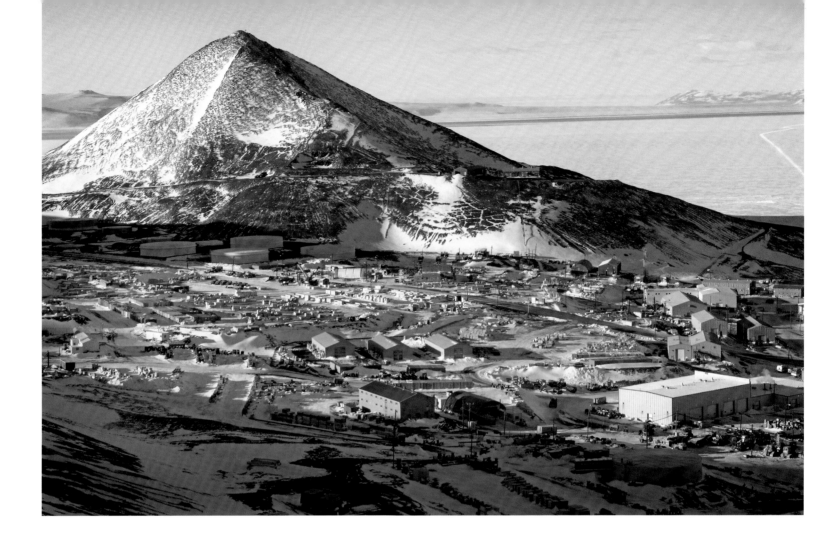

Here in Antarctica, it looks as though I could walk to Mount Discovery in a couple of hours. However, in this clear air it's easy to misjudge distance, and reaching the mountains would actually be a 40-mile trek across 12-foot-thick sea ice. In between I would encounter no animals, birds, or plants of any kind. On this frigid continent, we can never be at home.

Yesterday, I got my computer completely hooked into the network and set up for e-mail. I'm fortunate to have office space in Crary Lab along with many of the scientists. In addition to offices, Crary has labs and an aquarium for the strange fish that live under the sea ice. On the top floor are a lecture hall, computer terminals,

and a library, all with panoramic views. When I'm tired I go to the top-floor windows, prop my head on my elbows, and stare outside at planes landing, trucks moving around on the sea ice, and the not-uncommon *fata morgana* where extra mountains appear, mirage-like, on the ice. Outside my office is a communal coffee pot with instant hot chocolate. I've quickly gotten into the routine of making a combination of hot chocolate and coffee for a late-morning pick-me-up.

Everyone is friendly and helpful. I am lonely but already feel that I'm becoming part of a community.

Humans who have adapted to cold weather, like the Inuit, have short arms and legs and thick bodies, which hold heat close to their core. Some Northern Europeans, who were exposed to a drastic drop in temperatures some 12,000 years ago, may have developed juvenile diabetes as a way of pouring glucose into their blood to keep it from freezing. But for long-limbed scientists working in Antarctica, adaptation to cold seems to involve a different physiological response. In extreme cold, their bodies use a thyroid hormone and neurotransmitter called T3 to stay warm. When the brain is deprived of T3, a mental slowness sets in. This is called the "Antarctic stare"—a blank gaze common among winter residents prone to forgetfulness, lack of focus, increased anger, irritation, and depression. —S.B.

Frostbite and Blizzards

OCTOBER 13, ROSS ICE SHELF, −15°F, WIND CHILL −43°F

HAPPY CAMPER SCHOOL is an Antarctic tradition, beloved by scientists and field workers. This rite of passage provides instruction on snow survival in a spectacularly beautiful setting on the Ross Ice Shelf. Everyone who works away from McMurdo must attend one of the two-day sessions to be prepared for those worst-case scenarios you can imagine from Hollywood disaster movies. Our little group of 16 sets off from McMurdo in the late morning after a brief lecture on hypothermia and frostbite. We drive in a weird-looking tracked vehicle called a Hagglunds over the hill behind Mac Town (as the locals call it), past Scott Base (a small New Zealand research station), and then out on the ice shelf. In the distance, we see Mount Erebus, our local fire-breathing volcano, almost 13,000 feet high.

We stop briefly in a small unheated metal hut, gobble sandwiches and juice, and learn how to light the Primus stoves. They aren't complicated, but I struggle to get all the little legs in the right position and to attach the fuel canister. The stoves come with a little packet of repair O-rings and tools, which I pray I never need to figure out how to use. We then drive about a mile farther to an empty flat area and unload our gear. The sun is bright, and the snow squeaks beneath our feet. Erik and Allan, our instructors, show us how to set up Scott tents (similar to the ones Robert Falcon Scott used but bright yellow and made with modern materials).

Suddenly, while pitching the tent, I realize my fingertips have turned to wood without warning. My fingers were very cold, then all of a sudden I can't feel them at all. I know instantly I have to take action. I put on my bear-paw mittens, which I had taken off to tie knots, ball up my fingers inside the mittens, and rotate my arms in big circles like the instructors showed us. For good measure I even run a few yards. Finally I can feel the tips again, burning as they warm up. My instructors say that if the skin starts to peel in a few days, it'll mean they were frost-nipped.

Next we build a snow dome out of a firm dry snow that feels much like Styrofoam. We cover all our gear with shoveled snow, pack it down, dig open a hole in the side, and remove the gear, leaving an igloo-like structure. We also practice making trenches and snow walls, which we're told can be used as emergency sleeping quarters. Several of the men really get into building them and later sleep in their constructions. Another

Happy Camper School

Setting up tents

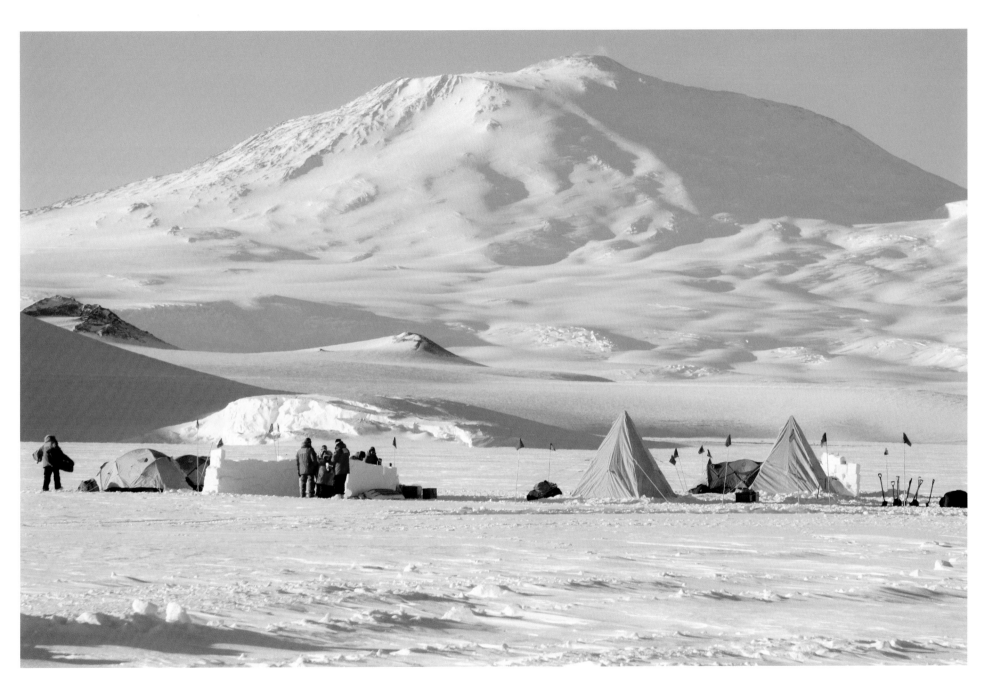

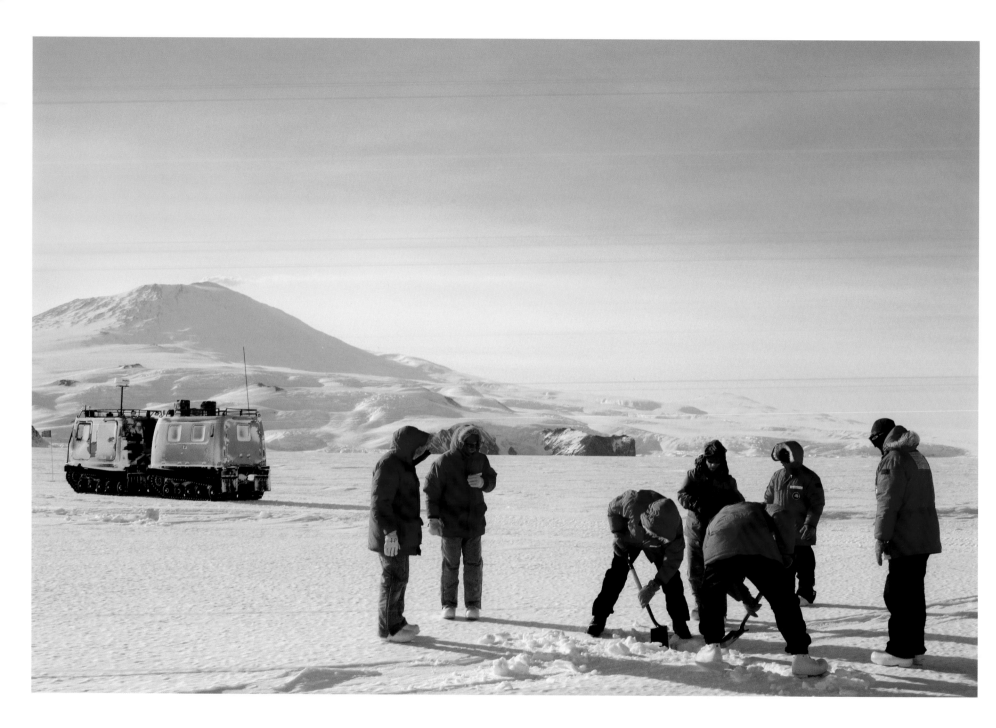

woman and I have been given a small dome tent to field-test. I set that up, hoping it will be more comfortable, if less daring, than their three-foot-deep trenches.

Finally we put our stove-lighting skills to the test and light several of them to boil water for dinner. After all that work, freeze-dried chicken and brown rice taste as good as any fine meal, and I finish off with hot chocolate. We've been encouraged to eat and drink a lot, since staying hydrated and eating enough calories are crucial to staying warm. After dinner it's still bright as midday. I walk a few hundred yards and look back at our little camp. It's dwarfed by its magnificent surroundings, but the yellow tents and red parkas make a bright splash on the ice. Despite my clumsy bear-paw mittens, I take a few photographs. The sun slowly sets about 9:30 PM, but it never gets fully dark. In a couple of weeks, it won't set at all.

By this time I'm tired and ready for bed, so I fill a water bottle with boiling water for the bottom of my sleeping bag and turn in, fully clothed, with three pairs of socks on my feet. So far, so good. If I put the hood of my parka over my head I can still breathe and not be too cold. I stash my digital camera inside the sleeping bag with me, afraid that otherwise I'll awake to find it sheathed in ice. The outside temperature is about 10°F so even in the tent I shiver a little, and my feet are cold despite the hot water bottle and extra socks. After tossing and turning a bit, I do fall asleep and stay reasonably warm until about 3 AM, when a sudden gust of wind rattles the untied guy wires on the tent. We tied only four of them down with snow anchors the night before, since it was perfectly calm and clear, and we didn't really believe our instructors' warning about the vagaries of Antarctic weather. Then another gust comes and another, stronger, one. Pretty soon the whole tent is shaking.

In the midst of all this, my tent mate, Christine, puts on her parka and bunny boots, struggles to open the tent flap, and sets off for the outhouse. You're very brave, I tell her when she returns. I have to go but decide to wait. An hour later, when I can't wait any longer, I open the tent flap and see that all our bags are covered in snow. The tent is shaking as if in the maw of an enormous angry dog. I put on my parka and boots and head for the green flags about 30 feet apart that mark the outhouse path. I can barely see them. When I'm ready to return, I can't see the flags at all. Everything is white—ground, air, sky. No horizon and no ground. The wind howls. It's as if the camp never existed. Afraid that I might get lost, I spend a little longer in the outhouse. When the gusts temporarily die down, I make it back. Happy Camper School is an abrupt warning that all the terrible things that befell the early explorers can happen to me if I'm careless.

When we finally finish in midafternoon, we drive back to McMurdo. I head straight for the small dorm sauna and take a very long hot shower. I sleep 12 hours and am still exhausted. When I get back to the computer, I look up the temperature and find that the low last night was −20°F with a wind chill of −84°F. Clearly I will not make a polar explorer!

Learning to "read" the cracks in the sea ice

Antarctica plays beguiling tricks on the human eye. At the South Pole, ice crystals in the cold air frequently create spectacular sun dogs (parhelia) and sun halos by refracting and reflecting light. More disturbingly, with no trees, buildings, telephone wires, or other familiar landmarks to calibrate perspective, distances are virtually impossible to comprehend. What appears to be 10 miles away is actually 100 miles away. A vast whiteness and emptiness overwhelm the senses. When alternating layers of warm and cold air form over the ice, far-off mountains are reflected as inverted castles that dance in the air. The mingling mirage is called a *fata morgana*— after King Arthur's half-sister, the Fairy Morgan, who lived in an underwater crystal palace and built fantastic structures out of thin air.
—S.B.

Last Sunset

OCTOBER 15, MCMURDO STATION, −10°F, WIND CHILL −45°F

'M BEGINNING TO FEEL COMFORTABLE in this extraterrestrial outpost. Tonight I'm staying up to photograph the sunset, one of the last before the sun remains above the horizon for the rest of the season. The sun has hovered at the horizon for an hour now, hesitating, reluctant. The sea ice is turning peachy, waiting.

Sunsets take forever here, when they happen at all. When the sun finally sets tonight, it will rise a few hours later and then not set again until February 20. Until then, the sun will rule the land both day and night. At the austral summer solstice on December 22, the sun will circle the sky, scarcely bowing at the horizon. At most the moon will glimmer palely in a day-lit sky; the stars will be invisible the entire summer.

Night and day, as well as the seasons, have a different meaning close to the Poles. Forget spring, summer, fall, and winter. Here the seasons are about light and darkness. At the South Pole, only one sunrise and sunset occur each year. After six months of darkness, that first sunrise in September lasts for several weeks as the sun circles near the horizon and finally climbs above it.

For those who have lived and worked in the polar darkness for what feels like an eternity, it's an indescribable joy to witness the return of light. For those who work here during the austral summer, the constant light is as difficult to adjust to as the winter darkness. It's a blessing and a curse. With no darkness, it's just as easy to photograph at 2 AM as it is in the afternoon, so it's possible to set any work schedule you want. On the other hand, sleeping in the brilliant light, especially outdoors in a tent, is difficult. Without the regularity of darkness, you tend to work more and sleep less.

View from my office window

Last sunset—24-hour daylight until February 20

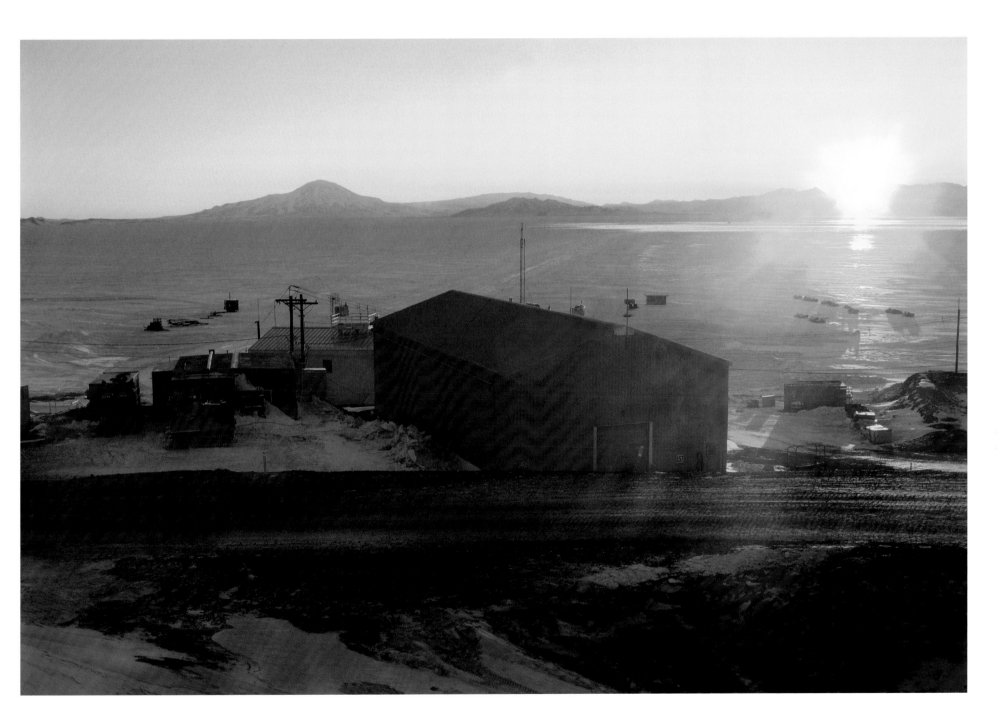

Dormitory rooms

A Home Like Any Other

OCTOBER 16, MCMURDO STATION, −13°F, WIND CHILL −29°F

COMMUNITY LIFE AT MCMURDO is as unusual as the place. It's egalitarian in that everyone has a job, works very hard, and respects the work that others do. But some are more equal than others. The scientists are the highest caste, and everyone else is here to support them. So sometimes you hear support staff saying, "This place would be great if it weren't for the scientists."

Friends and family at home ask me what McMurdo's social scene is like. Isn't it strange to have so many people here by themselves, without family? McMurdo is a giant family of sorts, and no more or less dysfunctional than any other. For some people here, their McMurdo family is all that matters to them. They have close friends who've been coming here for many years. Since everyone here works very long hours, they get to know fellow workers better than they know friends back home. I overhear one of the older men say, "You know, I think I keep coming down because that's where all my friends are. I don't have much in common with people at home."

Most people do have families "off the Ice." Many have spouses and children. They come here because the pay is good, they need the money, and work in Wyoming or Alaska isn't easy to find in the winter. I know one man who has been coming down for 15 years. He and his wife have worked out an arrangement where he's home part of the year with her and their four kids, and on the Ice the rest of the time. Other folks have partners or spouses here with them. They fix up their dorm room with a couple of beds pushed together into a king-size bed, find a chair and a couch, and call the place home. They work different jobs during the day and find time to eat together and relax in the evening. A number of couples have wintered-over together. Many others are young and single. The dating scene is reportedly quite wild for the young at heart, but since I'm neither young nor single, I can't report firsthand on that.

Support Staff

OCTOBER 17, MCMURDO STATION, 3°F, WIND CHILL −36°F

'VE BEEN PHOTOGRAPHING THE STATION'S support staff, who greatly outnumber the scientists. All of them work for Raytheon Polar Services, the only contractor for the U.S. stations. You wouldn't think it would take so many people to keep the station in operation, but the longer I'm here the more I understand it. When you have only 20 scientists you can get by with a minimal support crew, but by the time you have 150 scientists you need a support staff for the support crew. Then you need administrative help for planning the logistics, staff to help move everything around, and supervisors. At New Zealand's Scott Base, which has a population of about 80 in the summer season, everyone helps wash the dishes. Here, we need a dishwashing crew.

Yesterday I walked to the top of McMurdo, which is built on a hill, to photograph part of the waste recycling system. When I get to Fortress Rocks, a baler is munching up large metal conduit and squashing it into rectangular cubes. Denise, the operator, is happy to lean out her window and smile for a photo.

At the Paint Shed, I photograph two women who work in the only building "on station" with lots of color. They have painted every cabinet door a different hue. Since NSF has only approved colors that blend with the environment, most structures are a dreary brown outside; inside, walls are light brown, mustard color, or lime green. The women have just finished painting the exterior of the fire station and say it doesn't look any better than it did before. It's still brown. In a place where the only outside colors are white, brown, and black with an occasional blue sky, we could use some strong reds, yellows, oranges, greens, and purples.

Carpenter
Cutting pansies from the greenhouse, South Pole
Carpenter shop

Paint Shed door

Janitor

Baler

Waste barn

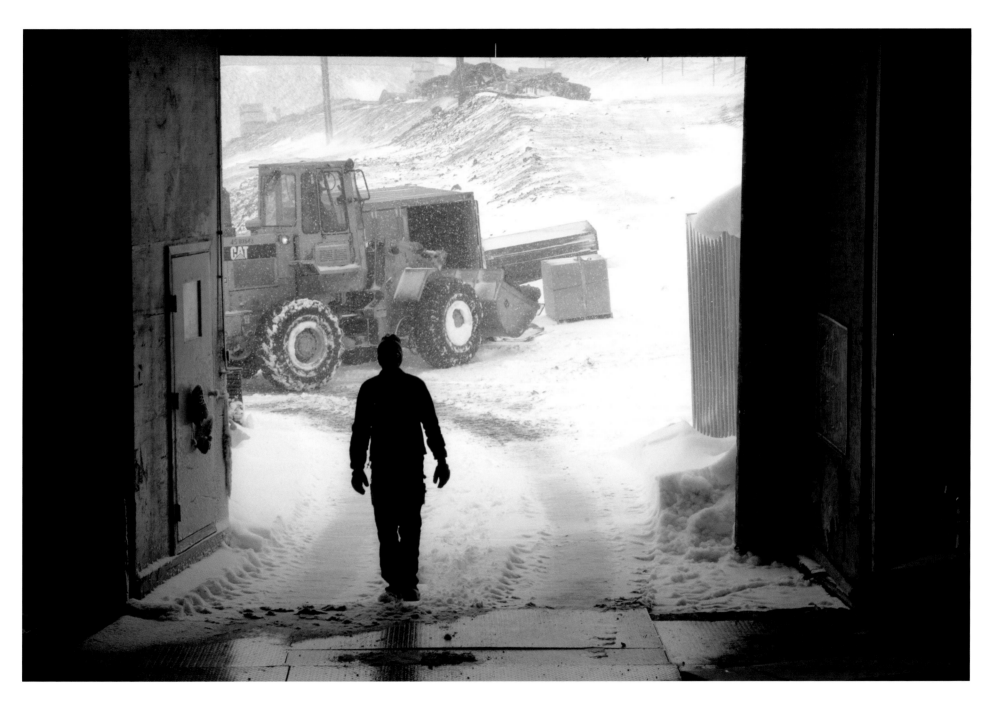

Marble Point field camp

Ralph, checking his GPS

Lost on the Ice

OCTOBER 19, MARBLE POINT TRAVERSE, 5°F, WIND CHILL −17°F

MARBLE POINT IS A TINY OUTPOST about 50 miles from McMurdo across the sea ice to the northwest. It's used for staging supplies for research field stations in the Dry Valleys and as a fueling depot for helicopters, the major means of transportation in the area. Each year trucks carry supplies early in the season across the sea ice to Marble Point, and I've been invited to join one of the traverses. This is the moment I've been waiting for, my first real opportunity to photograph off-station.

We leave McMurdo in two Deltas, large red trucks with balloon tires that weigh 850 pounds each, and a Challenger Caterpillar. To reach the large heated cab in one of the Deltas, I climb a small ladder, which isn't so easy in my oversized bunny boots. I'm riding with Ralph Horak, who has been coming down for seven years, first working on station but gradually making more trips like this that take him farther away.

The day is gray with a slight wind. Minutes out of McMurdo, the town vanishes. I can't help but feel anxious. Is the sea ice really safe? Not far from here, nearly 50 years ago, U.S. Navy Petty Officer Richard Williams broke through the sea ice in his bulldozer and drowned. Willy Field, where the large Hercules planes now land, is named after him. Here we are, driving on the ice of McMurdo Sound in 15-ton vehicles on a day so milky that cracks in the ice would scarcely be seen before we fell into them.

I am not a fearless adventurer. I'm a coward and a wimp. I don't like cold. I dread the possibility of sleeping in a tent in freezing weather. Each time an "opportunity" like this comes along, I inwardly moan. Unlike many folks here, I don't get high on hardship. But, I'm here to take pictures, so I can't turn down adventures just because of anxiety and discomfort.

After an hour or so of the ice holding, I begin to relax and enjoy the rhythm of the journey. We follow a track made by the previous traverse, marked every mile or two by a red flag. Unfortunately the overcast darkens, and snow begins to blow across the track. The horizon disappears, and visibility drops to a few feet in front of us. Ralph hunches over the wheel and peers out at the tire tracks ahead of us. With no horizon, it's hard to judge and organize space. Suddenly we lose the track completely. Ralph stops, and the drivers converge.

"I'm sure we're off to the left of the route," says one. "I think it's over that way," says another, pointing off at a 90-degree angle from the first. "Good thing we've got GPS," says Ralph. They punch in figures, look at their charts, and we head off into the

featureless gray. Sky and ice blend together with no horizon and little visibility beyond the hood of the truck. To my relief and theirs, we soon see another red flag.

By midafternoon our world still consists of the truck-cab interior. We open our sandwich lunches and juice and eat as we drive. We follow the track when we can and GPS readings when the red flags disappear. The Deltas average about 10 mph on the traverse, so it's a leisurely pace, not too different from a mule pack trip in the Southwest. The sea ice is not smooth. It has lots of ridges and unexpected humps and dips we can't see in the flat light, and occasionally I'm tossed a few inches off my seat. The murky light isolates us completely in a place without time or defined space. Finally, about 4:30 in the afternoon, we leave the ice, cross a small spit of rocky land, and arrive at the station.

Deltas, Marble Point traverse

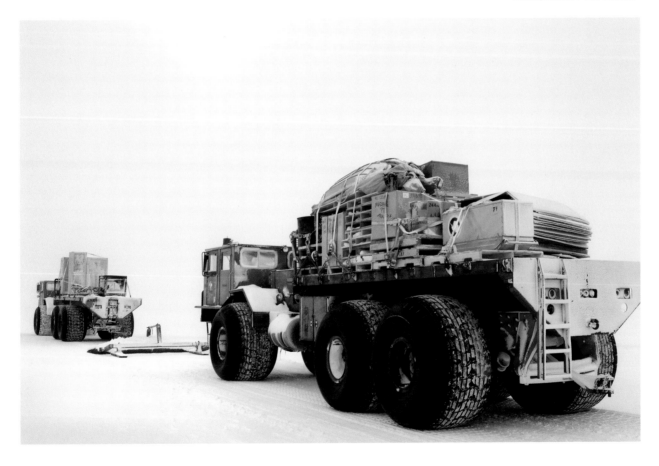

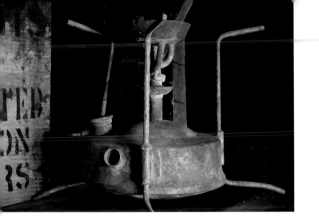

I may as well confess at once that I had
no predilection for Polar exploration.

ROBERT FALCON SCOTT

Voyage of the 'Discovery,' 1905

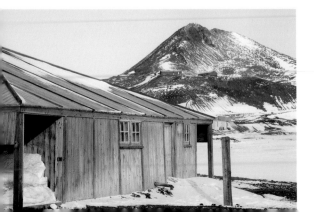

Observation Hill

OCTOBER 21, MCMURDO STATION, 5°F, WIND CHILL −35°F

WE ARE HERE AT A HISTORIC MOMENT. One hundred years ago next month, on November 2, 1902, Robert Falcon Scott, along with Ernest Shackleton and Edward Wilson, set off on the first attempt to reach the South Pole. The men were part of the 1901–04 *Discovery* expedition, and they left from Hut Point, a short walk from McMurdo. Although they didn't make it and had to turn back, all suffering from scurvy, it was the beginning of the race to the Pole that finally would be won by the Norwegian Roald Amundsen a decade later.

The 37-by-37-foot hut from the *Discovery* expedition, which Scott's men constructed of jarrah wood from a design popular in the Australian outback, is still here at the edge of the sea ice. It was used primarily for storage and still has large seal carcasses, preserved by the cold and stacked under the eaves, looking as though they might be chopped up for a stew. Well-aged meat!

For exercise, Scott's men climbed Observation Hill, a steep volcanic mountain that towers over McMurdo. One evening after a heavy dinner, a friend and I decide to do the same. It's a precipitous climb up volcanic cinders, a bit of a scramble over larger rocks at the top but not overly strenuous. As we hike up, we stop every so often to look back at McMurdo spread out like a dab of paint on the grand canvas of ice, snow, and volcanic rock below. In about half an hour we reach the top. The tiny summit of volcanic cinders and rocks with its large man-made cross is just big enough for a couple of people to stand, and we have it all to ourselves. The view is spectacular in all directions—across the sea ice to Black Island and White Island, down to Scott Base, over the ice shelf to Mount Erebus, and down to McMurdo below.

A decade later, in 1912, when Scott and his four companions from the *Terra Nova* expedition didn't return from the South Pole, a rescue party was dispatched from Cape Evans. The rescuers found, to their horror, the explorers' bodies frozen in their tent on the Ross Ice Shelf. Before the rescuers returned to New Zealand with their distressing news, they erected a heavy memorial cross made of Australian jarrah wood at the summit of Observation Hill. At the time, Apsley Cherry-Garrard, the youngest of the surviving men and a member of the rescue party, wrote that they did not expect anyone to ever come to this place and see the cross again.

Primus stove, *Discovery* hut, Hut Point

Discovery hut with Observation Hill

The heroic stories of exploration are the beginning of Antarctic history. Here at McMurdo on Ross Island, Scott and Shackleton's brief visits while attempting to reach the South Pole are the beginning of our local history. Without native peoples, the history we have pretty much dates from the arrival of white European males in the 20th century. Since they have also written the stories and the textbooks, our image of Antarctica has been forged on their anvils. It is one of struggle and endurance, heroism against all odds. Being a nonheroic woman rapidly approaching 60, I think about that a lot.

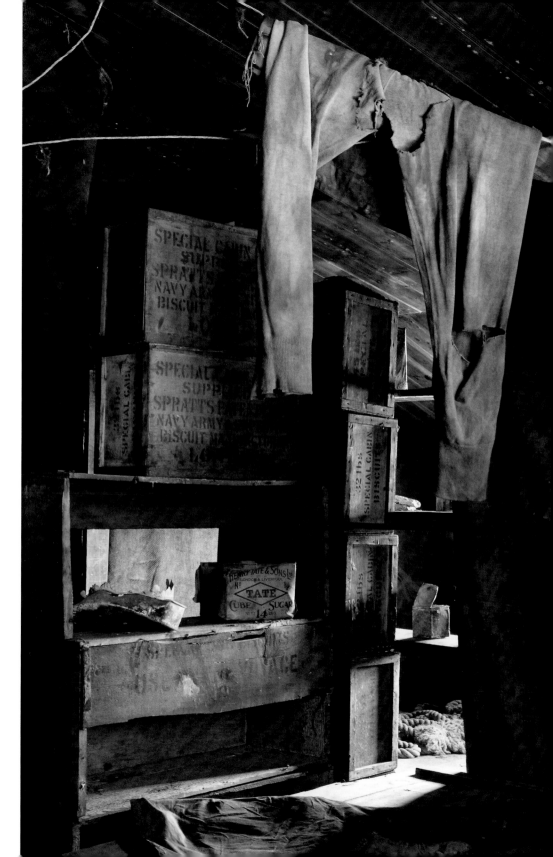

Inside *Discovery* hut, Hut Point

A BRIEF HISTORY OF ANTARCTICA

1772–76
James Cook crosses the Antarctic Circle, circumnavigates Antarctica without seeing it, and discovers South Georgia Island and the South Sandwich Islands.

1820
Nathaniel Palmer (United States), Edward Bransfield (England), and Thaddeus von Bellingshausen (Russia) independently claim the first sighting of Antarctica.

1841
James Clark Ross of Britain's Royal Navy penetrates the pack ice and discovers Ross Island, Mount Erebus, the Ross Ice Shelf, and Victoria Land.

1895
A party from the Norwegian whaler *Antarctic* makes the first confirmed landing on the Antarctic mainland. (Sealers had undoubtedly landed earlier on the Antarctic Peninsula.)

1899
Carsten Borchgrevink and members of the 1898–1900 British Antarctic expedition are the first to winter-over on the continent.

1902
Robert Scott, Edward Wilson, and Ernest Shackleton of the 1901–04 *Discovery* expedition make the first serious attempt to reach the South Pole.

1908–09
Shackleton and members of the 1907–09 *Nimrod* expedition make the second attempt on the Pole.

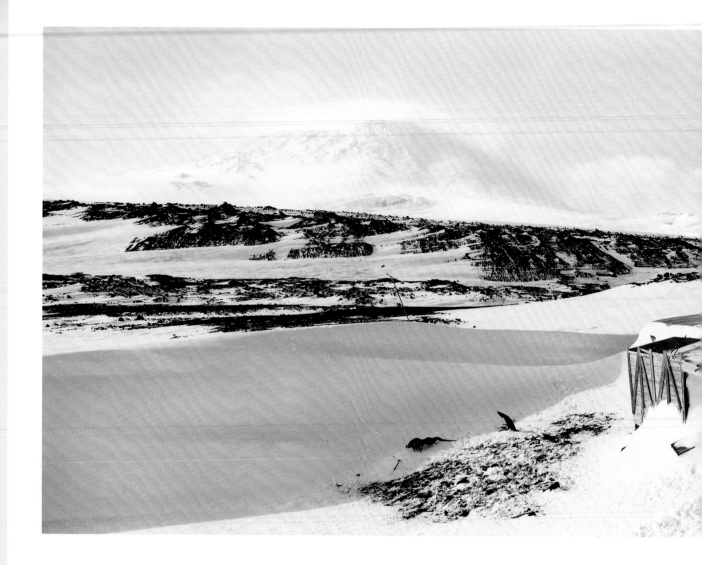

Scott's hut, Cape Evans

PAGES 44–45
Chemistry bench, Scott's hut, Cape Evans

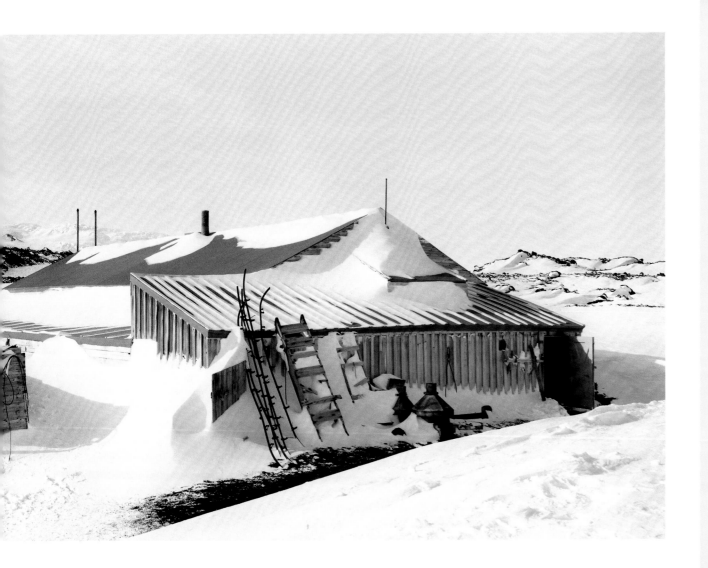

1911
Roald Amundsen and members of the 1910–12 *Fram* expedition are the first to reach the South Pole.

1912
Scott and four companions from the 1910–13 *Terra Nova* expedition reach the South Pole a month after Amundsen but die on the return.

1914–17
Shackleton's attempt to cross the continent fails when the *Endurance* is crushed in the pack ice. The Ross Sea party of his expedition lays depots for Shackleton despite being marooned at Cape Evans without adequate supplies.

1929
Richard E. Byrd and three others are the first to fly over the South Pole. Byrd returns to lead expeditions in 1933–35, 1939–41, 1946–47 (Operation Highjump), and 1955 (Operation Deep Freeze, which establishes McMurdo Station).

1957–58
The International Geophysical Year establishes ongoing Antarctic science exploration. The United States constructs and begins operation of the McMurdo and the South Pole stations.

1961
The Antarctic Treaty, which promotes peaceful and scientific use of the continent, takes effect.

1978
The Antarctic Conservation Act, which regulates conservation and environmental issues, takes effect.

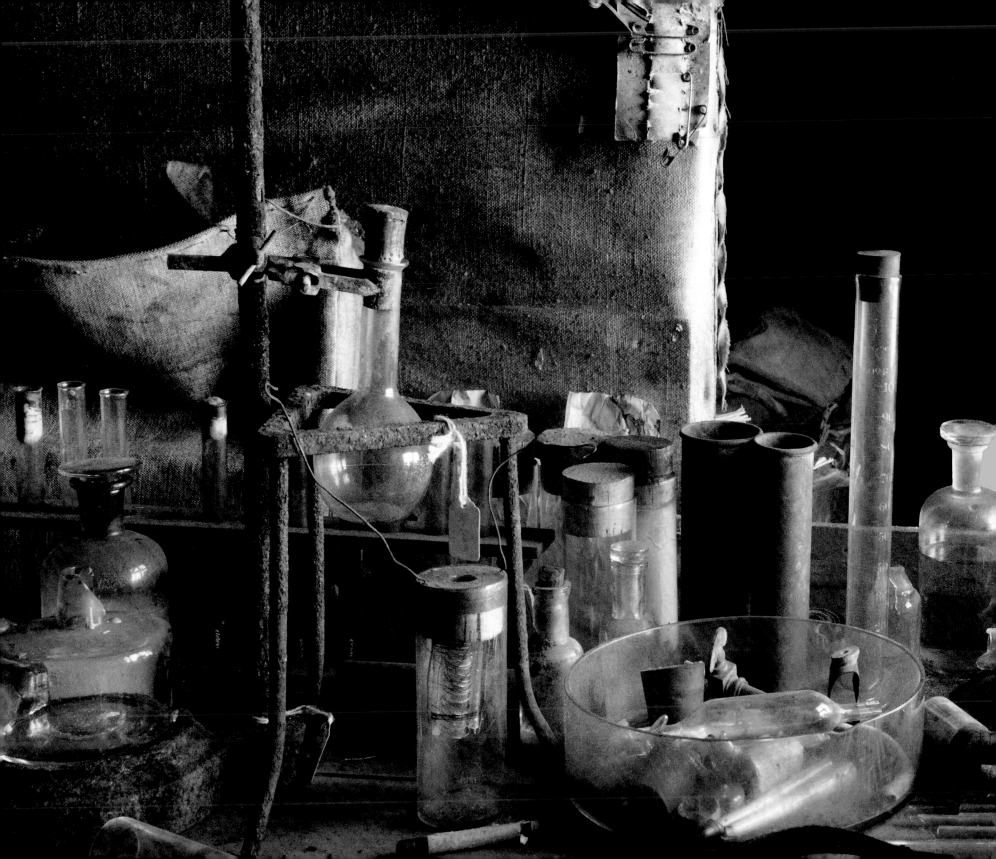

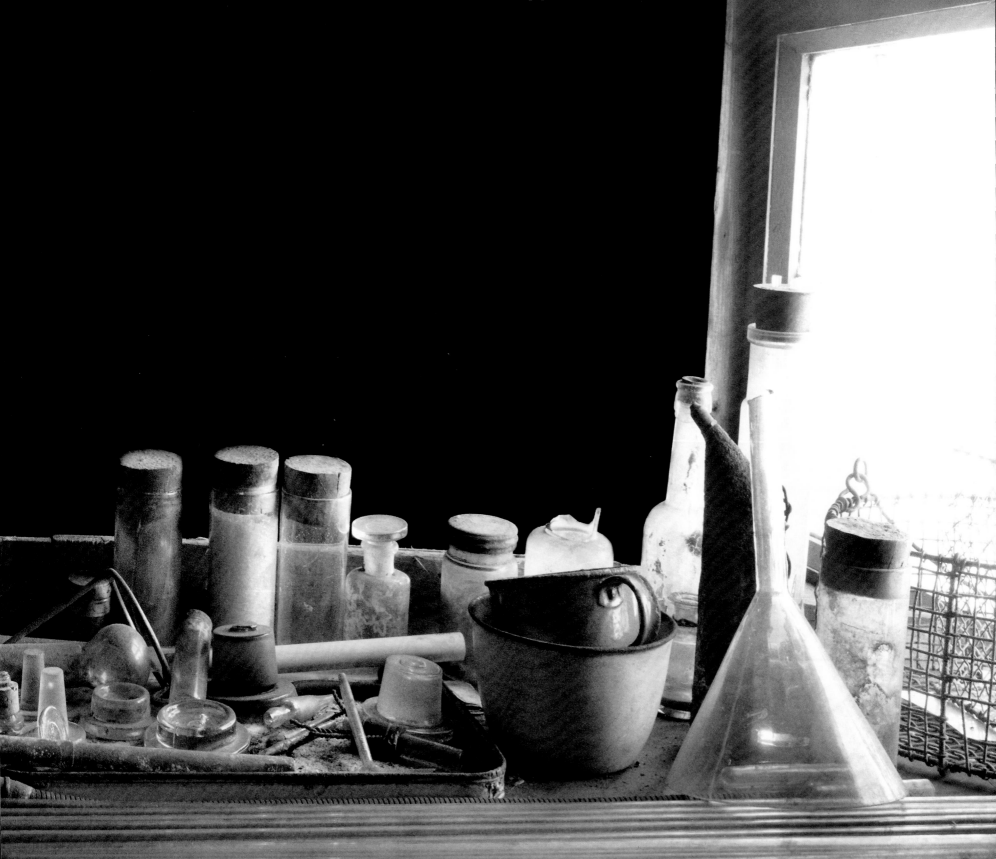

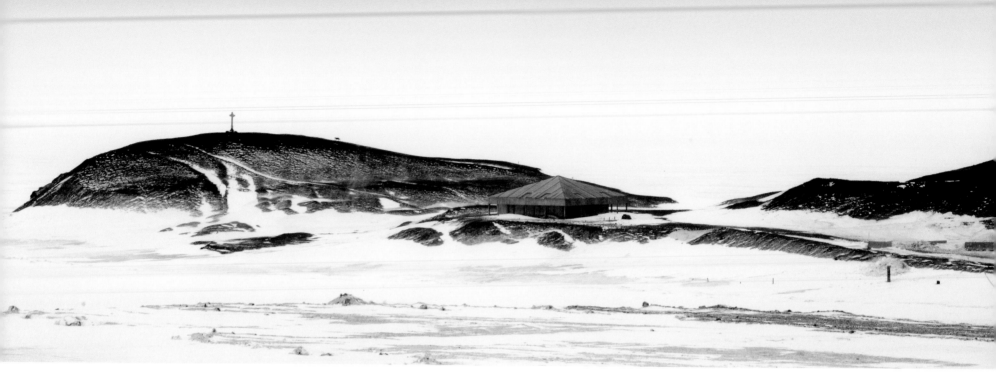

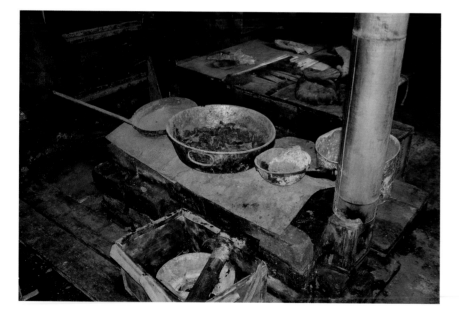

Hut Point with *Discovery* hut

Blubber stove, *Discovery* hut

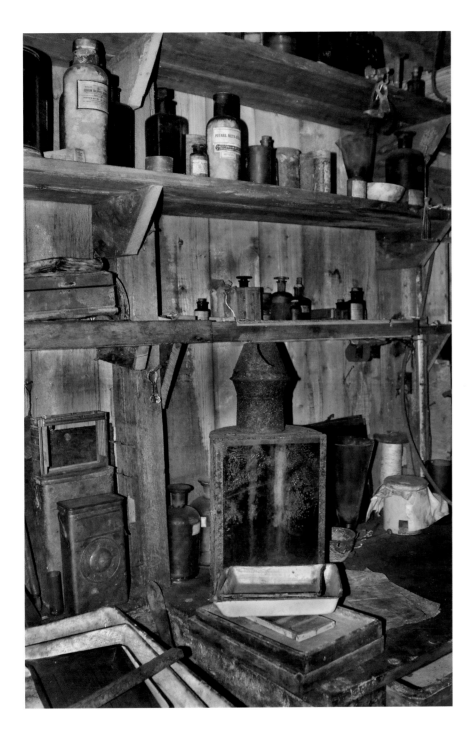

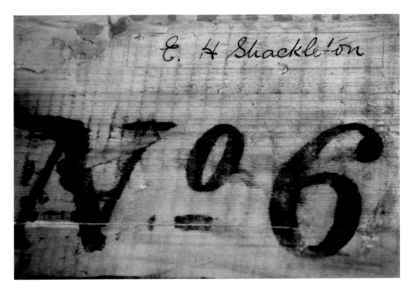

Herbert Ponting's darkroom, Scott's hut, Cape Evans

Pony troughs, Cape Royds

Shackleton's signature on his bunk, Cape Royds

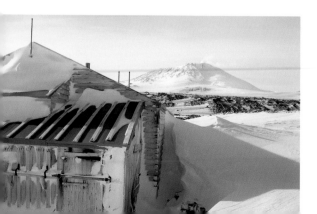

A Haunted Site

OCTOBER 22, CAPE EVANS, 7°F, WIND CHILL −17°F

WHAT A GREAT DAY! I set off in the early morning for Cape Evans with Eddie Quinn, who helps outfit scientists for Antarctic field camps. Many scientists remain at McMurdo only long enough to pick up necessary supplies and provisions before setting up field camps to do their research. Some are within snowmobile range; many require helicopter or fixed-wing aircraft support.

I'm happy to have a companion who'll be able to solve any problems we might have, and he's pleased to spend a day outdoors. We get the Pisten Bully (a macho-looking enclosed truck on treads) gassed up, load cameras and survival gear, pick up sack lunches from the galley, and drive down to the sea ice. It's a good feeling to be leaving town and heading out. The Pisten Bully is not a fast or fuel-efficient vehicle. It takes us over an hour and 8.5 gallons of diesel fuel to travel the 15 miles from Hut Point over the ice to Cape Evans.

Our route was flagged early in the season so heavy vehicles can safely travel it. Eddie notes that we're seeing terrain little changed since Scott's *Terra Nova* expedition. When we round the Cape we can see Scott's hut nestled under Wind Vane Hill. Scott, his scientists, and crew lived here and wintered over before making their doomed trip to the Pole. Shackleton's Ross Sea party used the same hut in 1915–17 as they laid depots, unaware that because the *Endurance* was crushed by pack ice, Shackleton would not set foot on the continent.

To peer into the hut's darkness is to see time frozen. There's something both eerie and awesome about seeing the quotidian marks of men who lived here almost a century ago. You enter the hut via a small hallway where snow shovels and other outside tools are hung. Beyond the entryway are piles of seal blubber, perfectly preserved, and the pony stables, lined with bales of hay. Inside, along the walls of the living area, are open cubicles with sleeping bunks, Scott's little den, and Captain Oates's bunk draped with harnesses and snowshoes for the expedition ponies he was hired to handle. A frozen emperor penguin lies on the table ready for dissection by Dr. Edward Wilson, scientist and artist.

When Scott wintered-over, he used a wall of provision boxes to divide the space into a mess deck for the nine seamen and a back wardroom for himself and his

Scott's hut, Cape Evans, with Mount Erebus
Inside looking out, *Discovery* hut, Hut Point

15 officers and scientists. (I remember a photograph showing Scott's 43rd and last birthday dinner at the central mess table. The men are eating seal soup, roast mutton with red currant jelly, fruit salad, asparagus, and chocolate.)

A hundred years ago, the British had a policy of leaving behind anything they did not need for the next group that came along. It saved Shackleton's men, who lost most of their supplies when their boat broke anchor and drifted out to sea. One could still survive for a considerable period of time on the food and supplies left here.

To photograph this haunted site is challenging. One of the rules for entering the huts, made by the New Zealand Antarctic Heritage Trust which administers them, is not to touch anything. Since you're not allowed to move anything, you can't make a still life neat and tidy. Plus, the only light for the entire hut comes from a single long window over the chemistry table. Everything else is in frigid darkness.

But I come prepared. I bring hand warmers to put inside my gloves and an external battery pack to run both camera and flash, so I don't have to worry about batteries dying. It's a nuisance to hook it all up and to wear the heavy battery under my parka, but it works. Eddie shines a flashlight around to help me see what's stacked on shelves, in crates in the kitchen, and in the corners of the men's beds. I can't see enough to accurately frame a picture, but I can focus and shoot. I'm often surprised by what appears on my digital monitor, since the camera sees a lot more than I do.

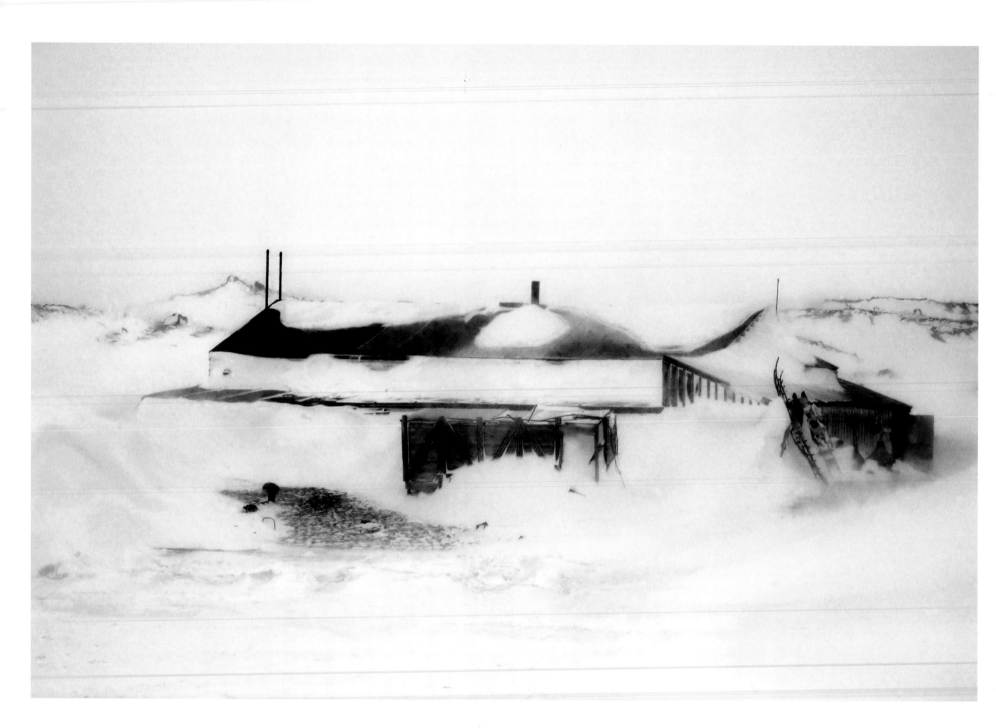

Blizzard, Cape Evans

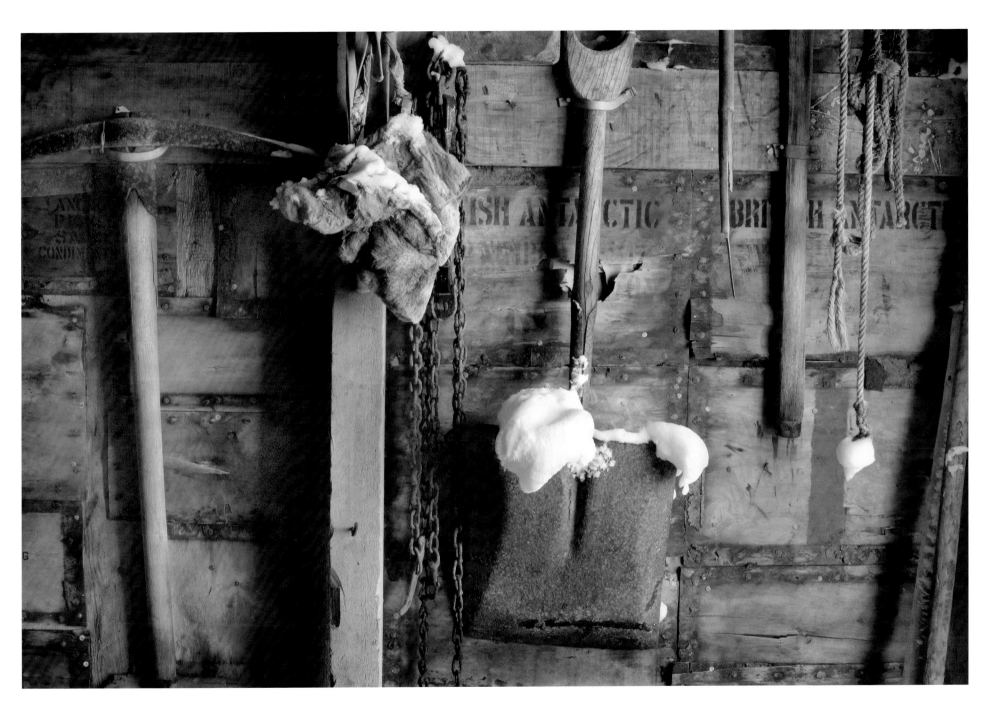

Entry, Scott's hut, Cape Evans

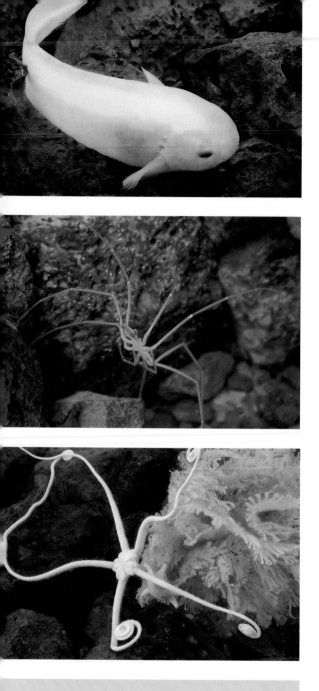

Creatures from McMurdo Sound:

Snailfish

Sea spider

Brittle star

Life in the Cold

OCTOBER 28, MCMURDO STATION, 4°F, WIND CHILL −18°F

THE WATER UNDERNEATH THE 12 FEET or so of sea ice in McMurdo Sound is so salty that it doesn't freeze, even though it's several degrees below freezing temperature. Fourteen divers are currently working under the ice on various research projects. They all love their visits to the "underworld" and can hardly wait to go down each day. I'm helping out as a dive tender, which means I help them fasten their tank straps and put on tight-fitting gloves. It's a laborious process to suit up for diving in this cold. When they finish putting on all their layers, only their lips are exposed. They say their diving gear provides good insulation and that they're not uncomfortable after the initial 30 seconds or so.

They sink slowly into a hole three feet wide and 12 feet deep that has been drilled through the ice inside one of the huts. A few bubbles mark their departure, and then it's just a blue hole. The team uses a down line with signal flags and flashing lights to mark it, but later in the season, when algal bloom decreases visibility, they'll use a tether to find their way back. They descend 90 feet (130 feet is maximum, for safety), down a steep slope, into some of the clearest water on the planet, with visibility about a quarter of a mile. A Weddell seal swims gracefully up to them and then glides away. When they reemerge after a half hour or so, their lips swollen by the cold, they have a net of starfish, sea urchins, and other strange creatures to take back to the lab.

In the evening, Donal Manahan from the University of Southern California gives a lecture on his current research entitled "Growing Up Cold and Hungry: Larval Biology in Antarctica." According to Manahan, the polar organisms that he has studied have metabolic processes that are as fast as similar marine animals found in the tropics. They synthesize proteins at a phenomenal pace. The embryos of some species can live up to a year and a half without food, just waiting for the right conditions to complete development. It makes me wonder what life might be like on another planet with very cold or very hot temperatures. We tend to assume that life cannot exist in such places, but after tonight's lecture I'm not so sure.

Entering a dive hole

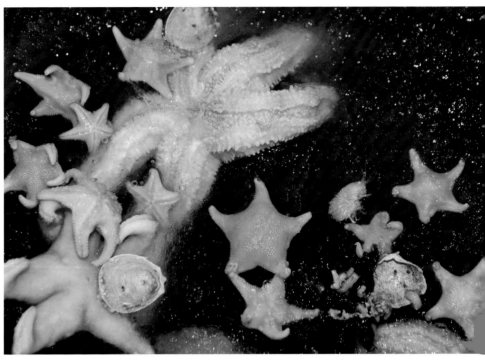

Starfish

Halloween is the biggest party of
the season. It's held in the gym, a
Quonset hut down by the helicopter
pad, and decorated for the occasion
with black lights, cobwebs, and other
regalia saved from one year to the
next. Costumes are creatively made
with whatever odds and ends can
be scrounged up.

> But, after all, it is not what we see that inspires awe, but the knowledge of what lies beyond our view. We see only a few miles of ruffled snow bounded by a vague wavy horizon but we know that beyond that horizon are hundreds and even thousands of miles which can offer no change to the weary eye, while on the vast expanse that one's mind conceives one knows there is . . . nothing but this terrible limitless expanse of snow. . . . Could anything be more terrible than this silent, wind-swept immensity when one thinks such thoughts?

ROBERT FALCON SCOTT
Voyage of the 'Discovery,' 1905

Up in the Air

NOVEMBER 1, MOUNT NEWALL, 7°F, WIND CHILL −25°F

TODAY I JOIN SEVERAL ENVIRONMENTAL TEAM MEMBERS who are inspecting the field camps to make sure they comply with the Antarctic Conservation Act. (The ACA implements the Antarctic Treaty and mandates environmental protocol for all U.S. stations operating in Antarctica.) Mount Newall, in the Dry Valleys, is the site of a small radio repeater station and seismic transmitter station on a high ridge between two valleys. The helicopter pilot flies up a fractured cascading glacier, sets down on the top of the ridge, and shuts down for a couple of hours while the men take their inventory. He stays inside the aircraft cabin, toasty warm from the solar gain, and reads his book.

The ridge is several thousand feet above the valleys and the sea ice. I wonder if it has ever been climbed on foot. The dark tips of the mountains stick out of the snow, but otherwise everything is covered in white. On top are the transmitters, a small hut, a wind generator for power, and a survival cache. The view is unobstructed in all directions. I feel I can reach up and touch the sky.

It's calm and clear, just above 0°F. I stay warm except for my fingers, which were, in fact, frost-nipped at Happy Camper School. They still feel very tender, so I put a hand warmer in each of my gloves. The snow makes sounds when I walk on it, sometimes a light airy crunch, and other times a deep pitch, as if I am walking over something hollow. I could work a week here doing pure landscapes.

Later I'm offered a trip on a Twin Otter, a small prop plane on skis that can land on sea ice, snow, or water. The U.S. Antarctic Program has chartered two of these planes, which are flown by two Canadians, Sean Loutitt and his wife, Sandy. A few years earlier, in the middle of winter, Sean flew the same plane on a daring rescue of a doctor who suffered a heart attack at the South Pole.

Weeks earlier at lunch, I sat next to Dr. Betty Carlisle, the physician who was flown to the Pole to take his place. She's a feisty lady, about my age, self-effacing. I ask her how she felt about being part of such a dangerous undertaking. If the Twin Otter's equipment had failed between Rothera, the British base on the Antarctic Peninsula, and the Pole, nobody could have rescued them. She said she hadn't thought much about it until they were ready to leave. All the pilots at the base lined up to shake their hands

Suess Glacier, Dry Valleys
Canada Glacier

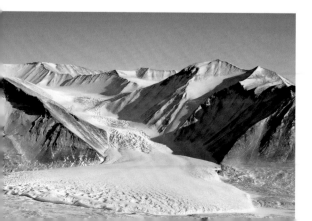

Mount Newall

and wish them luck. "That's the moment when I knew what we were doing was dangerous."

Today we fly north, over the sea ice past the Dry Valleys, all the way out to Cape Reynolds at the edge of the Drygalski Ice Tongue, about a 50-minute flight. Below the plane are icebergs stranded in the sea ice. Farther out, I can see that the sea ice is beginning to crack, and leads, or cracks, of water reach out like giant tentacles. This flight is delivering six barrels of emergency fuel for helicopters. Sean circles a flat open area that is just off the sea ice, part of a glacier descending to the sea. He sets the plane down on the ice, as gently as if he were on a groomed runway, but when we open the door and hop down, there isn't a sign that anything human has ever visited this place before. White ice stretches to the horizon. Unlike my visit to the top of Mount Newall, I can find nothing to photograph in this flat empty landscape.

Herbert Ponting made a pilgrimage to Cape Royds in 1911, two years after Shackleton and his *Nimrod* expedition left and not too long after Scott's expedition had taken up residence at Cape Evans a few miles away.

The photographs that I had previously seen of it had impressed themselves on my memory, and when I saw the hut for the first time I seemed to have known it for years . . . I entered this simple dwelling-place with a feeling akin to awe.

HERBERT G. PONTING
The Great White South, 1923

. . . for one brief moment the eternal solitude [of the Antarctic] is broken by a hive of human insects; for one brief moment they settle, eat, sleep, trample, and gaze, then they must be gone, and all must be surrendered again to the desolation of the ages.

ROBERT FALCON SCOTT
1911

Cape Royds

THE JOURNEY FROM MCMURDO TO SHACKLETON'S HUT at Cape Royds must still be made over the sea ice. None of the expeditionary parties who stayed out at Evans or Royds attempted a land route over the slopes of Mount Erebus to the Ross Ice Shelf on their way to the Pole. The land is folded and crimped into dangerous crevasses. Instead, they sledded around the volcano on the sea ice as far as Hut Point and present-day McMurdo before heading south. Today in a Pisten Bully, it takes a little over two hours to drive past the Erebus Glacier Tongue and Cape Evans to Cape Royds.

In 1908, the men on Shackleton's *Nimrod* expedition built the hut at Cape Royds, where they wintered-over before setting out on their unsuccessful attempt to reach the Pole. Within the 33-by-19-by-8-foot hut, 15 men slept, ate, worked, and amused themselves for a winter. Shackleton had his own cubicle; two men shared each of the other seven. Located on a low spit of volcanic land, the hut does not enjoy as dramatic a setting as Scott's Cape Evans hut, but it's more sheltered and comfortable. And because it has more light, it feels less like a cold dark museum and more like a place where you can imagine men returning at any moment to cook dinner.

Many objects remain from the expedition. Cooking utensils hang on the wall. A large teakettle sits on the stove. I photograph biscuits, bottled currants and gooseberries, and tins of tea, cod roe, curried rabbit, boiled mutton, and veal and ham paté. Bunks with reindeer sleeping bags await their occupants' return. Shoes are neatly stowed under the bunks. Outside, a skua, a large brown scavenger gull, pecks at the beans spilling out from the tins piled around the hut walls.

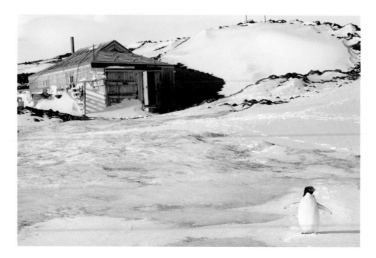

Shackleton's hut, Cape Royds
Stove, Shackleton's hut, Cape Royds
PAGES 60–61
Barne Glacier

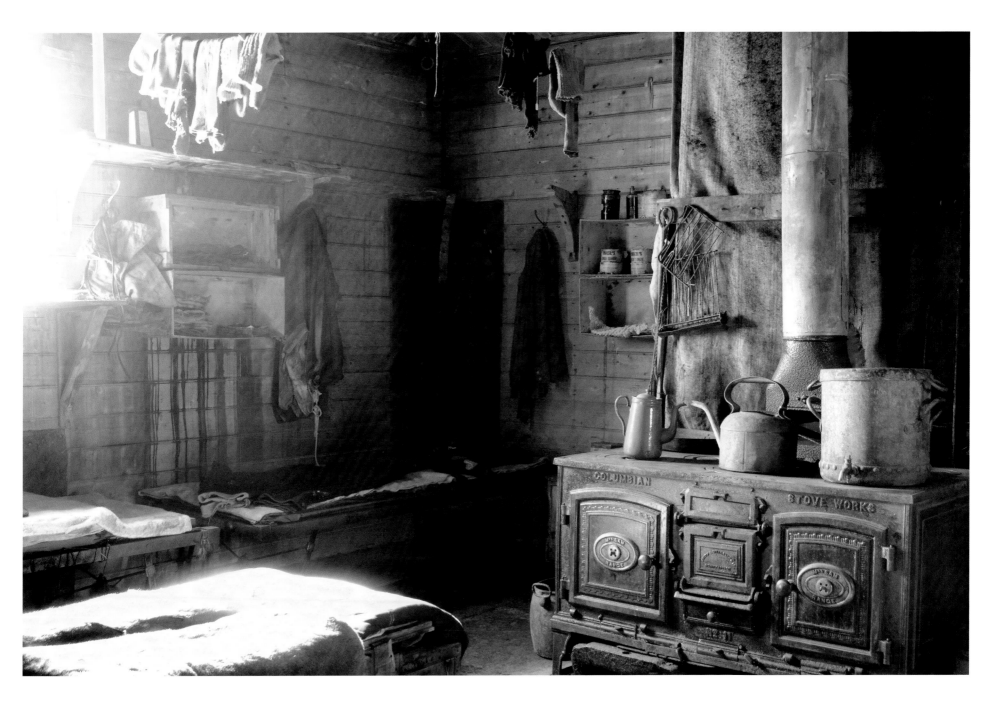

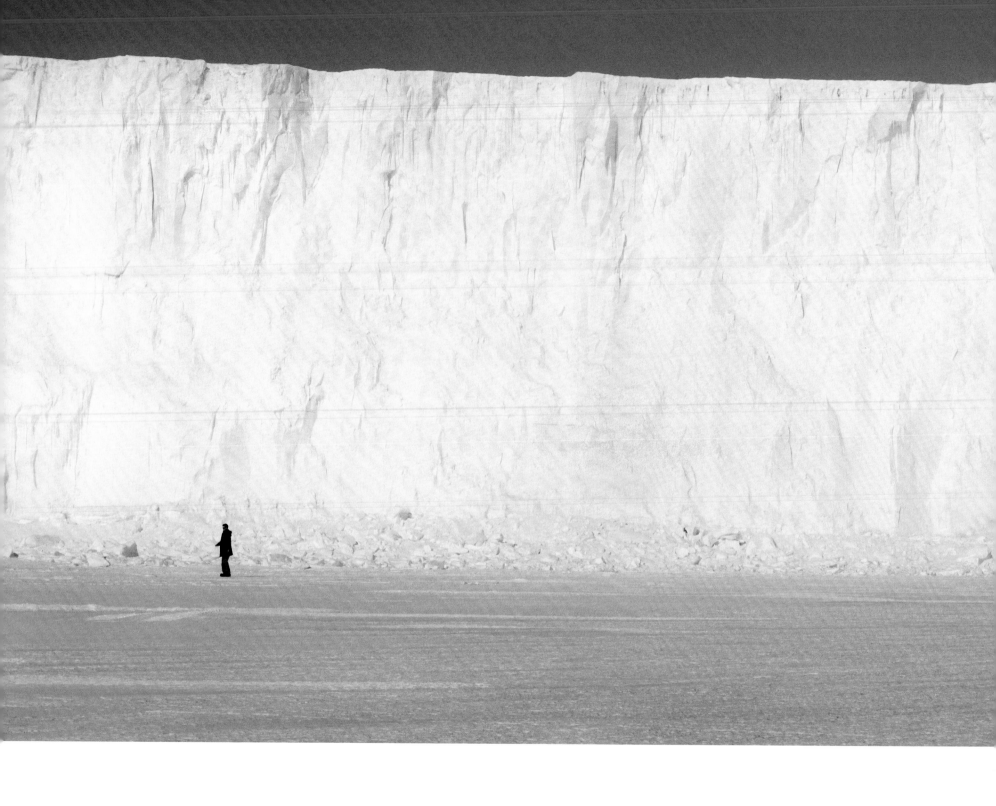

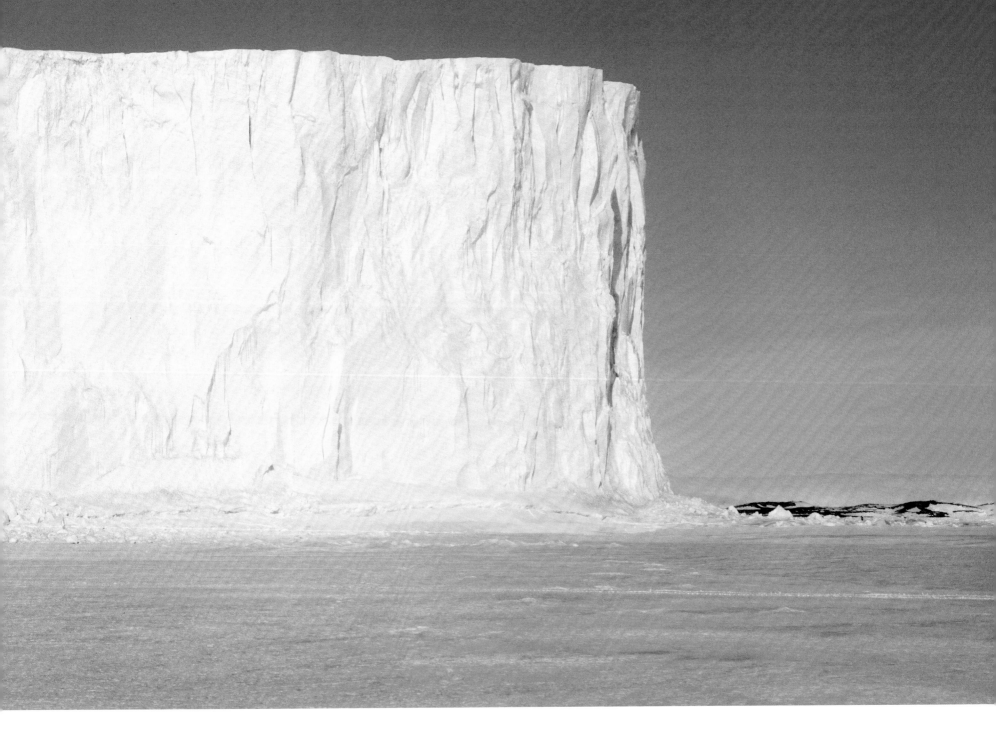

The awful shadow of some unseen Power
Floats through unseen among us, — visiting
This various world with as inconstant wing
As summer winds that creep from flower
to flower

PERCY BYSSHE SHELLEY

"Hymn to Intellectual Beauty"

Getting Warmer

NOVEMBER 4, MCMURDO STATION, 11°F, WIND CHILL −4°F

YESTERDAY WAS THE FIRST DAY that the temperature actually got above freezing. It was a summery 33°F in the afternoon, and all over McMurdo you could see wet volcanic pebbles underfoot. It didn't last long. Today is blustery and cool with blowing snow. But I can feel a change.

Another first is the arrival of the skua population. These scavenger gulls nest on several of the islands in the area and scrounge what they can from the bins of sorted waste in front of the buildings and dorms here. They aren't pleasant birds. If you come anywhere near their nests, they dive-bomb you, swooping down with great force from above. Here they aren't nesting, so they simply raid the garbage. A friend said that a skua once flew down and swiped a donut she was about to put in her mouth.

Nevertheless, it's great to see a bird soaring overhead. It's a sterile place, this white continent. Critters you can see with the naked eye are rare. At McMurdo, which is imprisoned by more than 70 miles of sea ice right now, we don't even have penguins, only an occasional Weddell seal, which hops out of an ice hole down by Hut Point. We have no squirrels, no pigeons, no dogs or cats, no insects of any kind. You can leave food outdoors or inside and, other than an occasional skua, nothing will come to eat it.

Waiting for helicopter pickup on Mount Newall

Asgard Range from Mount Newall

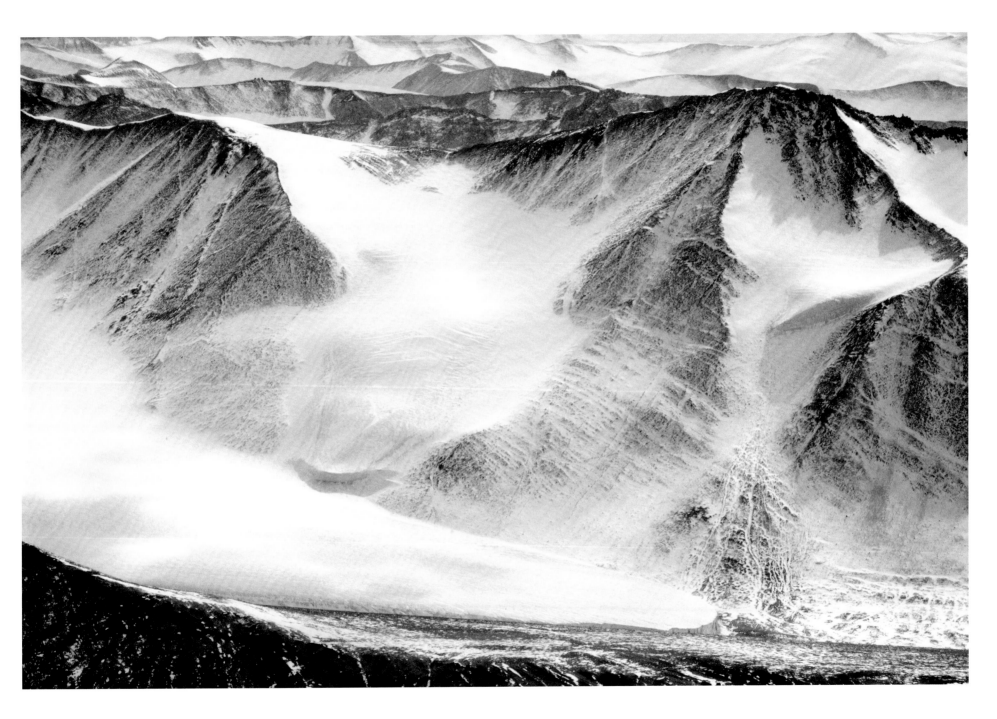

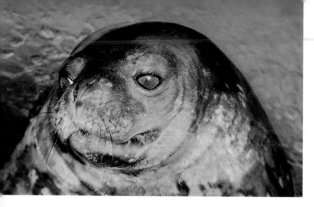

We had come to probe its mystery, we had hoped to reduce it to terms of science, but there was always the "indefinable" which held aloof, yet riveted our souls.

DOUGLAS MAWSON,
AUSTRALIAN ANTARCTIC
EXPLORER
The Home of the Blizzard, 1915

Weddell World

THE SEAL CAMP, nicknamed Weddell World, is a few miles out of McMurdo on the sea ice. Joe Yarkin installs solar and wind power for field camps and has a repair to do, so I accompany him. More and more field camps are now being provided with wind and solar energy for their primary power (with a fuel-powered generator for back-up) since diesel requires air delivery and three or four people to plow a runway and unload. Even in the sunless winter, there's no shortage of wind on the plateau.

Weddell World is a large temporary camp with a 19-section Jamesway structure that serves as home, kitchen, living area, computer space, and laboratory for seven people. It will be removed when the ice begins to thin in December. Researcher Randy Davis from Texas A&M University at Galveston is looking at the foraging and roaming behavior of free-ranging Weddell seals. These seals dive deep—up to several thousand feet—in the ocean. They have to breathe every seven or eight minutes, so they hold their breath under the sea ice until they can come up at a small breathing hole or open crack. They eat while they're underwater. Nobody knew much about how they did all that until Randy and his crew started putting cameras and instruments on them.

Weddell seals are large docile creatures with no land predators, so they don't scoot away from humans. Randy has fitted several nonbreeding females with video cameras and monitoring equipment, which they don't seem to mind carrying and make no effort to remove. The seals "shoot" amazing video footage of themselves diving and eating. After they've shot their footage, they are captured and their video cartridges are replaced. The monitoring lasts for only a couple of weeks, then all of the machinery is removed and the seals are no longer tracked.

Sometimes after diving, a seal surfaces in her hole only to find it's been taken over by another seal. Both seals have to breathe, so it's battle or die. You have to admire and respect such amazing mammalian machines, especially when you see them in action. When they're lying on the ice like huge slugs, you'd never guess they are extremely fuel-efficient creatures that have evolved to maximize every ounce and calorie they ingest.

Weddell seal

On the way back, we stop at the Razorback seal camp to visit my tent mate from Happy Camper School. It's a good location for seals because there's a large open crack in the sea ice near the island, so they have a place to get out of the water and up onto the ice. Christine's research group is beginning to weigh the baby Weddell seals that have been born the last couple of days. The mothers are big, over 1,000 pounds, but they're gentle and seem to tolerate a brief kidnapping of their offspring. The pups make a sheep-like bleating sound, and the mothers answer with a similar, lower-pitched bleating. In a couple of weeks, the pups will be five times their birth weight—their mothers' milk is 80 percent fat. They don't fear photographers (one of the worst predators!), so I take photographs of the nursing pups from only 10 feet away.

Weddell seal research

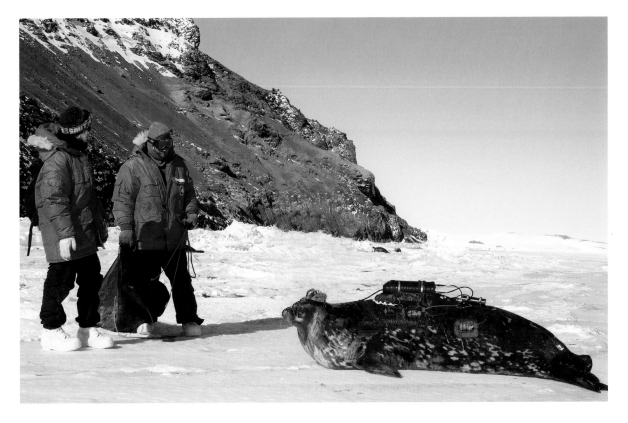

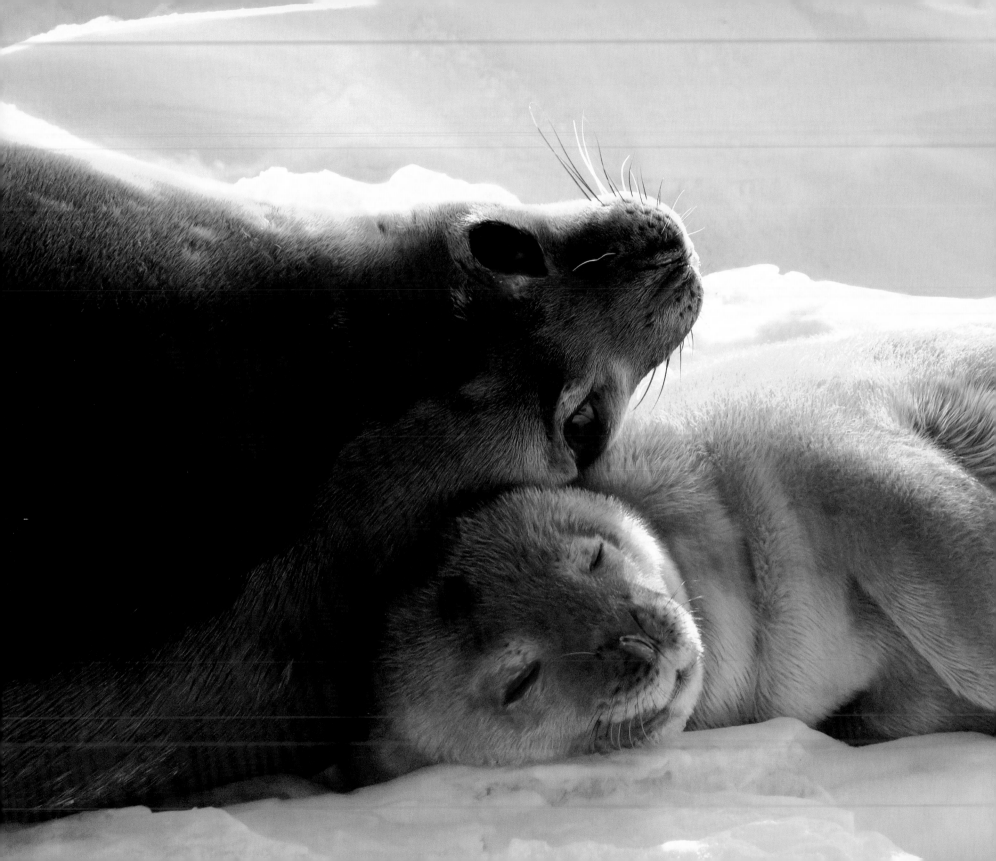

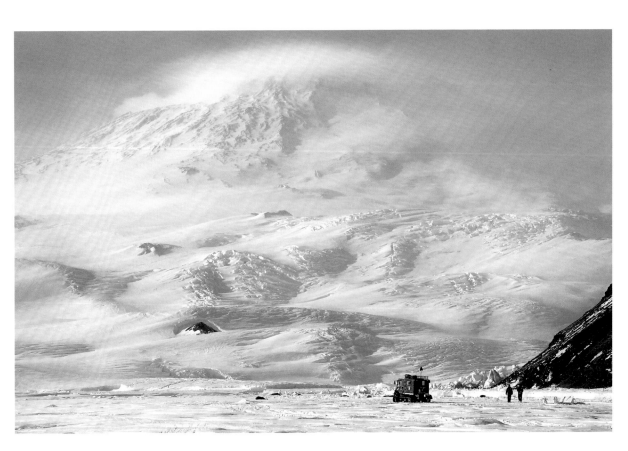

Weddell seal and pup

Razorback seal research camp

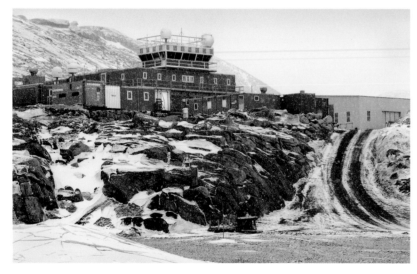

Lunch at Terra Nova

Terra Nova Station (Italy)

Terra Nova

NOVEMBER 13, TERRA NOVA, 6°F, WIND CHILL −34°F

ON OUR FLIGHT SEVERAL hundred miles north to Terra Nova, an Italian research base, Sean flies the Twin Otter along the Ross Island coastline. I peer out the back window at Mount Erebus while winds gusting down off the glaciers toss the plane around. As we head north, the sea ice looks thinner than it did a couple of weeks ago; the leads of water are wider, indicating the ice is beginning to melt. As we approach Terra Nova, the sky begins to darken, and it's snowing by the time we land on the ice runway.

A visit to Terra Nova is a lesson in national distinctions: the base has style! Evidently their program hired mountaineers from the Italian Alps to design the base and the cold weather gear. The main complex houses a galley and dining room, labs, living quarters (four bunks to a room with a bathroom down the hall), and a beautiful new command center on the top floor for directing aircraft and vehicle activity. All the main work and living spaces are connected, and the buildings are painted a spiffy blue and orange. About 20 scientists work in the Italian program, and the base can house up to 90 people. Its four women are dressed much better than we are! They're not clumping around in baggy clothes and bunny boots; their deep red parkas and wind pants are much more fashionable.

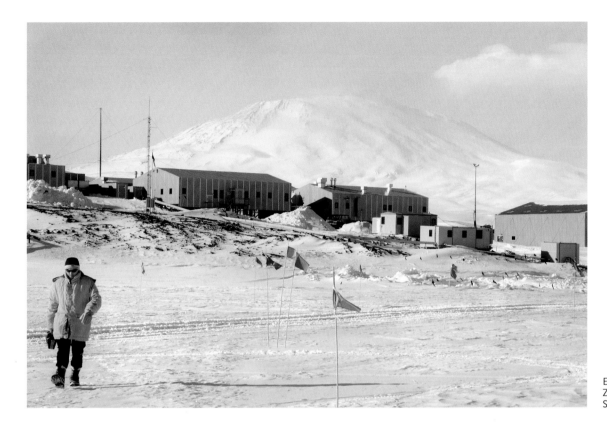

Exterior view of Scott Base (New Zealand). Of the many foreign stations, Scott Base is closest to McMurdo.

What's most distinctive about Terra Nova is its food. "Of course, the cook is from Naples," explains Giuseppe de Rossi, the base director. Lunch consists of freshly made pasta with grated Parmesan, bean soup, homemade bread, tender veal piccata, green beans, fresh lettuce and tomatoes, with kiwis, cheese, and chunks of chocolate for dessert. In the center of the long tables is a choice of red and white Italian wines and water, both still and sparkling. (At McMurdo, no liquor of any kind is served with meals; you have to go to Gallagher's, the nonsmoking bar, or the Coffee House to buy a drink.) Everything is delicious! After lunch, we all walk next door to the coffee bar with its enormous espresso machine.

Fortunately the pilot isn't in a hurry to leave, so after lunch Giuseppe drives me behind the station for a view of Terra Nova Bay. Since Terra Nova is several hundred miles farther north than McMurdo, it has a more benign climate, warmer and with more moisture, more like the Antarctic Peninsula. Unlike the fine volcanic stone that McMurdo is built on, the coastline here is rocky with large rounded granite boulders.

Finally, the pilot radios that he's ready. Giuseppe drives me out to one last stunning look-out and then down to the runway. We manage a reasonably satisfying conversation with his bits of English and my Spanish and a lot of hand movements. I thank him, we exchange e-mail addresses, and I leave, reluctantly, for the flight back to McMurdo.

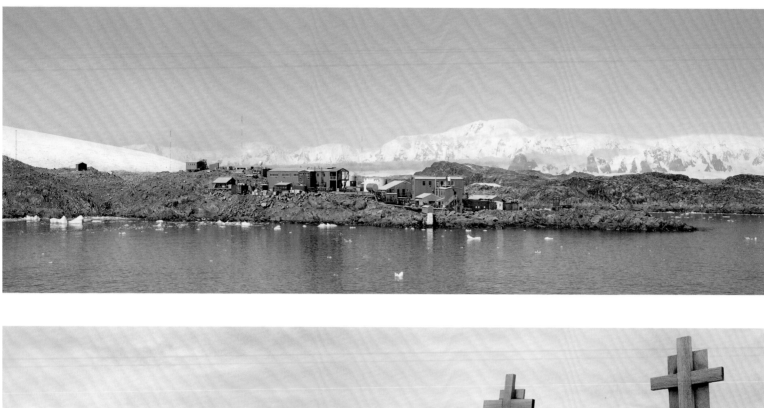

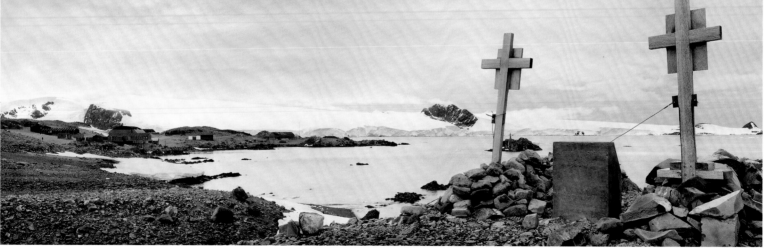

Palmer Station (United States)

Esperanza Station (Argentina)

Bellingshausen Station (Russia),
King George Island

Halley Station (England)

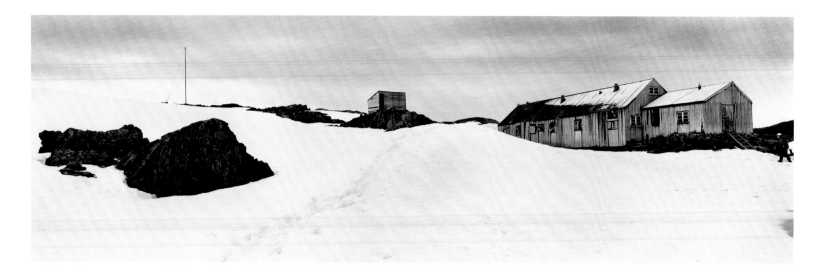

British field station (abandoned), Detaille Island

Neumayer Station (German). Now marked only by ventilator shafts, antennas, and several temporary buildings, Neumayer has slowly sunk 90 feet below the surface of the ice. Nine people winter-over here in two steel tubes, 26 feet in diameter and about 300 feet long, divided into living quarters, laboratories, kitchen, hospital, and power stations.

Chapel made of packing crates, Frei Station
(Chile), King George Island

"Freshies" delivery, South Pole

Making Do

NOVEMBER 14, MCMURDO STATION, 18°F, WIND CHILL 9°F

ONE OF MY NEIGHBORS AT CRARY LAB greets me with, "Have you been to the galley yet?"

"No," I say. "Why?"

"There are bananas and strawberries this morning."

This is a major event. We haven't had any fresh fruit or vegetables for the last 10 days. "Freshies," as they're called here, are treasures. Someone tells me that if they dropped oranges and $5 bills from an airplane at the South Pole, everyone would go for the oranges first. I believe it. It's not just the nutrition; you also miss the smells and tastes. When I get to the galley, I put a couple of strawberries on my hot cereal, and my breakfast smells and tastes better than the fanciest of meals. All the senses are deprived here, and the fragrance of a single strawberry is heavenly.

McMurdo has a high-fat, high-carb diet. We humans are considerably less efficient than penguins and seals. We require a wide variety of food, all imported at enormous expense to Antarctica, as well as imported fuel to cook the food and melt ice for water. All the veggies, except for salads, are frozen and rarely very appetizing. Even the fruit is often canned. Usually the galley has a vegetarian entrée, but even that tends to be pasta or stuffed pastry. If you're into meat, you'll be happy at McMurdo. Last night there was steak, and pork the night before. One night recently we had crab legs. I can see why there's such an emphasis on cholesterol in the pre-McMurdo medical testing. If you have a cholesterol problem before you arrive, you'll be in serious trouble here.

A friend at my dinner table last night found a tiny green worm in her lettuce salad. This may be the only such worm in the whole of Antarctica! She put the lettuce leaf on the palm of her hand and carried it around the room, showing the worm to everyone. She said she was considering keeping it as a pet but, given our erratic supply of "freshies," the tiny creature may soon go hungry.

Baker

Soup chef

Coffee House

Having Fun the Polar Way

NOVEMBER 15, MCMURDO STATION, 19°F,
WIND CHILL 14°F

'M CONSTANTLY SURPRISED at how many ways folks find to amuse themselves here with minimal resources. One day I photograph the Scott's Hut Race, a five-mile run held just before Sunday brunch. Since it's snowing and the wind is blowing some 20 mph, it doesn't look like fun to me, but about 50 people turn out. For $15, you get a number, a T-shirt, and a chance to win dinner for two in Christchurch.

Another time I photograph a renewal of wedding vows at Hut Point for Shireen and Adam McDermott, who work at McMurdo. Off the Ice, they live in Alaska. They were first married on a glacier there, so they felt it appropriate to renew their vows at McMurdo in their parkas and gloves. Hut Point is always windy and cold so our small group of well-wishers is dressed in extreme cold weather gear, and the ceremony is short. I take a few pictures perched uncomfortably on the edge of the steep hill, wishing I had brought my wide-angle lens since I can't back up far enough to shoot without falling over the cliff. We then walk back up to the galley for cake and coffee. A portable stereo provides pop songs, and we all sign a guest book and wish the couple well.

This evening, after dinner, I walk over to the bowling alley, which arrived at McMurdo in the 1960s. It's one of the few surviving alleys with hand-set pins, and the machinery for setting the pins is quite ingenious. The operator, Kevin Reynolds, sits

Plastic bag sledding

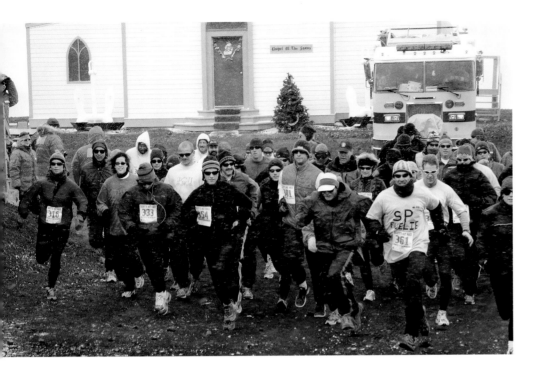

up on a ledge above the pins while the player bowls. The ball careens down the lane with a bang and knocks over pins. Kevin then dashes down, picks up any knocked-over pins, puts them into the machine, and returns the ball. After the second bowl, he lowers the pins, the metal sleeves release, and he pulls the machinery back up again. When someone bowls a strike, he strikes a cymbal with a wooden drumstick. Every week or so, players enjoy "cosmic bowling," with fluorescent pins and balls, black light, and a fog machine.

Race

Football at Willy Field

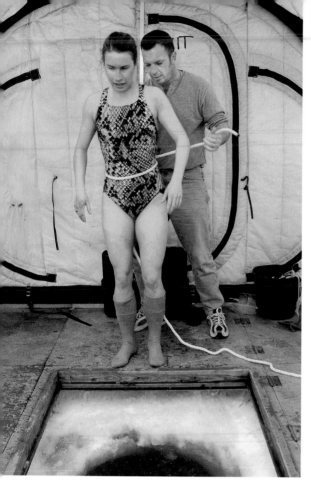

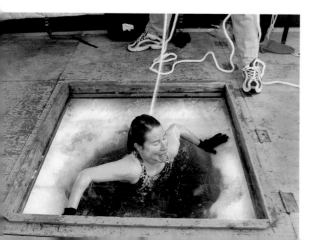

Polar Plunge

NOVEMBER 16, MCMURDO STATION, 16°F, WIND CHILL −2°F

SEVERAL FRIENDS CONVINCE ME to photograph their Polar Plunge. This isn't an NSF-sanctioned activity, but it's ignored rather than forbidden. To participate, you take off your clothes and completely submerge yourself in the below-freezing saltwater of McMurdo Sound. There are two kinds of people: those who are willing to do just about anything for a new experience and those who consider the possible consequences. My friends are younger than I and more open to new experiences. I keep thinking about cardiac arrest.

We walk out a short distance on the sea ice from McMurdo to a small unheated hut with a dive hole used occasionally by the Kiwis for fish research. The transitional sea ice is beginning to melt pools here and there, so we tread lightly and avoid thin areas. Inside the hut we enlarge the opening with an ice axe and use a long-handled net to scoop out the several inches of loose brash ice that covers the water in the hole.

Susan, the event's organizer, comes prepared with a bathing suit (claiming modesty) and socks. We attach a stout rope around her waist just in case she doesn't return. She hesitates only a moment on the edge of the hole and then jumps in. She surfaces, gasping. After she's helped out, teeth chattering and hair covered in brash ice, she says she's surprised that the water's so salty. Lisa, less determined, comes next. A moment of panic sets in as she sits on the hole edge and realizes she's about to leap into 28°F water. We encourage her. Finally, she holds herself up by her arms over the hole until her arms give way and she falls into the water, emerging with a cry a second later. Both women have towels and warm clothes to put on. Everyone leaves satisfied, either by the spectacle or the experience, and ready for a drink at the Coffee House.

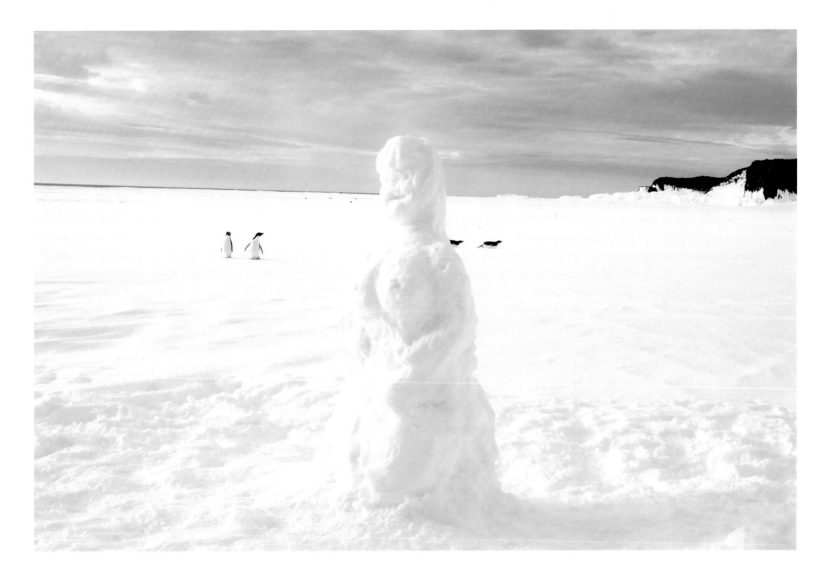

Snowmaiden

But I had to reach it. I had begun to think that there, at one of the only two motionless places on this gyrating world, I might have peace . . . I wanted to stand in the dead center of the carousel, if only for a moment; try to catch my bearings.

THOMAS PYNCHON
V.

Lands doomed by Nature to perpetual frigidness; never to feel the warmth of the sun's rays; whose horrible and savage aspect I have not words to describe. Such are the lands we have discovered; what then may we expect those to be, which lie still further to the South?

JAMES COOK
A Voyage Towards the South Pole and Round the World,
1777

To the Bottom of the Earth

NOVEMBER 18, SOUTH POLE STATION, −40°F, WIND CHILL −65°F

THIS MORNING I FLY WITH TWO OTHER PASSENGERS and lots of cargo on a Hercules LC-130 from McMurdo to the South Pole. One of the other passengers is Father Damien, McMurdo's Catholic priest, so I figure I'm in good hands for the flight. The pilots invite me up to the cockpit shortly after take-off, so I can view Black Island and get a close-up of Minna Bluff, which is visible in the distance from McMurdo. This was Scott and Shackleton's route to the South Pole. After Minna Bluff are miles and miles of the Ross Ice Shelf, a floating extension of the polar plateau whose flatness made it easy going for the expeditions.

We fly past the upper reaches of Beardmore Glacier, the means by which Scott and Shackleton reached the polar plateau. The Beardmore is the largest glacier in the world, and it swirls like a mighty river from the plateau to the ice shelf below. On either side are the Transantarctic Mountains, their dark heads sticking out of the two miles of ice that cover their base. Then comes the flat polar ice cap. When you fly halfway across the continent, you see how large and empty and white it really is. A whole continent with no roads, structures, or power lines (except for extremely small, isolated stations like McMurdo and South Pole). Our "civilized" world would certainly have occupied and exploited this land had we been able to, so the emptiness is testament to its total incompatibility with human survival.

As we approach the Pole, the weather closes down until we're flying in clouds without any definition. It's like being inside a Ping-Pong ball. The pilots descend slowly but deliberately, following their instruments closely. The South Pole has no radar-equipped tower to guide in planes so landings must be made by visual references. As we get closer I notice that one pilot is flying on instruments as the other pilot and crew peer out the windshield for the lead-in flags that will direct them to the end of the skiway. None of them can see a thing. A sinking feeling tells me that we may have to turn back to McMurdo. The navigator reads off a steady stream of information using the aircraft's own radar. Suddenly, the skiway and the buildings of South Pole Station appear, and seconds later we are setting down. You don't land here if the visibility is less than one mile. We have exactly one mile.

It's a balmy −18°F when we arrive. "Polies" are walking around in their fleece with no parka or hat. I even see a guy in a T-shirt and jeans. For me it's cold, despite a heavy parka, balaclava, and layers of fleece. (By dinner time it cools off to −40°F.)

When we leave the plane we see lots of buildings and construction equipment for the new station, all slightly obscured by the low overcast. Someone points us in the direction of the dome, or old station, but there's no path and no vehicles to help us with our luggage. The third passenger, an assistant cook, is welcomed by the kitchen staff and vanishes in the cold clouds. Father Damien and I, less important in the scheme of things, are soon lost in a field of antennas. We clamber around on snowdrifts with our bags, the snow tinkling like tiny bells under our feet. The altitude of 9,300 feet makes us pant. How strange to be lost at the South Pole! Finally someone sees us and points us in the right direction, and we drag our bags into the tunnel that leads to the dome.

Built in the early 1970s, the South Pole Station dome is slowly sinking into the polar ice. However, until the new station is completed, the dome is the center of Pole life. It incorporates smaller structures containing the mess hall, communications center, computer center, some housing, and considerable storage of supplies. Other buildings nearby house staff offices, a library, recreation rooms, and a medical facility. The galley is in a small metal structure that was designed to serve 40 people and now, with the construction crew, serves more than 200, in shifts. Fresh produce, dairy, and meats and beverages not meant to be frozen are stored in the "freshie shack," a giant room much like a walk-in refrigerator. Whenever a load of "freshies" arrives, a general call goes out on the radio and anyone who's nearby comes over to help unload it.

South Pole Station is very different from McMurdo. It has the feeling of a small rural town. Those who winter-over form a special bond. Outsiders stick out and are carefully scrutinized. But when I introduce myself in the mess hall, I am met with smiles and questions.

The South Pole. The place on the bottom of the globe where the fastening pin attaches. A mythical place. A place that Scott and his companions suffered for and died to reach. As far south as you can go. The end of the earth. A place that's nearly impossible to reach. But here I am.

Beardmore Glacier
PAGES 82–83
South Pole Station dome

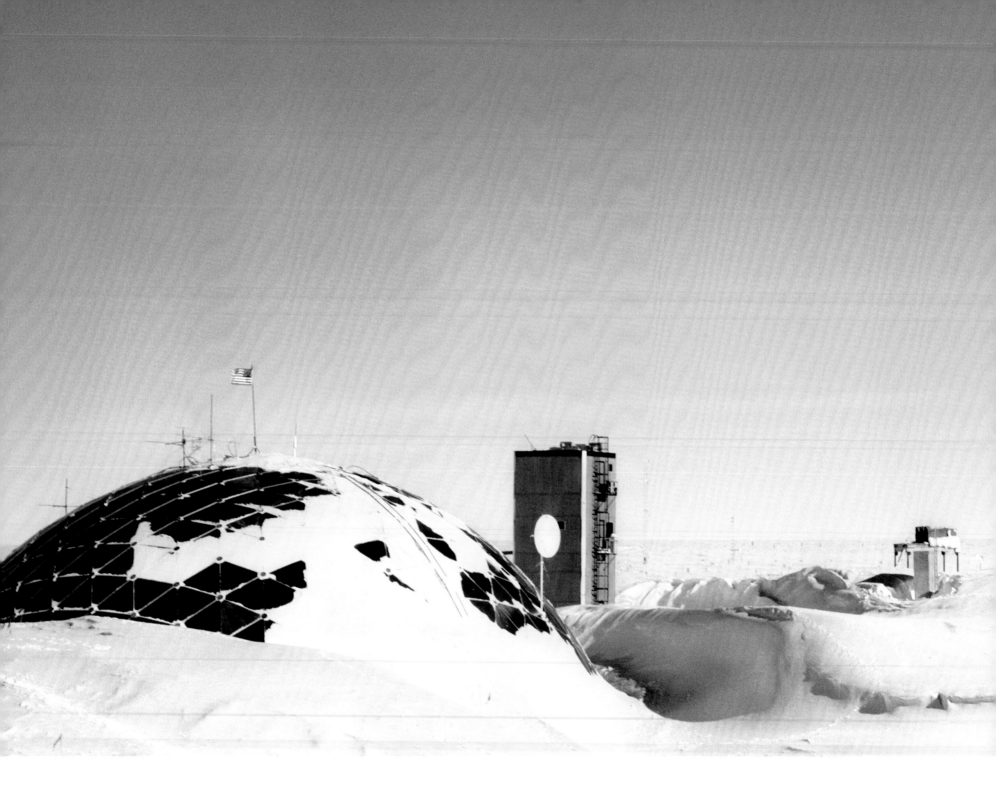

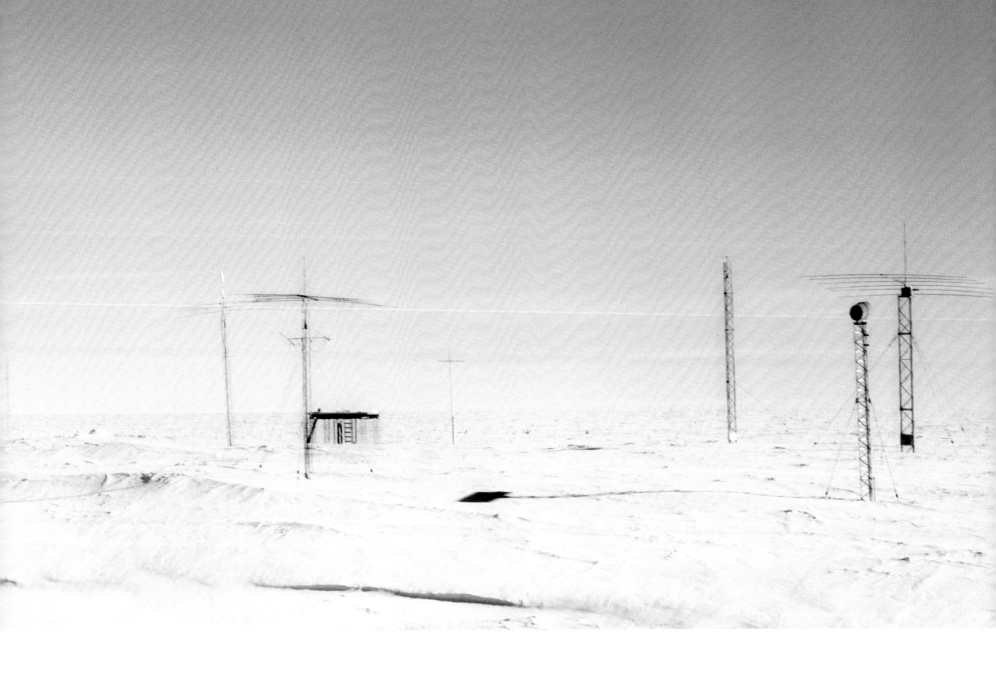

The Dark Sector

NOVEMBER 20, SOUTH POLE STATION, −42°F, WIND CHILL −69°F

SURPRISINGLY, THE STATION IS SPREAD OUT over a fairly large area. My living quarters are a 10-minute walk from the dome, which may not seem like much until you consider the temperature. Much of the science is at least half a mile away from the dome. That's a long and nippy walk. More than the cold, though, the altitude bothers me. It's only a little over 9,000 feet here, but the physio-altitude is 10,800 feet because of the different atmospheric pressure. To me it feels more like 13,000–14,000 feet. I pant as if I'm climbing a mountain when I walk a short distance; carrying a large bag is all but impossible. A single Pisten Bully (along with several snowmobiles used by field camps) is the only working transport vehicle here. Because of my camera gear, I'm fortunate enough to rate its transportation and am very grateful to climb in and drive out to see what the planet's most southerly astronomers are doing.

The Dark Sector is where the telescopes, including the neutrino detector (Antarctic Muon and Neutrino Detector Array, or AMANDA), are located. It's called the Dark Sector because most of the telescopes need dark skies for best visibility and function only during the six months of polar night. The astronomy at the Pole is much more abstract than the biology, geology, and climate research being conducted near McMurdo. Several of the projects are looking at the Big Bang billions of years ago, the remnants of supernovas, and galactic magnetic fields. Observations from the Dark Sector are greatly exciting astronomers all over the world. Even the telescopes are not conventional mirrors but rather hybrids of optical and electromagnetic radiation detectors. They're not much to look at but they do at least provide me something physical to photograph.

AMANDA and its upcoming counterpart, IceCube, are especially difficult to comprehend. AMANDA is a group of some 40 detectors that have been sunk in the ice to observe traces of neutrinos as they pass through the earth on their way back to outer space. These subatomic particles pass through the solid mass of the earth as if it didn't exist, and only recently has their existence been widely accepted. I'm amused by the AMANDA lab, which is encircled by thick colored wires across its walls and ceiling—esoteric science held together by duct tape and clamps.

The Martin A. Pomerantz Observatory (MAPO) makes it possible for astronomers to operate state-of-the-art instruments despite average winter temperatures of −76°F.

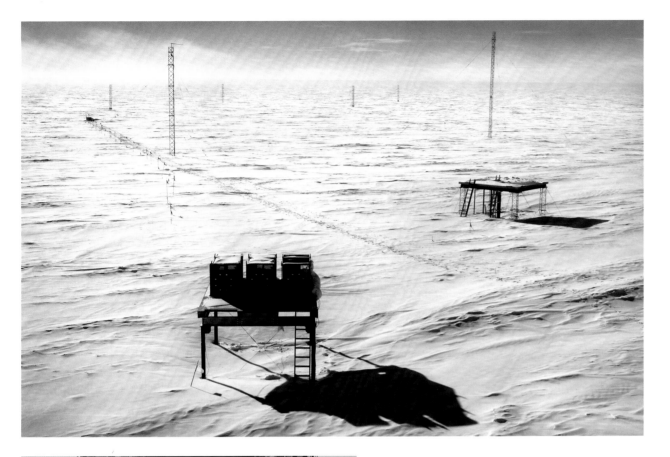

The South Pole gives a foretaste of eternity,
when the soul will have to leave its warm body.

SAUL BELLOW
More Die of Heartbreak

Neutron monitor

The Viper telescope records slight temperature fluctuations in the cosmic microwave background, allowing cosmologists to test their theories about the origin of the universe.

ASTRONOMY

The South Pole is ideal for astronomy—high, dry, and pitch-black for half the year. It is a great place to catch neutrinos—mysterious subatomic particles from outer space that have almost no mass, like ghosts in the galaxy. A neutrino detector called IceCube is under construction. Scientists are drilling 80 holes in the ice, each 1.5 miles deep, with hot water. A string of 60 modules, hung like pearls on a cable, is being lowered into each hole and allowed to freeze over. Over this grid is a companion detector called RICE, or radio-ICE, designed to pick up radio waves given off when neutrinos collide with detectors inside the cube. Another new telescope, called QuaD, is looking at cosmic microwave background, a relic of the Big Bang. It will map polarization patterns in this background to model the early universe, look for dark energy, and perhaps explain the nature of gravity at the beginning of time.
—S.B.

SHOVELING IS GOOD FOR YOU!

Since all supplies, particularly the fuel required to provide water and heat, must be delivered by aircraft first to McMurdo and then on to the South Pole, costs are high.

Auto fuel
 McMurdo Station $1.25
 South Pole Station $15.00
Shower (cost per minute)
 McMurdo Station $.06
 South Pole Station $1.00
Operation of 60-watt bulb (cost per year)
 McMurdo Station $8.00
 South Pole Station $590.00
Load of laundry
 McMurdo Station $.80
 South Pole Station $13.00

(Source: *The Antarctic Sun,* December 8, 2002)

Life at the South Pole

NOVEMBER 21, SOUTH POLE STATION, −38°F, WIND CHILL −59°F

BEING AT THE SOUTH POLE is like living in a space capsule or on another planet. It's disconcertingly unfamiliar. Outside the dome, the sun circles high in the sky and never sets on the spare, icy landscape. Inside, you are warm and well fed. Although you have satellite Internet communication for about 12 hours a day (depending on the position of the satellites), your world does not intersect with the outside. You are totally dependent on fuel and other imported necessities for survival. You are totally separate. Completely isolated.

My living quarters in a temporary Jamesway are simple—a room about 6-by-8 feet with a couple of rough wood shelves, a metal wardrobe, a bed, and a light for reading. There's a large window, but I have to keep it covered with heavy Velcro fabric. The Jamesway's eight rooms share common overhead space, and light from an unshaded window would make the whole dorm too bright for those who sleep days. The white noise from a constantly running overhead fan also helps people sleep.

A trip to the bathroom involves going through a double set of doors to an uninsulated, unheated passageway with snow on the floor and frost on the inside walls. It's only slightly warmer than the outside −42°F. You don't go in bare feet or sandals, and you don't linger. After a couple of turns you come to another pair of doors and the heated bath/shower room, one for men and one for women with laundry machines in between. All the water for our dorm must be trucked in, so you're allowed only two two-minute showers each week. Since everyone here wears overalls and boots all the time, nobody cares how you look. It's a bad-hair day every day.

Kathleen Reedy, a physiologist studying the effect of Antarctic conditions on the body, told me that we increase our oxygen consumption by 30 percent doing normal activity and by 20 percent at rest (basal metabolic rate). This change begins to occur within a couple of weeks of arrival. During this time, we increase our caloric intake by 40 percent (usually without gaining weight). Meanwhile our thyroid is so busy coping with the metabolic demands that it doesn't produce enough hormones for the central nervous system. Short-term memory loss is common. I can attest to that. For several days after my arrival at McMurdo, I couldn't remember a single name. The same thing happened at the Pole, but that soon passed. The physiologists here are doing applied research on whether a thyroid additive might help.

Graffiti in dormitory

Dr. Will Silva, the station doctor, has equipment to handle many emergencies but nothing like what's available in even a small American hospital. If you have a heart attack, you don't have a group of medical doctors and nurses swarming around you, hooking you up to complicated machines. The station's blood bank, all of us, is walking around station. Since the match may not be perfect, however, a transfusion could be iffy. During the polar summer, a dentist flies in once a week from McMurdo; during the polar winter, Will has to do dentistry as well.

I ask him about the attraction of working under these conditions for modest compensation. "It's a great adventure," he says. "I can practice medicine as I always imagined and wanted it to be. There are no time clocks. I can visit patients and have time to listen to what they want to talk about. They have time to feel comfortable with me."

Yes, he admits, someone can die at the Pole because of the difficulty in reaching medical care. Indeed, a scientist died from breathing problems last July during the polar winter. Since his body could not be flown home for another four months, volunteers, with the family's permission, made a casket for him, chipped a grave into the ice in −102°F weather, and buried him near the Pole marker for 2000. A black flag marks the site.

Overview of South Pole Station

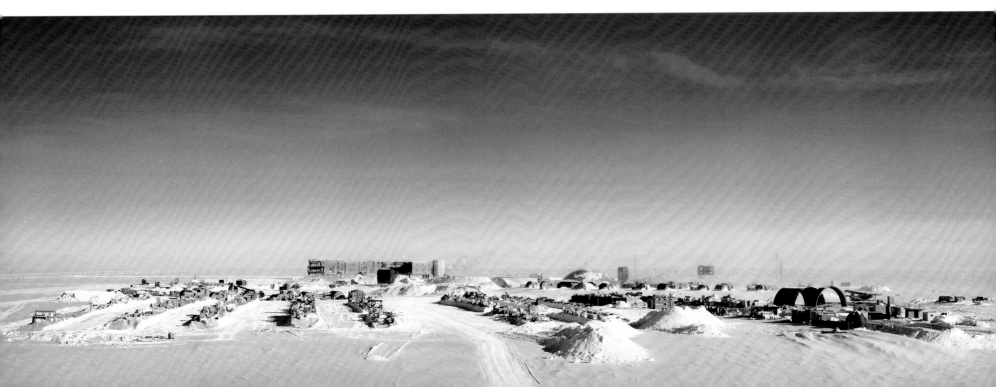

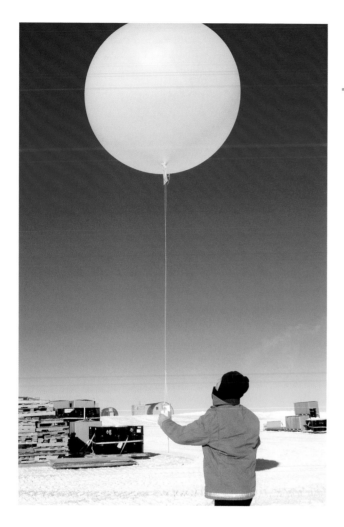

Twice a day scientists launch a balloon that measures wind speed and direction, temperature, relative humidity, and air pressure. The World Meteorological Organization uses the data in its Southern Hemisphere forecasting models.

The New South Pole Station

NOVEMBER 22, SOUTH POLE STATION, −38°F, WIND CHILL −58°F

THE NEW SOUTH POLE STATION, scheduled to be dedicated in 2007, is a modular building on stilts perched uncomfortably on the polar ice cap. Several of its modules are nearing completion. The station is heated with waste heat from the power plant and has 13-inch-thick R50 insulated walls. The locals are expecting to be able to use the new galley and some of the living quarters by January 2003, though they will continue to use the dome for several more years.

The construction of the new station has had all sorts of problems, mainly logistical, since all supplies have to be delivered by Hercules LC-130 aircraft. A South Pole survey team has been scouting a 1,200-mile land route to truck in supplies over much of the same territory first explored by Scott, Shackleton, and Amundsen. With modern technology, the team can pinpoint and dynamite crevasses, but nobody knows whether the route will prove practical.

Little construction issues pop up daily. For instance, doorknobs have to be individually taken apart and lubricant removed before installation or they freeze solid. A larger problem is that the new station structure is settling in unexpected ways and will soon require jacking up its stilt legs to level the building.

I photograph in the new station, mainly shooting through the second-story windows. When I return to the dome, I'm starving. The galley is a great social mixer. You never know whether you'll be chatting with an electrician, a cargo loader, or an astrophysicist. And the food is excellent, better than at McMurdo. Tonight we have grilled lamb chops, couscous, asparagus, fresh rolls, potato soup, and lots of dessert choices, including cookies, baklava, cake, and cranberry bread. Fortunately, you can't gain weight at the South Pole. Cookie Jon, the Pole's main chef, stands ready to accept compliments. Nobody ever criticizes the cook.

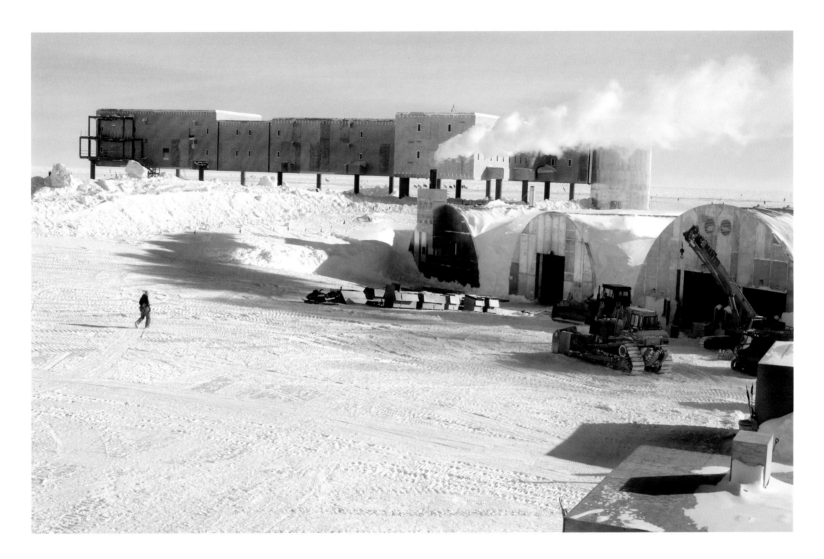

New station

MANY SOUTH POLES

The Geographic South Pole, or International Reference Pole, is at 90° south latitude. It is one of the two points on the earth's surface where all of the lines of longitude meet, and it stays in the same place from year to year. Since the 10,000-foot-thick ice sheet that the station is sitting on moves about 30 feet a year, the U.S. Geological Survey re-surveys the location annually and places a marker to show its current position on the ice.

The ceremonial South Pole is about 90 feet from the geographic Pole. It has no scientific purpose but displays all the flags of the original Antarctic Treaty nations flying in a half circle around a reflective silver ball on a striped barber's pole.

The magnetic South Pole is the location on the earth's surface where a compass would spin wildly around, unable to indicate any direction. This Pole moves around comparatively rapidly and once in a great while swaps places entirely with the magnetic North Pole. At present it is about 1,750 miles away from the geographic South Pole off the coast of the Antarctic continent.

The Ephemeris Pole or Axis of Rotation Pole is the spin axis of the earth. It is located about 30 feet from the geographic Pole and wanders in a big circle during the year due to the motion of the inner core of the earth, the tidal motion of the oceans, and other effects.
—Chris Martin, Oberlin College astrophysicist

Geographic South Pole

Marker, Geographic South Pole

Communications center

Old and new stations

Life in the Dome

NOVEMBER 23, SOUTH POLE STATION, −39°F, WIND CHILL −47°F

DON'T THINK IT'S POSSIBLE to describe how this place feels. Perhaps the unreality of this immense blank landscape has contributed to the tight, family-like community at the Pole. You forget the lack of familiar reference points when you're inside the galley enjoying a delicious meal. As soon as you get a mile away from the station you see how fragile it is in its uncompromising environment. It's so flat here that you can see the curvature of the earth 360 degrees around you. It's like standing in the center of a fish-eye lens.

The old dome would make a great set for a sci-fi flick. The yellow light inside gives it a magical, unearthly look. I'm told that after the last plane leaves for the polar winter, the "polies" play a video of *The Thing*. You definitely get the feeling that strange phenomena might happen here. The dome, like its original 1950s predecessor, is gradually and inevitably sinking into the ice. The exit door frames are deformed and covered in ice. The dome and its tunnels are the temperature of the outside air. Layers of frost cover the inside walls and pipes as well as the boxes of supplies stored there. Icicles hang from the ceiling. A small central circular opening in the top of the dome lets in a little natural light, and a few yellow bulbs provide additional dim illumination. When the new station is complete, the dome will be gradually disassembled and removed from the continent.

"Polies" love their enclosed hometown and worry they will lose their sense of community in the new station. For someone like me, who is cold in New Mexico much of the year, this is like reaching Dante's ninth circle of hell, the circle of ice.

Every New Year's Day at the South Pole, a ceremony is held to place a new marker at the exact location of the geographic pole. Creating the annual Pole marker is an honor, and it's traditionally designed and made by staff who worked the previous winter at the station. This year's engraving of the moon rising over the old dome and the new elevated station is a work of art.

Since the bedrock below the Pole is covered by several miles of glacial ice, the markers slide downhill toward the ocean at the rate of roughly an inch a day. (The Pole moved 32 feet 8.4 inches during the past year.) If the Pole markers are left undisturbed and continue traveling at their present rate, they'll fall into the Weddell Sea, about 840 miles away, in roughly 140,000 years.

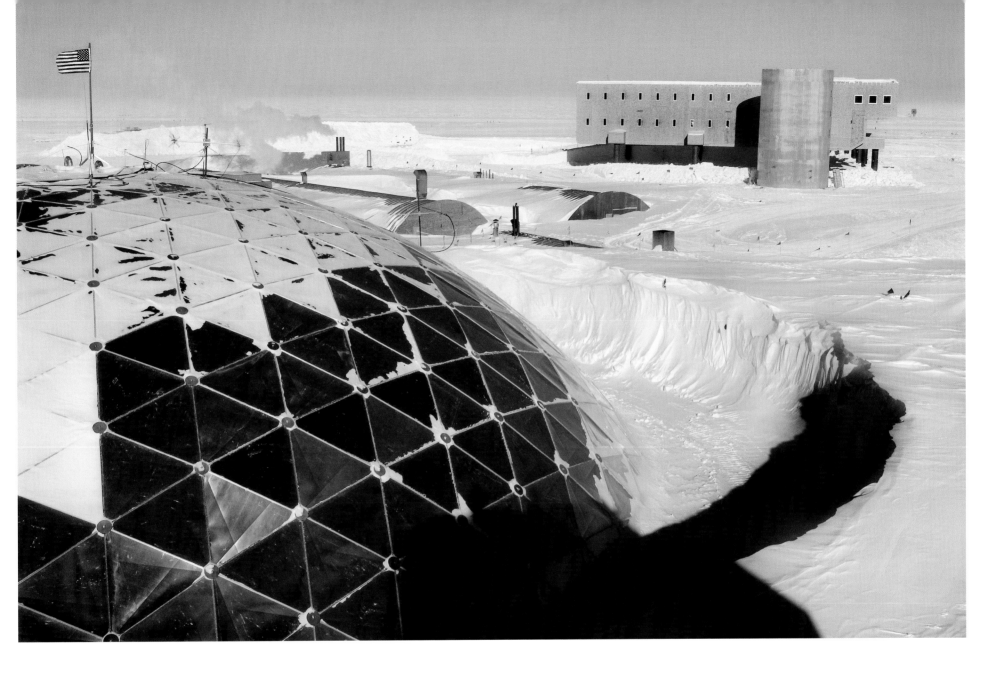

Dome exit, showing compression from
the ice that is slowly burying it

Ceiling light inside dome

When I'm here, the outside world seems like a dream. When I get home, the South Pole seems like a dream.

SOUTH POLE STATION
ELECTRICIAN

Photographing at the Pole

NOVEMBER 24, SOUTH POLE STATION, −38°F, WIND CHILL −53°F

SEEM TO HAVE ADJUSTED SOMEWHAT to the altitude and cold here, because if I keep moving, my fingers don't get cold and I'm quite comfortable. Most of the time I don't wear my parka hood, and I'm actually a little too warm when I'm walking around. The place starts to seem a little less alien.

One of the plumbers invites me to go down in the snow tunnels this morning. These tunnels were carved out of the ice last year to house the new station's water and sewage pipes. Janice Martin (who has a plumbing company in Kanab, Utah, when she isn't down here) persuasively describes the beauty of the tunnels, and I can't resist. Because of the constant −60°F temperature, we dress in balaclavas to prevent frostbite to our faces, plus the usual layers. I put my Nikon D100 under my parka and set off. We walk slowly down the main tunnel, admiring the beauty of the ice walls. My breath begins to freeze into crystals on the outside of my balaclava. When we get into one of the side tunnels, I understood why I have been urged to come. With no breeze to stir the air, elegant dinner-plate-size snowflakes have formed in long chains from the ceiling. They are so lacy and delicate that a slight breath will destroy them. Never have I seen anything like it. When we come out again, I take a picture of Janice with hoarfrost on her eyelashes and balaclava.

This afternoon I shoot film panoramas, including several at the end of the ice runway, where a Hercules LC-130 crashed years ago and now lies buried in the snow with only its tail showing. It's much harder to set up the panorama camera than to shoot digital. The panorama requires a tripod, and my tripod freezes solid at these temperatures in about five minutes. It's too cold to take my gloves off to change film, so I keep going in and out of buildings. Static electricity can leave lines on film in this dryness, so I try to wind the film very slowly. On the last roll, the film pulls off its backing paper. It's too cold to solve problems in the field, so I call it a day.

AASTO, short for Automated Astrophysical Site-Testing Observatory, at the South Pole Station, provides information for planning new observatory sites.

Buried Hercules aircraft

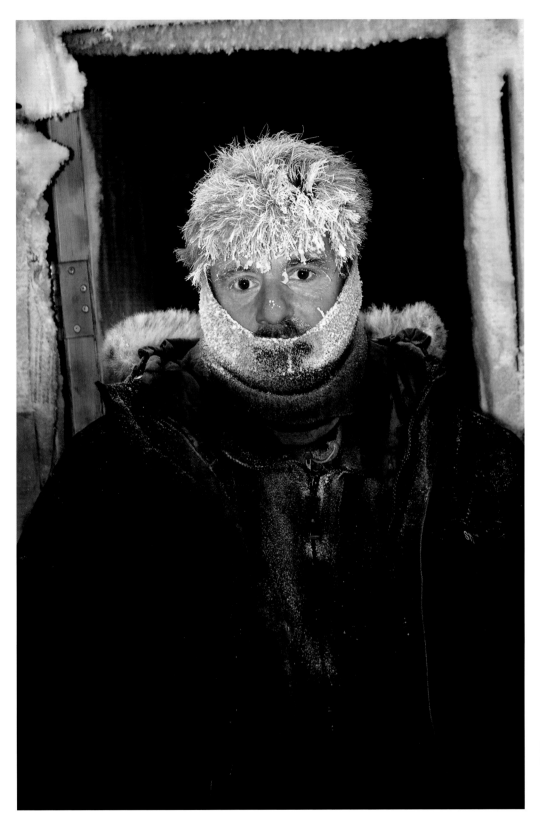

Plumber, working in the service tunnels
at −60°F

> *Beyond this flood a frozen continent*
> *Lies dark and wilde, beat with perpetual storms*
> *Of whirlwind and dire hail, which on firm land*
> *Thaws not, but gathers heap, and ruin seems*
> *Of ancient pile, all else deep snow and ice.*

JOHN MILTON

Paradise Lost

This place is 360 degrees of wow.

MCMURDO STATION
KITCHEN WORKER

Fire and Ice

RETURN TO MCMURDO FOR ONE NIGHT and then take a helicopter up Mount Erebus the next morning. By leaving so quickly, I don't lose my acclimatization to the altitude that I gained at the South Pole. Erebus is not as cold as the Pole but it's higher, 12,447 feet. After a week at the Pole, I'm fairly adjusted but still huff and puff whenever I carry gear or climb very far.

The helicopter ride to the field huts is spectacular since you ascend about a thousand feet a minute up the snowy flanks of the volcano. You aren't aware you're climbing that fast, but as you ascend you get a grand view of Ross Island, the sea ice, and the ever-closer plumes of steam. Erebus gleams in its white drapery, dazzling the eye. Bits of lava rock poke up here and there. Steaming ice towers attest to the fire inside the ice goddess. Finally, the helicopter flies over the top flank of the volcano, giving a view of the steamy crater before setting down outside the hut on the other side.

Mount Erebus is a live volcano with a simmering lava lake in its crater. Officially it's called an open-conduit Strombolian volcano, which means that it explodes episodically from a magma lake fed from the earth's mantle. It continuously sends up puffs of gas that periodically propel car-size rock bombs down its sides. It's the most southerly active volcano on the planet and a natural laboratory, since it's only about 20 miles from McMurdo. Although active, it's safer to study than most volcanoes, since its open magmatic system keeps it from building up pressure. It has had major eruptions in the recent past and is certainly capable of doing so again. Its last largish eruption was in 1984, and since then it has been content to bubble and steam. Its magma chamber is a window to the center of the earth.

Fire and ice. The upper slopes of Erebus have to be one of the strangest and most picturesque places on our planet. Everywhere I look I see steaming ice sculptures and gnarled, braided lava formations poking through the snow. Towering ice formations have entrance holes to warm caves hidden beneath them. It's deceptively tranquil, a delicately elaborate world of ice and cooled lava concealing its underground source of heat and power.

The two field huts are just below the summit on a flat plateau. Thirteen people will be working at this camp starting next week. The main hut is about 20-by-25 feet

Ice towers

Crater rim

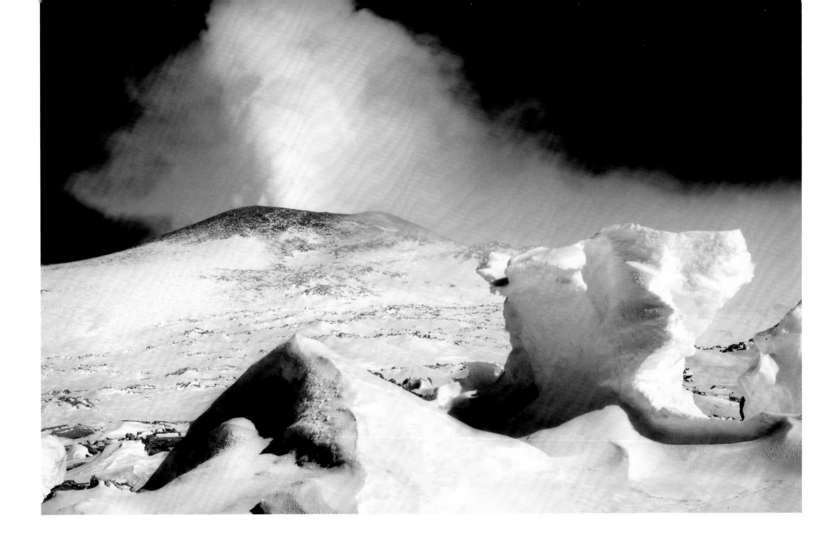

and serves as kitchen, dining, communications, and relaxation area. A Preway stove running on diesel fuel provides plenty of heat. Four large windows look out toward the top of the mountain. The other hut is for storage and a bathroom. I've elected to sleep there for the couple of nights I'll be here, so I won't have to set up a tent. It's rough and ready, but it's heated and there's plenty of room to spread out a sleeping bag on the wood floor. Alas, it reeks of diesel fuel.

Neither hut has running water. All the water comes from snow melted down in a giant pot on the Preway. Since it takes lots of snow to make water, the pot is used sparingly, mostly for drinking and cooking. I wash my face with a tiny bowl of warm water. Even for those who work a season here, there are no showers or baths.

When I arrive at the field huts and start walking around, I realize that this is how I always imagined Antarctica to look—hilly, rocky, and ornately icy. I know the ground is unstable and the volcano merely resting, but I wish I could remain here and photograph for several weeks. The rock formations emerging from the ice (rather than sand) remind me of the desert Southwest. Even with the discomfort of the altitude and cold, this place seems accessible to my camera.

Mount Erebus steam clouds

PAGES 100–101
Mount Erebus landscape of volcanic rock
and ice towers

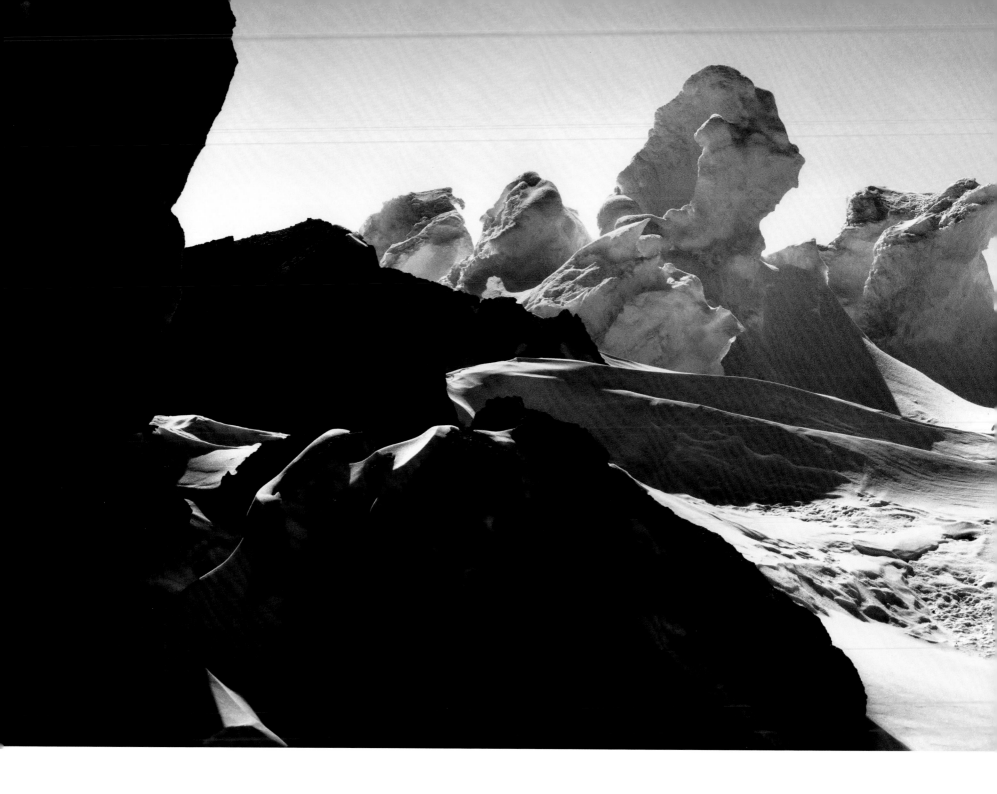

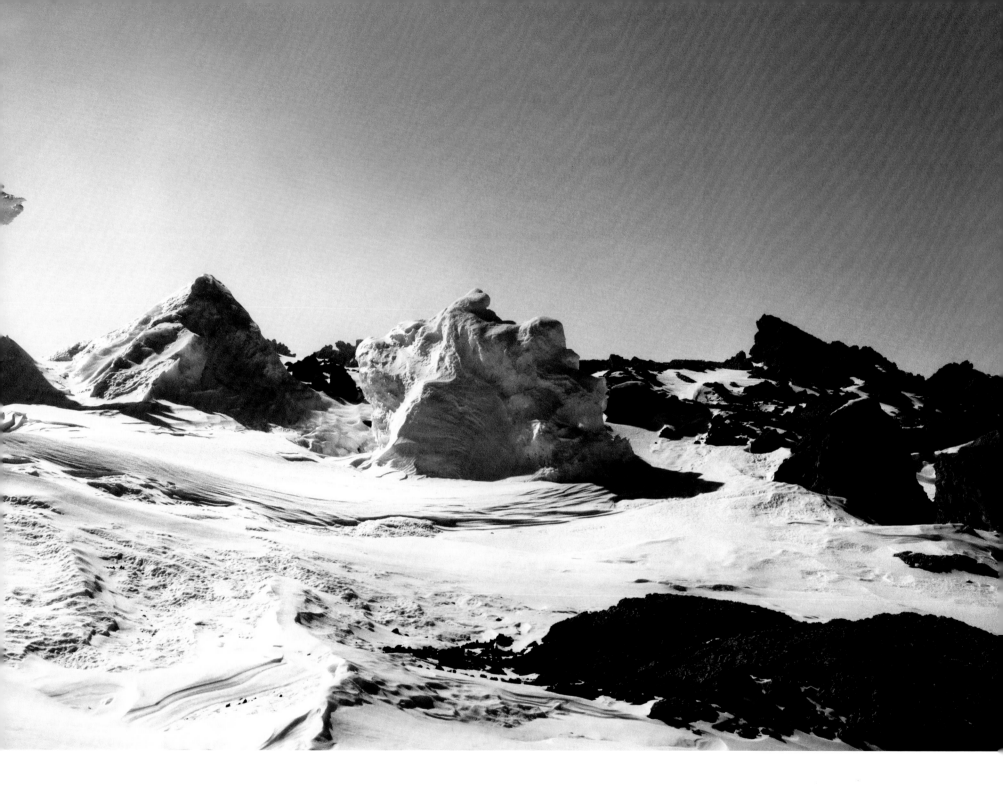

To the Rim

NOVEMBER 27, MOUNT EREBUS, −10°F, WIND CHILL −15°F

THE SUN IS OUT, AND THE VOLCANO'S PLUME is going straight up, so it seems a fine morning for a hike to the summit. To get closer to the top, mountaineer Brian Johnson, who is helping set up the base camp, and I ride a snowmobile up about 1,200 feet. From there we have to climb the last 800 feet to the rim. In my bunny boots with smooth soles and no crampons it takes almost 45 minutes to do the climb over loose lava, ice, and snow.

Everywhere underfoot are Erebus crystals—feldspar crystals ranging in scale from the size of a fingernail to about three inches in length. Other volcanoes have feldspar crystals but none as large or as perfect as these. Before I left McMurdo, many friends asked me to bring them back a crystal. As I huff and puff up the mountain, I slowly fill my parka pockets. By the time I reach the top I am hot, panting hard, and 10 pounds heavier.

The view into the volcano from the crater summit is extraordinary. The crater is deep and lined with ice sculptures. Clouds of sulfurous steam pour over the side and obscure or reveal the crater below, depending on the whims of the wind. One area at the bottom has the lava lake, another has a smaller vent that puffs and steams, and to one side a vent sends up clouds of ash. From the lava lake far below, I hear what sounds like waves breaking on a distant shore, followed by a hissing sound. I sit on a lava bomb a foot from the 1,000-foot drop to the crater floor and muse that this must be how the earth will end, covered in ice with a few final openings to the rapidly cooling molten core. The scope of the crater is impossible to photograph, especially with the clouds of steam, but I try to give a sense of its power and mystery. How can something so hot exist in this land of perpetual cold and ice?

After dinner Sarah, the camp manager, takes me for a magical snowmobile ride in the brilliant late-evening sunshine. I hold on tight to her, like a motorcycle passenger, and we bump around the flanks of Erebus, through lava flows and fumaroles, across the snow and ice to an old hut that was used for research until the 1984 eruption. Since lava bombs rolled down the slopes near the hut, it was deemed too dangerous and was abandoned. Inside it is still stocked with a stove, a bed, and cooking utensils and supplies, but it's more rustic than the hut we're now using. The return is a rough ride down the icy mountain and a grand view of Beaufort Island in the distance and, 12,000 feet below, the bay, Cape Bird, and the icebergs blocking the movement of the sea ice in the Ross Sea. It's a ride I'll always remember as the closest I'll ever get to exploring another planet of unimagined extraordinary beauty.

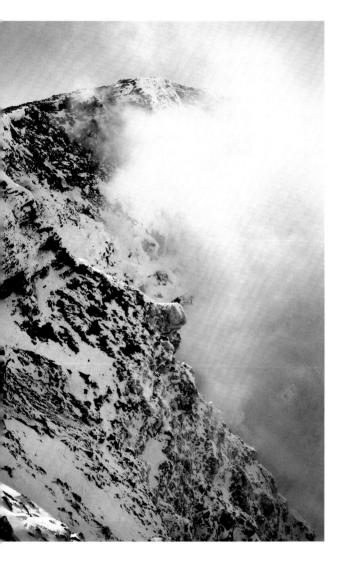

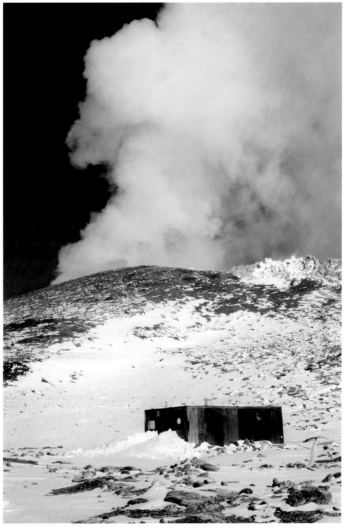

Crater rim

LEFT
Studying the ice caves

Research hut (abandoned)

Volcanic formation

CLIMATE CHANGE
Worries about climate change drive much of the current science in Antarctica. The west coast of the Antarctic Peninsula is warming dramatically. Sea ice is melting and is therefore less extensive. Plants are spreading into areas recently covered in ice. Permanent snowbanks are also melting. At Dome C, the highest point on the continent, researchers are measuring how much sunlight is reflected off a plateau the size of the United States. Is more solar radiation being absorbed? In the Dry Valleys, the continent's largest relatively ice-free area, a long-term ecological study of microscopic life and geophysical forces is under way. The rate of global warming will be reflected in these sensitive ecosystems.
—S.B.

Mummy Pond

DECEMBER 10, LAKE HOARE, 28°F, WIND CHILL 12°F

LAKE HOARE IS THE CENTRAL FIELD CAMP for all the Dry Valleys climate research. The camp buildings are located a few hundred feet from the flat base of Canada Glacier, which towers over them. You'd think that it would be a precarious existence, but Canada Glacier is what they call a "cold glacier." That means it's advancing and receding at about the same rate so it doesn't appear to change much. It doesn't calve off large pieces like the glaciers that flow down to the sea ice. On days where the temperature is around freezing, it drips down into small streams, which the scientists measure.

The main camp building is built in the same basic plan as Shackleton's hut at Cape Royds. At one end is the kitchen and dining table, large enough to seat 20. Pantry shelves and cupboards line the countertops and are filled with many of the same supplies—canned goods, dried beans and rice, and tea, coffee, and other drinks.

On one wall is the Preway stove with an enormous pot of water melting chunks, or "glacial berries," cut from the glacier. Above the stove are clotheslines to dry wet gloves, socks, and towels. On the other side of the room are the radio and telephone used for the camp manager's daily communications with the helicopters and other camps. The ceiling is festooned with Thanksgiving drawings, wire sculptures, and Christmas lights. A researcher could do a history of previous occupants from the artifacts that remain behind, just as historians are now doing with the Scott and Shackleton huts.

In addition to the main building, which runs on solar panels with a diesel generator for backup, the camp consists of three small lab buildings, a Jamesway for storage, and several rocket toilets. When a toilet is full, a propane burner is turned on and burns up the waste. (A black flag is hung outside to indicate the process is under way.) The name is alarming, but they're effective and more user-friendly than the usual field camp outhouse, where the different kinds of waste are dealt with separately.

The researchers all have small tents somewhere up on the hillside. I share a Scott tent close to the glacier face with Sandra Blakeslee, a science writer for the *New York Times*, who's spending three weeks here on an NSF press grant. After my unpleasantly cold Happy Camper School experience, I haven't looked forward to Antarctic tent camping. However, it's not bad outside, in the 20s or so, and my sleeping bag is rated to −50°F. I have a Thermarest mattress, a pillow, and, for companionship, a stuffed cat that my husband bought me for good luck before I left New Mexico.

Mummified seal bones
Ice, Lake Bonney

In the afternoon, several of us take a six-hour hike up Lake Hoare, across Lake Chad, and around Suess Glacier to Mummy Pond. The hardest part is walking on the lake. It's now starting to melt slightly on the surface, and the ice is quite slippery around the shoreline. If we walk more toward the center where the ice is rough, we risk stepping on a melt hole. That's where ice has melted and refrozen right on the surface, but is so thin that we can fall through a foot or more into water. We put stabilizers on our boots, but they don't fit well. We move slowly and uncomfortably over the ice, worrying with every step that we will slip and fall. Eventually we're moving so slowly that we decide to leave the ice and follow a rocky, hilly, and equally difficult path around the shoreline.

The way is better when we reach Suess Glacier and begin to circle up around its edge. Its flat edge, some 15 feet high, meets the ground in a slight trough that will no doubt run as a stream when the weather warms it just a bit more. The hillside upon which it sits is dirt, not ice, and is not too difficult to climb. I can walk close enough to the glacier to reach up and touch its hard surface and yet remain on dry ground. I flash on Ronald Colman in the movie *Lost Horizon,* trekking around an icy, precipitous mountain path with his beautiful love guiding him. Wouldn't I, too, stay young in a place like this where time is so irrelevant?

When we reach the top of the ridge and began to descend, we can see Mummy Pond below us. It's a small icy lake with the glacier feeding it from one side and Lake Bonney on the other. Its name comes from the desiccated seals around the edges of the ice. We find four of them around the lake, golden ones with their fur still intact despite the hundreds of years they've been exposed to the elements. Nobody knows how they got here or why they came. Even allowing for a rare pinniped lust for adventure, it's hard to imagine them coming this far from the sea.

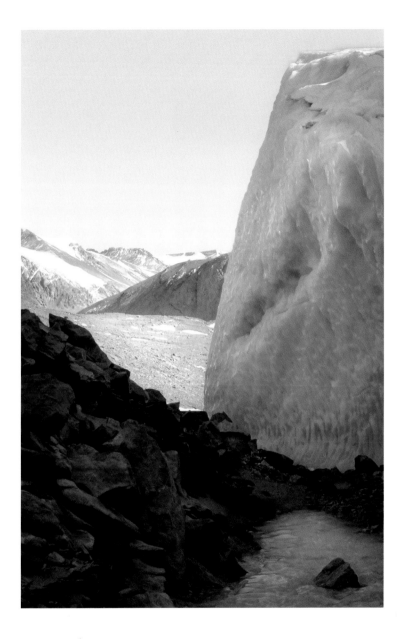

Mummy Pond

> *Antarctica was like a dream that stung. . . .*
> *Most of all there was the clarity of the air. The*
> *ordinary slight humid haze of temperate lands*
> *was wholly absent and distant mountains*
> *stood revealed in incredible detail. Instead of*
> *sharpening perception this clarity seemed to*
> *confuse it. The mind lost its common reference*
> *points and the landscape seemed less real,*
> *not more. Antarctica was as vivid as fantasy,*
> *as substantial as reverie.*
>
> WILLIAM DIETRICH
> *Ice Reich*

Beacon Valley

DECEMBER 14, BEACON VALLEY, 25°F, WIND CHILL 12°F

A HELICOPTER FLIES US TO BEACON VALLEY, a majestic site of imposing sandstone and dolomite formations. It edges Taylor Glacier, an enormous river of ice that flows down from the polar plateau to the coast. Geochemist Ronald Sletten of the University of Washington and an assistant are tent camping, far from the relative comforts of heated field camp huts. Their camp consists of two small tents, nothing else, amid a boulder-strewn valley enclosed by a bowl-shaped rock formation thousands of feet high. Every day they walk for hours over this extremely rugged terrain, researching the ice underneath the thin earth coating.

The helicopter flies us from Ron's camp down the valley to a site where his soil and atmospheric measuring devices are located. Ron has found a massive ice deposit, the remnant of an ancient glacier, overlain by volcanic dust and rock. Ron's study of the ice, millions of years old, will lead to a better understanding of the stability of Antarctica's ice sheets and, by extension, the earth's climate.

From the landing site, we walk for half an hour across an enormous field of rocks of all sizes and shapes. Many are ventifacts, rocks that have been sculpted into sharp ridges and worn smooth by the wind that blows most of the time in the area. Some of the smaller rocks are neatly organized into a flat desert pavement, a geological term for the compacted layer of stones that covers the ground in a desert plain. Wind erosion carries away the finer sand and dirt particles, leaving a pebbly surface that looks a bit like coarse-grained concrete. But most of the larger boulders are jumbled in uneven piles, making walking with camera gear hazardous.

On the edges of the valley are variegated formations much like the sandstone bluffs of the Four Corners area of the American Southwest, but on a grandiose scale and with glaciers dripping over their sides. I keep looking up the hillsides for bighorn sheep and down on the ground for Indian arrowheads. I take deep breaths of the cool air, longing for the scent of sagebrush. But there is no wildlife and no visible vegetation of any sort. You hear no sounds other than your own breathing and the wind passing over your parka.

Taylor Glacier

Ventifacts (wind-sculpted rocks)

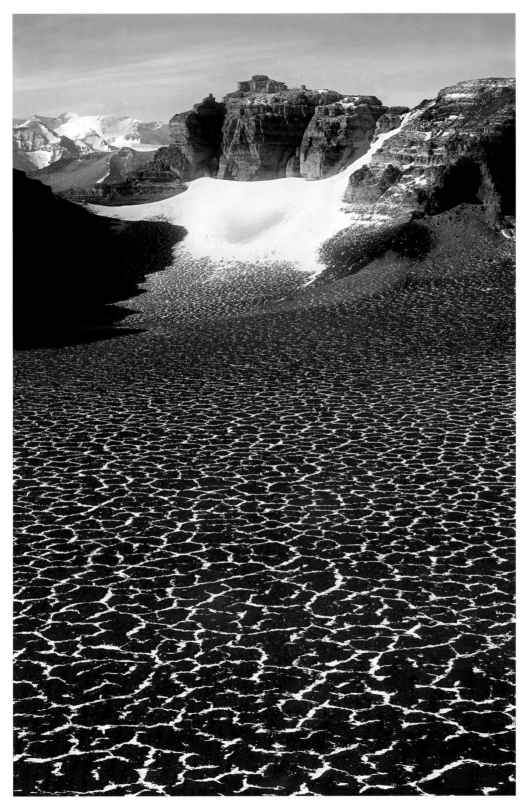

Beacon Valley polygons. In some areas of the Dry Valleys, like the Beacon Valley, precipitation has been negligible for at least the past 10 million years. This dryness, combined with the cracking of an ancient glacier lying beneath the soil, formed these dark polygons of soil, which range from 30 to 100 feet across.

Life on a Small Scale

DECEMBER 19, MCMURDO STATION, 28°F, WIND CHILL 19°F

DESPITE THEIR DESOLATE APPEARANCE, the Dry Valleys are neither sterile nor empty. Only two percent of the continent is free of ice, and much of that land is in the Dry Valleys. Beacon Valley and others like it are some of the most extreme environments on the planet, with strong winds blowing down from the polar ice cap, an average annual temperature of −4°F, and average precipitation of less than an inch a year. No wildlife is in evidence, except for the occasional suicidal seal. No trees or bushes or grass grow. Yet life on a small scale is thriving in the soil, the ice, even in the depths of the lake sediments.

Biological studies in the Dry Valleys have revealed life-forms that have colonized rocks, soils, glaciers, glacial meltwater streams, and lakes. When I visited Ron Sletten in the Beacon Valley, he lifted a piece of sandstone and showed me the greenish stain of cyanobacteria, some of the oldest and most important groups of bacteria on Earth. Lichens are found on rock surfaces, from the valley floors to the summits of some mountains. Further up the food chain are microscopic rotifers, tardigrades, and nematode worms, the largest land-dwelling creatures in the Dry Valleys.

David Marchant from Boston University who, like Ron Sletten, has studied the soil and ice of the Beacon Valley, has been dating the stagnant glacier below the valley floor by dating volcanic ashes that overlie the ice. He believes that around 12–15 million years ago, the ice sheet over East Antarctica was considerably larger than at present. The stagnant ice preserved on the floor of Beacon Valley may be a small remnant of this much larger ice sheet. Some soil samples he has examined are about 17 million years old and contain tiny mosses and other plant life that suggest a relatively warm and wet Antarctica. No ice from this warm period could be preserved. But the younger ice samples he studies, some of which may be up to 8 million years old, are likely the oldest in the world.

The Dry Valleys are pristinely ancient. James Head, a planetary geologist from Brown University who's been involved in the space program for more than three decades, has been working with Dave in the field for the past few years. James has found a suite of landforms on the polar plateau side of the Dry Valleys that resembles features on Mars. Scientists have long wondered if this region represents Earth's best analog for Mars, he says. If that's indeed the case, then scientists will eventually find

Ice-core sample of million-year-old ice, Beacon Valley

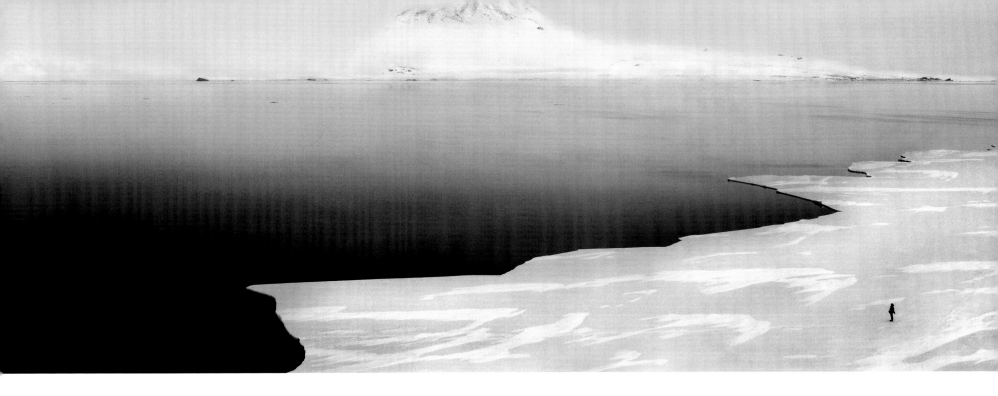

Ross Sea at the edge of the sea ice

Laurie Connell, a marine biologist from the University of Maine, brings yeast samples from the Dry Valleys to Crary Lab to grow colonies. The yeast species, many endemic to the Antarctic, are vital to the ecology of the polar food web.

Diatoms found under the sea ice are a critically important part of the food chain.

near-surface ice on Mars, beyond the polar regions, and quite likely under a thin layer of debris.

Who knows what interesting microscopic critters will surface when we can sample other planets and moons? Scientists I have spoken with agree that where there's water, there's life.

Summary Warmth

Summer Warmth

DECEMBER 21, MCMURDO STATION, 36°F, WIND CHILL 33°F

YESTERDAY WAS THE FIRST TIME since I arrived that the temperature with wind chill has been above freezing. Back home, I would be bundled up and cold at 36°F, but after the last couple of months here, it feels like a heat wave. Lots of people are walking around in shorts and T-shirts. It feels great not to be cold or have to wear all those extra layers of balaclava, hat, and heavy gloves. It's equally wonderful not to have to worry about the cameras fogging up and the tripod freezing solid. When it's a struggle to lug the cameras around and to get everything to work, it's hard to concentrate on taking a good picture.

After Sunday brunch, several of us set off in a Pisten Bully for the two-hour run to Cape Royds. It's a glorious day for a trip on the sea ice. As it turns out, it's probably the last day of the season for such a journey. Every year, a giant crack forms where the edge of Barne Glacier meets the sea ice. (Herbert Ponting called it the "Big Crack.") It's now more than a foot across with open water not far below the surface. Not good for travelers. A group of Kiwis just behind us also stops. They have a couple of 12-foot boards, which they lay across the crack to stabilize the vehicle tracks. We thus cross safely with many joking comments about the best way to escape from a Pisten Bully if it sinks. (Start by unlocking the roof hatch—we figure that at least a couple of us will have time to get out that way.)

Years ago, Cape Royds was a favorite destination for "distinguished visitors"—U.S. congressmen and high-level government officials. NSF would helicopter them into the middle of the Adélie penguin colony where they would leap out and grab several birds to pose with for a picture to send home. Gradually, the birds were traumatized and began abandoning the colony. When the Antarctic Treaty was established, guidelines were formulated that required helicopters to land away from the penguins and specified that visitors take pictures a short distance from the birds. The colony soon rebounded.

This year the penguins are having a hard time. The giant icebergs, especially B15, which is about the size of Connecticut, are stuck in McMurdo Sound and have changed the water currents so that the sea ice doesn't break up as fast or as close to the shore of Ross Island as it once did. As a result, the penguins have to walk 25 miles to feed. For a small bird with little stubby legs and flippers, that's a very long walk for dinner. Both parents help with brooding eggs and feeding chicks, but because of the distance they must travel, the chick mortality rate is very high.

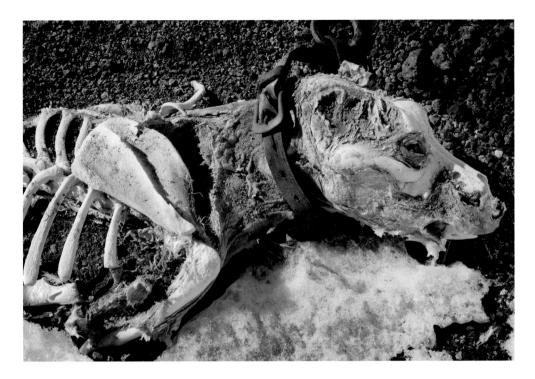

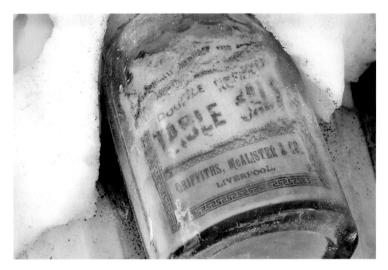

Today, it's quiet with some birds nesting in small depressions lined with carefully selected pebbles they've brought to the nest site. Many nests are unoccupied. A few birds without eggs are walking about, stealing pebbles from unused nests and piling them up in their own.

After a successful return over the Barne Glacier crack, we stop briefly at Scott's hut at Cape Evans. It's warmer than the last time I was here, and the piled-up seal blubber is partially defrosted and oozing red. Snow no longer covers the windows of the hut, so I can see the names on the tins and can photograph without a flashlight. I try to capture the natural light streaming in through the small windows to give a sense of what it would have been like to live here.

On the hill behind the hut, I find the remains of a dog from Shackleton's Ross Sea party, now exposed by the melted snow. It still has a collar and chain on its neck. Perhaps the chained dog was ill and couldn't be rescued with the men or maybe it died in winter and was buried by snow. The men loved their dogs and would never have mistreated them.

Dog remains from Shackleton's Ross Sea party, Cape Evans

Table salt, Cape Royds

What an evening! The sun is high in the heavens in spite of the late hour. Over all this mountainous land of ice, over the mighty Barrier running south, there lies a bright, white, shining light, so intense that it dazzles the eyes. But northward lies the night. Leaden gray upon the sea, it passes into deep blue as the eye is raised, and pales by degrees until it is swallowed up in the radiant gleam from the Barrier. What lies behind the night—that smoke-black mass—we know. That part we have explored, and have come off victorious. But what does the dazzling day to the south conceal? Inviting and attractive the fair one lies before us. Yes, we hear you calling, and we shall come. You shall have your kiss, if we pay for it with our lives.

ROALD AMUNDSEN
The South Pole, 1913

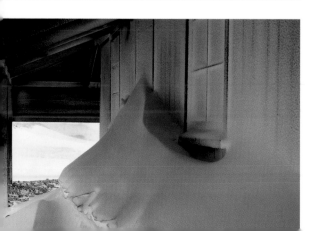

Sensory Deprivation

DECEMBER 22, MCMURDO STATION, 23°F, WIND CHILL −3°F

TODAY IS THE AUSTRAL SUMMER SOLSTICE. I miss darkness. It's hard to adjust to the abrasive light that never dims. If you wake up during the night, it's hard to go back to sleep. No matter when you wake, it looks like morning.

This morning my clock says it's time to get up, but Sunday brunch, the best meal of the week, doesn't start until 10. I lie in bed imagining homemade waffles with berries and whipped cream, smoked salmon with cream cheese and bagels, sticky buns, and omelets.

The morning is clear and warm by the time I walk from my dorm over to the galley for breakfast. I take a deep breath, as one does on such a pleasant day. And once again, I am disappointed. I've become accustomed to no children, no pets, and no insects, but I can't get used to the absence of smells. Of course we have food smells in the galley and whiffs of diesel fuel from passing vehicles. But that's it. With no vegetation and none of the usual soil decay, the ordinary scent of organic life on the planet is absent. When you breathe in deeply, you usually don't smell anything at all.

I've found myself creating smells that are not there. A friend sent a picture of himself on the beach, and I could smell the suntan lotion. Watching a hula troupe at the Women's Soiree the other night, I could smell the moist sweet fragrance of Hawaii. It was so intense and I longed for it so much that I found myself in tears.

With little color or noise here, the senses are deprived. Even taste. The cafeteria food, though filling and nutritious, lacks the chilies I'm used to in New Mexico. Without Bernie, I don't get enough hugs, so touch is also in short supply. But for me, the lack of smell is the hardest to get used to.

Discovery hut, Hut Point

Photographing in a Blizzard

DECEMBER 23, MCMURDO STATION, 24°F, WIND CHILL −2°F

A BLIZZARD FOUND US LAST NIGHT and has battered the station ever since. You can only look on such a storm with reverence. Despite all the extra work that the snowdrifts make for the work crews, you can't help but respect its beauty and power. For support workers, this is the Antarctica they came to see.

"A blizzard is when the snow falls sideways," according to a child's definition hanging in the window of our little McMurdo store. Here blizzards blow sideways and very hard indeed. They are usually more wind than snow, since this is such a dry place, but this storm dropped enough snow to make McMurdo look ready for Santa's arrival. Dave Bresnahan, the station director, wants to make his traditional Christmas deliveries to all the field camps—dressed as Santa and transported by helicopter—but he hasn't been cleared for take-off.

I photograph outside several hours this morning and again this afternoon. Unlike our previous storms, this one is warm, which lets me stand in one place and plan a shot. In fact, I stand still so long preparing for a shot that a friend walking by asks me if my feet are stuck in the ice. Still, it's not easy to photograph in a blizzard like this. Even though it's not cold, you still have to contend with wind that tries to knock you down and snow blowing onto your camera lens. Once the lens gets wet, it's hard to dry it off and continue shooting. Letting your nose drip down onto a frozen lens is disastrous. I keep the camera inside my parka until I'm ready to shoot. Then I pull it out quickly, turn it on, frame, focus, and shoot. If I have some protection, I may have time to put it on the tripod. After an hour or so, I begin to feel like I've been beaten up by the wind. Then it's time to come inside, take off my layers of clothing, have a cup of hot chocolate, and relax before putting all my clothing back on and going out again.

I found the Antarctic a very disappointing region for photography. It was exasperating to find the weather so often thwart one when half-way to some goal.

HERBERT G. PONTING
The Great White South, 1923

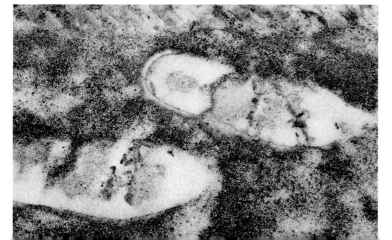

Footprints
Kitchen staff

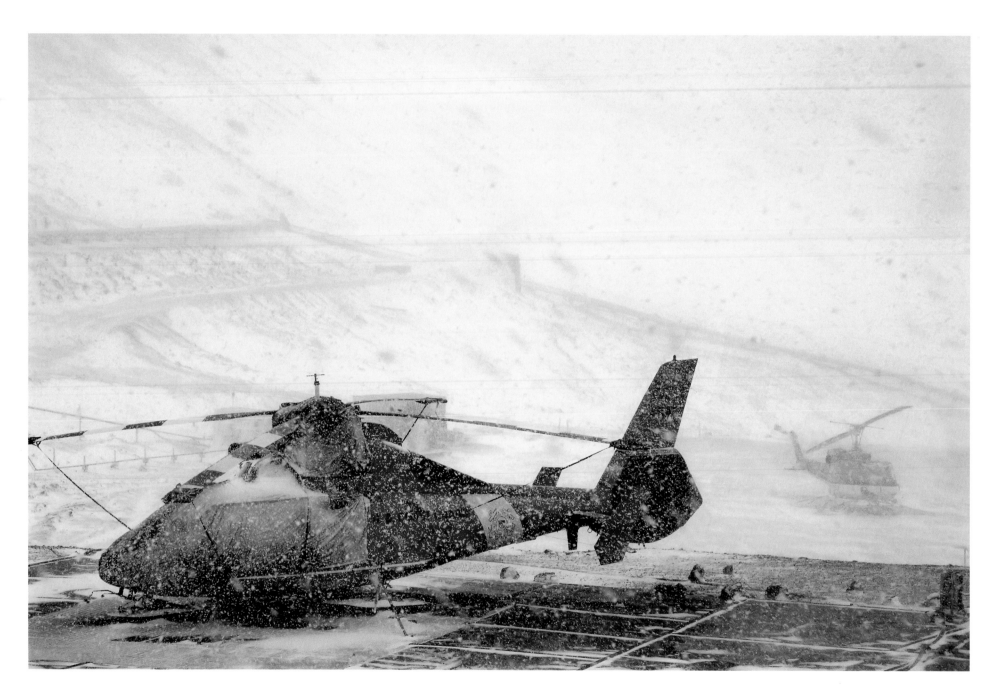

Helipad, McMurdo

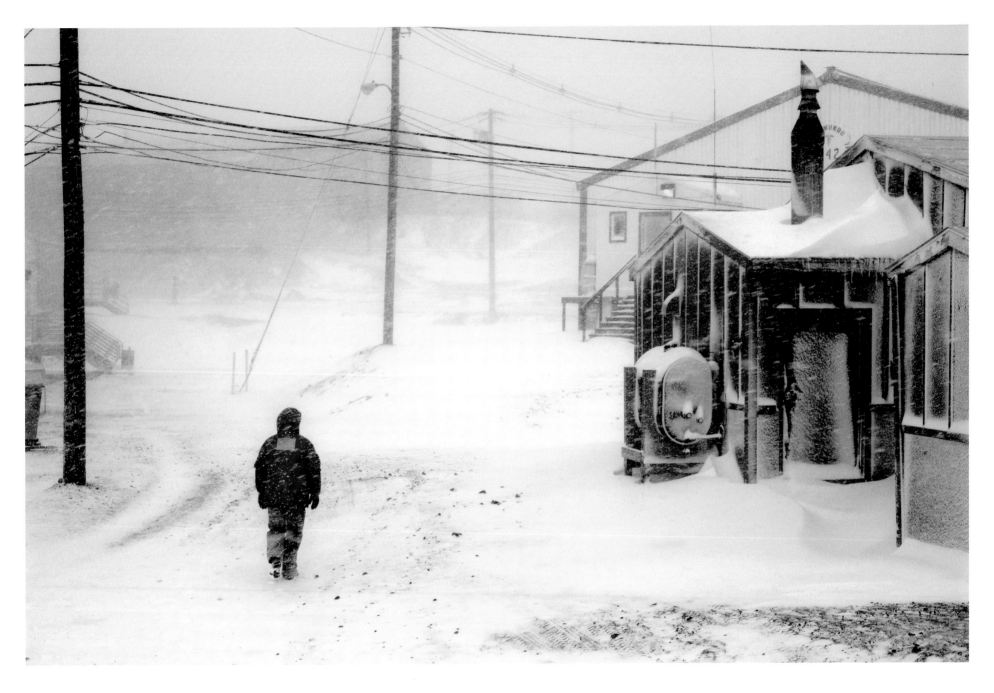

Blizzard, McMurdo

Chapel

Too Far for Santa

DECEMBER 25, MCMURDO STATION, 24°F, WIND CHILL 0°F

CHRISTMAS DAY IN ANTARCTICA! From my window I see the white of the sea ice and the white of the sky with a thin line of blue mountains floating serenely between them. It's an emptier landscape than any painted by a Japanese *sumi-e* master. Not a single figure, bird, or even vehicle occupies the foreground. It's as if the artist painted the background but never got around to adding the subject.

Many scientist friends have left, having finished their research before the holidays. Crary Lab is quiet and a little dismal. The remaining scientists are still working hard, but the support staff is looking forward to a couple of days off. No flights will depart for the next week. We're cut off from the rest of the planet.

This place has plenty of ice and snow, but it's hardly a Christmassy environment. Santa lives at the North Pole. Family and friends are continents away. All the small holiday rituals and connections that one establishes over the years are missing. For me those are the funky tree decorations that my kids made when they were in elementary school, the Cochiti pottery nativity scene, my mother's black-and-white meringue cookie recipe, and Gene Autry singing Christmas carols. What's totally absent is the usual noisy consumerism of the holiday. Nobody is blaring Christmas music or trying to sell a product. There's nothing to buy in the McMurdo store anyway, besides sundries, liquor, and T-shirts.

For newcomers, it's often an uneasy respite from their busy work schedule, a time to be concerned about family back home. One man I talk to married shortly before coming down to work. His wife is fed up with being alone and threatens to leave him. Another friend's mother is so worried about her being here that the mother breaks into tears whenever they talk. Despite such stresses, Christmas is the most laid-back two-day period of the work season.

As we drink wine and eat our bountiful meal, I can't help but think of Scott, Wilson, and Shackleton struggling toward the South Pole in December 1902, a hundred years ago. Their dogs were too weak to pull loads, and the men struggled to drag 170 pounds each across the plateau on meager rations of pemmican, biscuit, and seal meat. They were hungry all the time and suffering from scurvy. Their eyes stung from snow blindness, and their skin was dry and cracked. Yet they were determined to enjoy Christmas.

Later in the evening, I join a party given by one of the fish research groups in the Coffee House, which is strung with Christmas lights. Everyone brings a small wrapped present for a "white elephant" gift exchange—from partially consumed bottles of gin and tonic, to a handmade hat, to a tiny bottle of Polar Essence (a faux perfume made from lab alcohol). When it's your turn, you can choose an unopened gift or take what somebody else has picked, so often the best gifts rotate through several owners. Someone suggests that we all take a drink if the wrapping or present includes any red or green. So with the cries of "Ooompah," the party becomes a decidedly festive occasion. Being an early riser, I make it through only one round of "pin the beak on the penguin" before calling it a night.

Christmas decorations

Gingerbread houses made by kitchen staff

"For a week we have looked forward to this day with childish delight," wrote Robert Falcon Scott in his journal in December 1902. "When we awoke to wish each other 'A merry Christmas,' the sun was shining warmly through our green canvas roof."

For the first time in weeks, they ate all they wanted—a breakfast of biscuit and seal liver fried in bacon and pemmican fat, followed by a large spoonful of jam. Later in the day they made a Christmas stew with a double serving of everything.

"Meanwhile," Scott continued, "I had observed Shackleton ferreting about in his bundle, out of which he presently produced a spare sock, and stowed away in the toe of that sock was a small round object about the size of a cricket ball, which when brought to light, proved to be a noble 'plum-pudding.' Another dive into his lucky-bag and out came a crumpled piece of artificial holly. Heated in the cocoa, our plum-pudding was soon steaming hot, and stood on the cooker-lid crowned with its decoration."

(Source: *The Antarctic Sun,* December 22, 2002)

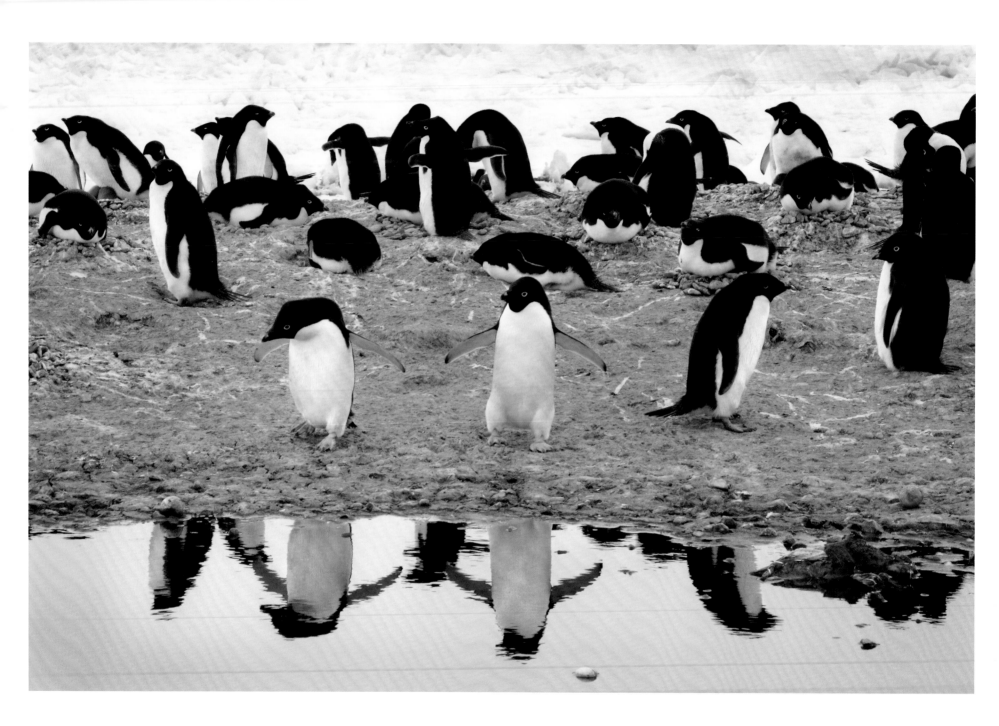

Beaufort Island

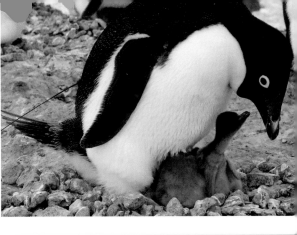

BEAUFORT ISLAND IS A MAGICAL PLACE, a truly wild place. So few people have ever set foot on this small island, some 45 miles north of McMurdo in the Ross Sea, that it remains an elemental fragment of the pre-human planet. Its center is a volcanic mountain that extends nearly to the ice edge on all sides, leaving only a small rocky beach where Adélie penguins have been living for centuries.

Where the sea ice meets the land, large pressure ridges have formed, jagged cerulean jumbles of ice that make for treacherous walking. The Adélies pass through these ridges on their way to the water to feed, ambling in long lines or pushing themselves down blocks of ice with their flippers. The researchers grab their boxes of gear, I put on my backpack, and we all make our way gingerly across the cracks and pressure ridges to the beach.

The Beaufort Island Adélie colony is large—some 50,000 birds—and much healthier than the one at Cape Royds. About 20 percent of the birds have nests, some with eggs, most with two healthy chicks. The tiny gray young spend most of their time sheltered by their parents. It's hard to get good shots of them or the eggs because the adults are very protective. No wonder, with scavenging skuas flying constantly overhead. Broken eggs and the remains of penguin skeletons are scattered on the ground. Life here is not easy.

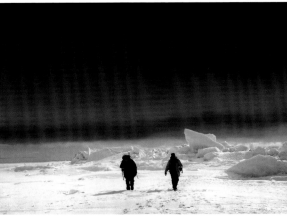

The skuas struggle for survival as well. They nest farther up the mountain and dive-bomb me as I get close to the upper edge of their colony. Four of them soar down, one after another, aiming for the top of my head. With their wings spread, they are like kamikaze pilots coming in for the kill. I put up an arm, and they veer off at the last moment. I decide that retreat is preferable to the picture I might get if I walk farther up the hill. When I move away, they let me go without further assault.

We stay on the island for several hours. Several researchers weigh and tag birds. Others attach antennas and tracking devices to a few nesting females to learn more about their habits when they feed their young. I wander along the edge of the pressure ridges, photographing the birds as they leave to feed, and then slowly walk through the

Adélie penguins, Beaufort Island
Mother penguin with research antenna
Researchers, Beaufort Island

The land looks like a fairytale.

ROALD AMUNDSEN
The South Pole, 1913

I try in vain to be persuaded that the pole is the sea of frost and desolation; it ever presents itself to my imagination as the region of beauty and delight. There . . . the sun is forever visible, its broad disk just skirting the horizon and diffusing a perpetual splendour. . . . What may not be expected in a country of eternal light?

MARY SHELLEY
Frankenstein

colony photographing the adults feeding their chicks. As long as I don't poke my lens right in their faces, they ignore me. Small dramas play out in front of me—courtship displays, thievery, skua assaults, and penguin defenses. I shoot all the flash cards I have with me and wish I had several more.

When I get back to my office, I am tired and very happy. But I smell awful. The office stinks so much that one of my friends wrinkles her nose at the doorway and asks, "Are you sure you don't want to put that into the freezer?" There's nothing like walking around in a penguin rookery for several hours to acquire a distinctive fishy aroma. I wash my boots off in the sink and take my clothes back to my dorm laundry to wash.

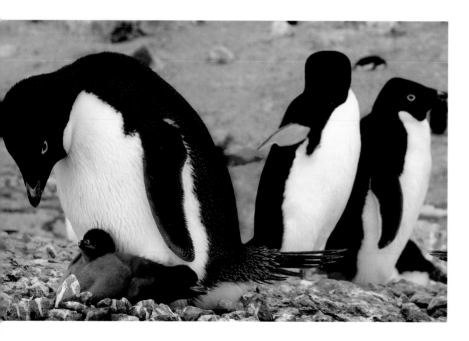

Penguin remains

Mother penguin with recently hatched chicks

Penguin on its way to open water to feed

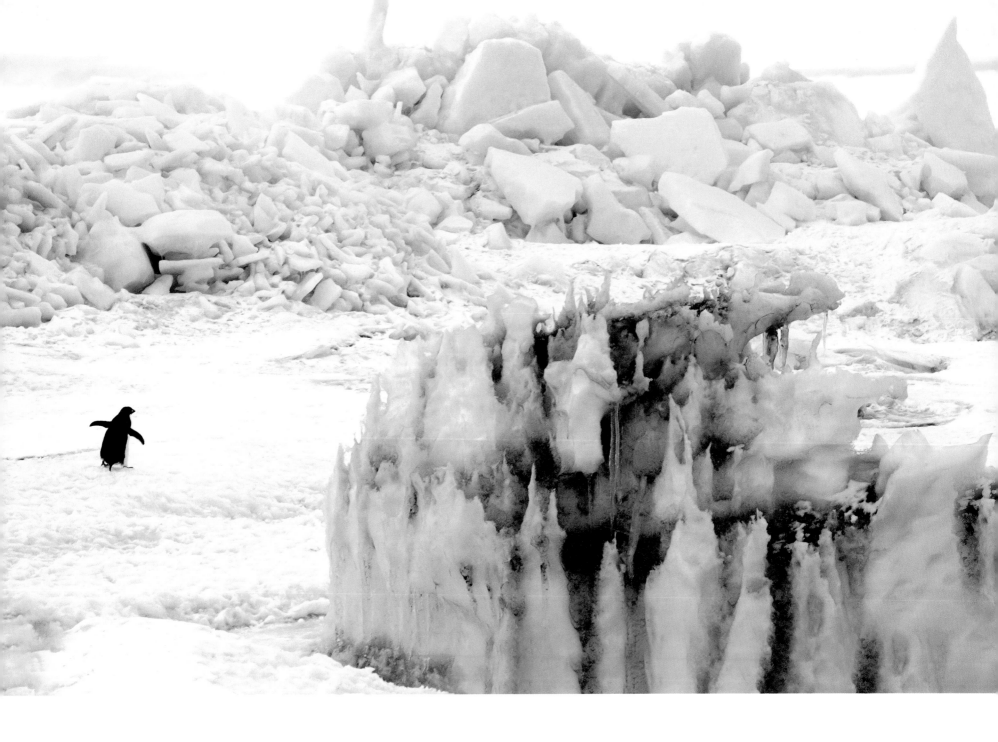

Sea ice channel with the Dry Valleys
in the background

Cutting the Channel

JANUARY 1, 2003, *POLAR SEA*, 23°F, WIND CHILL −2°F

THE U.S. COAST GUARD has three Polar Class ice-breakers. Each year one of them is responsible for cutting a channel through the sea ice in the Ross Sea so ships can deliver fuel and supplies for the McMurdo and South Pole Stations for the following season. Without these deliveries, neither could operate.

The 399-foot USCGC *Polar Sea* has the job this year. With three gas turbines and six diesel-electric engines, it's capable of 60,000 horsepower and is more powerful than 10 of the most powerful locomotives combined. Indeed, it's the most powerful non-nuclear icebreaker in the world. When you stand at the ship's stern, you see chunks of ice the size of small houses being tossed and overturned in the ship's wake as it plows through the ice. The power is awesome, the sight hypnotic.

That's when everything is working. The *Polar Sea* is 25 years old, and the Coast Guard has no money to replace it. When I come on board, about 23 miles from McMurdo, it's cutting well but suffering frequent mechanical problems. During the four days I'm on board, one part or another is always breaking down.

The *Polar Sea* breaks the channel by ramming its front end up on the ice and using its weight (including 1.5 million gallons of fuel) to crack the ice below. It has a rounded bottom and almost no keel just for that reason. Out near the water's edge, the ice is only a few feet thick, and the icebreaker makes excellent progress, cutting five to 10 miles a day. By the time I disembark, the ship is some eight miles

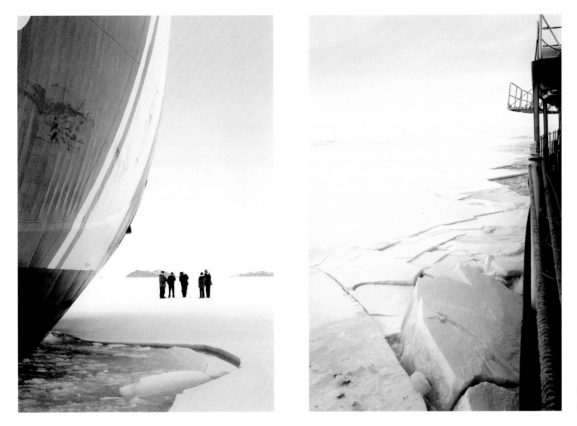

At liberty on the ice, *Polar Sea* crew

Cutting the channel

from McMurdo where the ice is considerably thicker—between eight and 13 feet. The force required to ram and crack this ice is prodigious. The ship rams her bow up on the ice, forces a crack here and there, then backs up and does it all over again. The cutter makes only a few yards' progress with each ram.

Being on board is like being inside a metal battering ram attacking a major fortification. The engines and turbines run constantly, so it's difficult to tell whether the boat is moving forward or backward, or has arrived at a moment of stasis as it prepares for the next attack. Fortunately for sleep, the turbines are shut off from midnight to 8 AM for maintenance.

Our food on board is excellent, with fresh fruit always available. Dining at McMurdo involves grabbing a tray, plate, and silverware, serving yourself from the buffet, and then finding a table. Manners become lax, and some folks forget the plates and just pile food on

their trays. On board the *Polar Sea*, meals are more civilized, especially since I eat with the officers in their mess. "Yes, sir," and "No, sir," are common, as is the use of last names. Being a Patrick O'Brien fan, I keep expecting Dr. Maturin to walk in for dinner and begin discussing his most recent penguin sighting.

The night I arrive, the crew is given "ice leave" from 6 PM to midnight. The ship rams up and parks itself on the ice. A gangplank is lowered, and officers and crew walk out on the sea ice. Some bring folding chairs and sit around in their parkas, drinking beer, and talking. Most play football, hockey, or soccer or just walk around. Groups of Adélie penguins shuffle through the games. They show no fear of the vigorous activity all around them and, after looking about, proceed on their way.

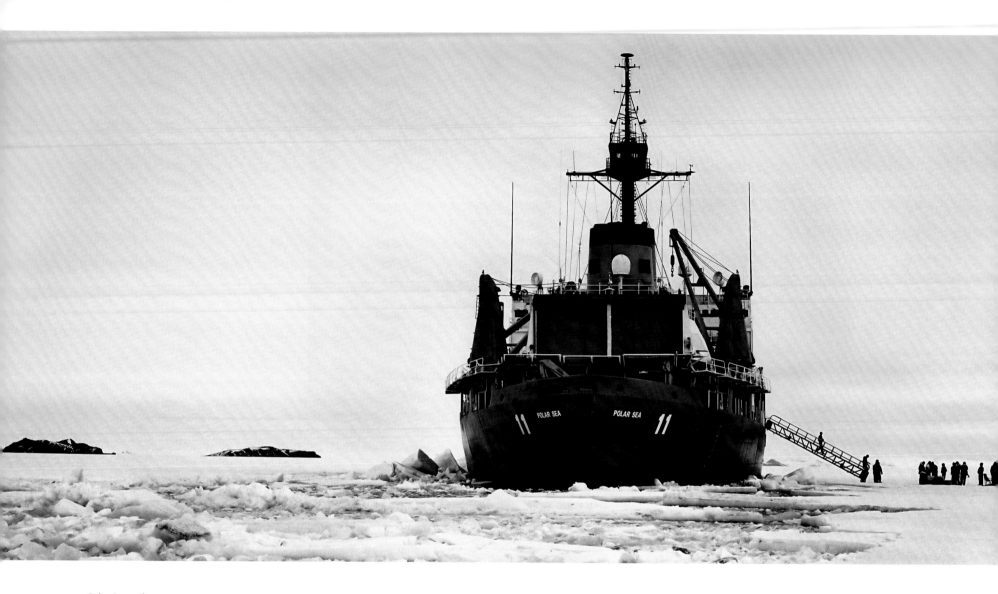

Polar Sea and crew

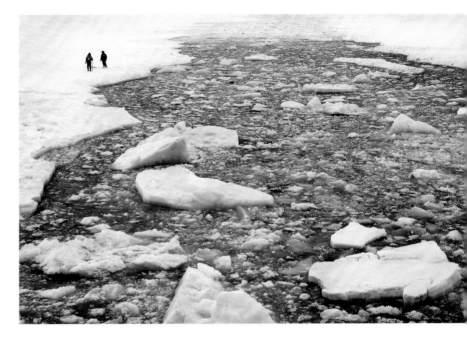

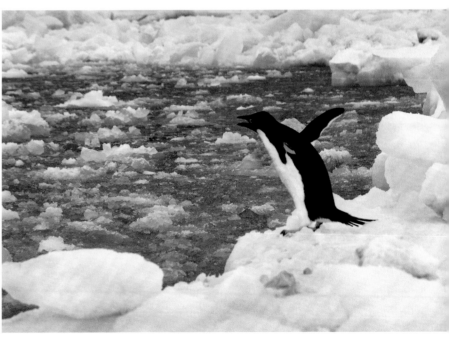

Walking along the channel
Adélie penguin diving from the sea ice edge

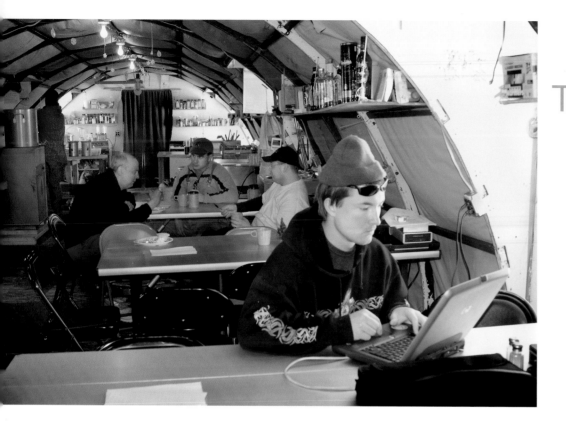

Main living Jamesway, Onset D

En Route to Onset D

JANUARY 4, 15°F, WIND CHILL −20°F

TWENTY-FIVE-KNOT WINDS push me and my cameras along as I walk from the shuttle van to the Twin Otter at Willy Field. Snow begins to blow across the runway. I wonder if I made the right decision to leave comfort behind and fly six hours across the ice shelf in a small plane in questionable weather to the remote Onset D field camp.

Once airborne, however, we quickly rise above the clouds and wind. I'm the only passenger and ride in the back seat. The center of the plane is piled to the ceiling with lashed cargo pallets, leaving me a tiny compartment with no view of the three crew members. After passing White Island, we travel across an area of Antarctica where there are no rocks or mountains, only the flat ice shelf as far as the eye can see. The ice surface is not featureless, however. In some areas it is composed of endless ripples called sastrugi, waves of snow and ice blown into waves like sand dunes in the desert. Sometimes, the patterns appear more curved and random, like hand-troweled stucco. When we fly across the ice streams, I can see miles and miles of incised lines in a variety of patterns, deep crevasses formed by the movement of the glaciers.

You don't get a sense of scale of Antarctica from living on its edge in McMurdo. Once you go into the center of the continent, you can travel for hours and it looks just the same. You go farther, and there's still more in all directions. Between McMurdo and Siple Dome, where we set down for fuel some three and a half hours into the flight, there's no human structure or activity. Nor are there any non-microscopic

life-forms. What an empty place! I can see a horizon separating white ice from blue sky; otherwise it's a void.

Siple Dome is a small field camp that used to conduct ice-core drilling as a means of studying the composition of the atmosphere 80,000 to 100,000 years ago. The research shifted elsewhere, so my friend Alice, who operates a forklift, and two men have been dismantling the camp. Remains are crated and ready for aircraft removal in a few weeks. It's great to see her enjoying herself and proud of what her little group has accomplished.

I can't imagine living in a blank landscape, sleeping in a tent, and working long hours every day with two strangers. It's not like you can walk to a neighbor's house or drive to the movies or go shopping for relief. If you don't like where you are, what you're doing, or whom you're with, you have absolutely no alternative.

The sky at Siple Dome hangs like a gigantic glowing bowl. You live in light and sky with nothing to mar the view. Three hundred sixty degrees of white. "From my forklift," says Alice, "I can see to the end of the world in every direction."

Twin Otter crew

Onset D field camp

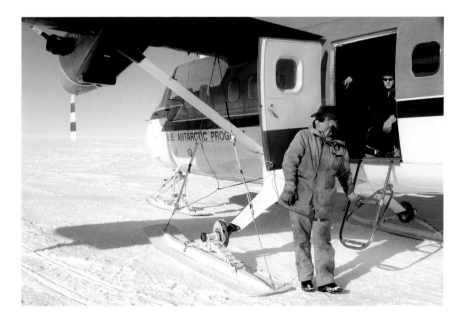

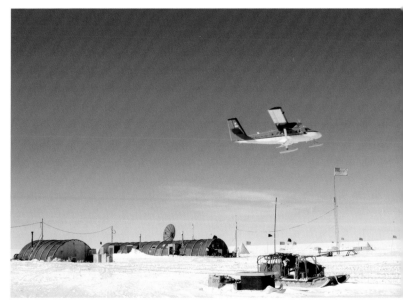

Onset D

JANUARY 5, ONSET D, 16°F, WIND CHILL −4°F

AN HOUR AND A HALF AFTER LEAVING SIPLE DOME, the plane lands at Onset D, the largest of the field camps this season. (An onset is the place where an ice stream starts, and this camp is studying Ice Stream D.) Far out on the West Antarctic ice sheet, the camp is dwarfed by the white expanse that surrounds it in all directions. Much of the work here is being done by snowmobile. The men commute 20–30 minutes each day to their work site, do their blasting, and return at night.

Sridhar Anandakrishnan, from Pennsylvania State University, is studying the topography beneath the ice sheet a mile and a quarter below the surface by blasting and conducting detailed seismic readings. In particular, he is studying the bedrock beneath the ice in order to understand ice streams, the sections of the ice sheet that move much faster than the surrounding ice. This phenomenon is what I saw as we flew in—the shear zone, an area of fractures and crevasses where the ice streams meet the regular ice.

Flora Millsaps, the cook, is the only woman among 15 men. She lives along the Yukon River in Alaska, and this is her first time in Antarctica. At night, she sleeps in her own small tent a few hundred feet behind the main hut. "It's good here," she tells me, "but I miss having other women to talk to." She got the job simply by applying on the Raytheon website.

At mealtime everyone grabs a plate and cup and helps himself to the food from the large pots and casseroles. The men love Flora's cooking. No wonder. We had roast beef, lobster tails, and crab legs for dinner last night and a wonderful vegetable frittata for breakfast with several kinds of homemade breads and muffins. Nobody ever goes hungry in a field camp.

The men who have worked for the last couple of months at Onset D have formed a tight community. I don't feel unwelcome, but I'm not part of it. It's as if I've entered a tribal group that has not seen strangers for a long time. Rhythms of interaction have been formed. Speech is unnecessary for most daily activities since everyone is familiar with the routines, and the talk I do hear has to do with the day's work schedule. Our plane has brought Christmas mail and packages for many of the men. I watch one guy open a package containing a small plastic Christmas tree and bags of candy. He puts the items out on the dining table one at a time, looks at them curiously for a long moment, and then puts them back in the box. Nobody says anything. I wonder if women wouldn't have made life more interesting here.

Snow castle with sleeping tents
Preparing for the morning's commute to the work site

ICE STREAMS

Glaciers and ice streams do for ice sheets what rivers do for lakes. They drain excess water as precipitation falls. In Antarctica, ice streams move vast amounts of ice off the main plateau toward the surrounding ocean. Flows can measure 60 miles wide and hundreds of miles long. They speed up and slow down, depending on conditions such as friction and topography at their base. Scientists are keeping a close eye on the continent's major ice streams for signs of acceleration due to global warming. If much of the West Antarctic ice sheet were to slip into the ocean and melt, world sea levels would rise by more than 15 feet. Good-bye, Florida.
—S.B.

Long-Duration Balloon

DURING THE AUSTRAL SUMMER in Antarctica, upper-altitude winds form a vortex centered at the Pole. A balloon launched at the right moment travels with these winds, circumnavigating the continent in 12 to 15 days at an altitude of 120,000 feet and returning close to its point of origin. At this altitude, higher than 99 percent of the earth's atmosphere, the instruments from long-duration balloon launches detect and measure high-energy galactic cosmic rays. After a mission is over, instruments parachute to the ground for recovery and data extraction.

The launches are logistically complicated since the balloon fabric is only .7-mil polyethylene (about the thickness of a dry-cleaner's plastic bag) and the length of a football field. Since this thin fabric must lift loads weighing as much as a small truck up to the edge of space, conditions in both the upper atmosphere and on the ground must be perfect. The preparations go on for weeks with launch times constantly set and then aborted. When the final countdown starts, the parachute is attached to the payload and then stretched out flat on the ice shelf. The balloon itself is slowly rolled out on a piece of cloth, attached to the parachute, and then inflated with .8 million cubic meters of helium.

I'm allowed to photograph on the work site until inflation begins, so I'm able to get good shots of the preparations. Once they release the balloon, it quickly springs above the parachute and then continues to fill as it ascends. What a lovely sight as it rises into the upper atmosphere, like a ballet dancer not subject to the pull of gravity. As I return to McMurdo and walk to Crary with my photo gear, I can see the balloon far overhead, a tiny globe pulling a long cord.

How much do we know about our universe? Science, I'm learning, is a perverse onion. You keep peeling away layers, but the onion keeps growing larger. The more we learn, the more there is to know. Which is why we're here in Antarctica.

OZONE

The dramatic loss of ozone in the lower atmosphere over Antarctica was first measured in the spring of 1985. Scientists all over the world thought their instruments had malfunctioned. They soon realized that ozone, a gas that forms a protective blanket around the earth, had thinned to dangerous levels. The cause: man-made chemicals containing chlorine and bromine were reacting with ozone and depleting it. An international treaty known as the Montreal Protocol began regulating the production and use of ozone-depleting substances in 1987, but recent balloon measurements show that ozone levels have not recovered. It may be another 10 years or so before chemical and climate changes reduce the amount of chlorine and bromine in the stratosphere.

—S.B.

Preparing the payload for launch

Inflating the balloon

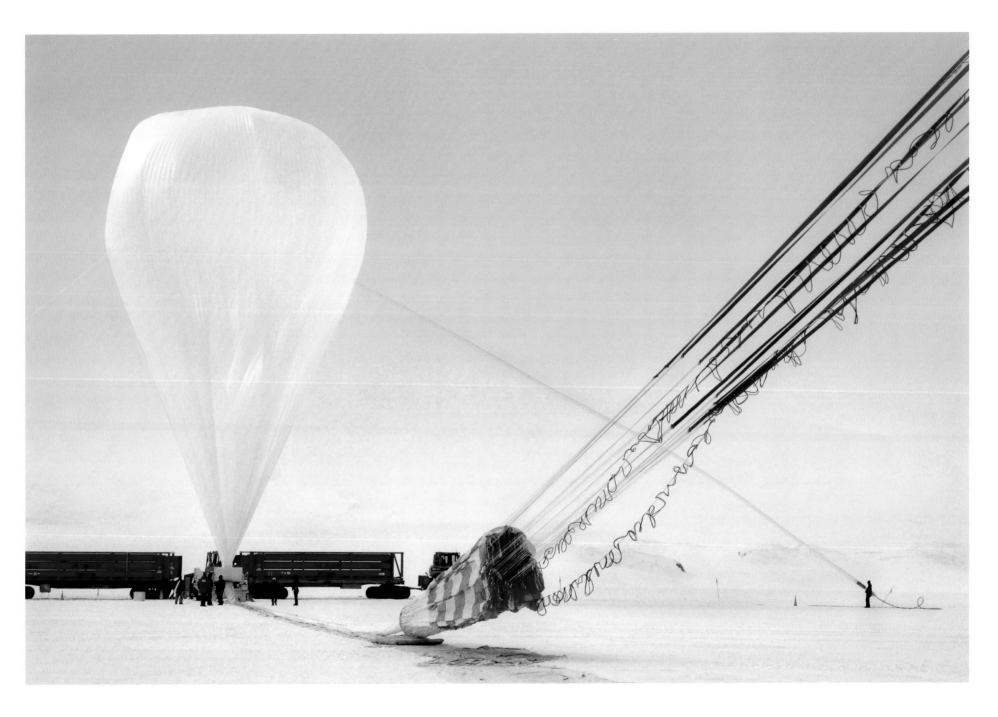

At the bottom of this planet is an enchanted continent in the sky, pale like a sleeping princess. Sinister and beautiful, she lies in frozen slumber...

RICHARD E. BYRD
National Geographic, 1947

In the Freezer

JANUARY 12, MCMURDO STATION, 23°F, WIND CHILL 20°F

ANTARCTICA IS THE WORLD'S PREMIER meteorite hunting ground. Over the past 25 years, ANSMET (NSF's Antarctic Search for Meteorites program) has retrieved more than 10,000 specimens from locations along the Transantarctic Mountains. If you want to find things that fall out of the sky, they say, lay out a big white sheet. Last year's major discovery was a 1.3 billion-year-old meteorite from Mars. Resembling bits of stained glass against a dark background, the rock is, in the scientists' words, "very, very, very sexy." It's being examined for evidence of life and for detailed information about volcanoes on Mars.

Since I'm unable to reach their distant field camps, I arrange to photograph three meteorites that were found here in Antarctica several years ago. Although part of the Smithsonian Institution's collection, they're kept in a locked case in Crary Lab. Getting permission to photograph them and set up the shooting session takes several weeks.

To prepare a slab of ice for photographing the meteorites, I find a large white plastic tray and fill it with distilled water. Susan Stalfort, from the Crary office staff, helps me carefully transport it on a cart into the lab's −25°F freezer room, where we leave it to freeze. While I'm away from Crary for a couple of days, a large crack forms down the center of the ice and splits the corners of the tray. Another week passes while the edges are taped up and sealed. I fill it again. This time, as we roll the cart up the ramp to the freezer, I let my end of the tray down too soon and water spills. I mop it up as best I can, but it leaves an icy film on the floor.

When I'm ready to leave, I realize that Susan closed the freezer door when she left, and I can't get out. I quickly turn cold and begin to panic. I pull harder at the door, but it doesn't open, and it's hard to gain traction on the icy floor. Since nobody is likely

Iron meteorite. Douglas Mawson, Australia's greatest Antarctic explorer, found the first Antarctic meteorite in 1914. Since the establishment of America's ANSMET program, thousands of meteorites have been sent frozen to NASA's Johnson Space Center in Houston, where they are photographed, named, and weighed. They then become part of the Smithsonian's collections. This year, scientists have collected nearly a thousand specimens.

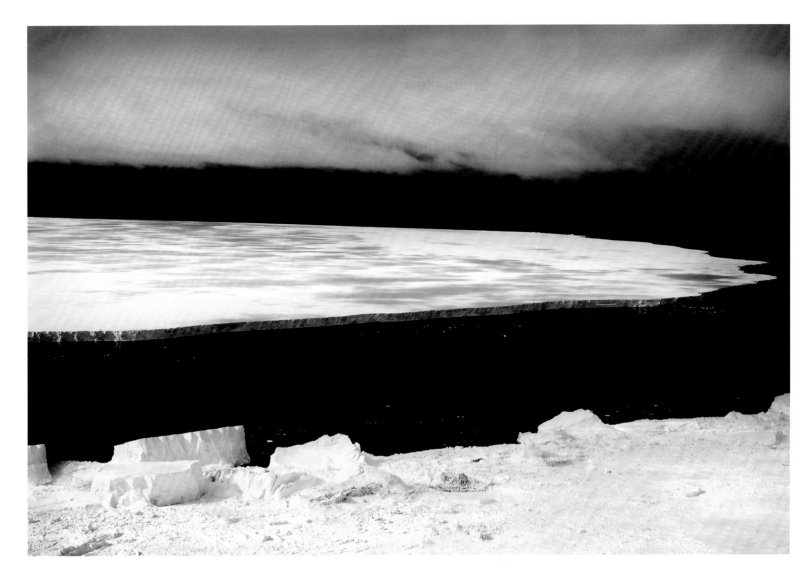

B15 iceberg from Cape Crozier

to open the door for another day or so, I can imagine my body being found frozen solid in a freezer in Antarctica. Talk about overkill! In desperation I yank at the door as hard as I can, the seal releases, and the door opens.

The actual photo session is less traumatic. The two smaller meteorites are ordinary chondrites originally formed in the solar nebula from small asteroids when the solar system began. The third, more unusual and larger, is iron, part of a planetary core thought to have originated in the asteroid belt. It's only about nine inches long but weighs 22 pounds. With its weight and dark color, it quickly begins to melt a hole in the ice, so I shoot quickly.

These unassuming rocks are at least 4.56 billion years old. Strange to think that I'm handling some of the oldest objects on Earth.

Crevasse

JANUARY 15, IMAX CREVASSE, 22°F, WIND CHILL 11°F

'M EXCITED TO VISIT THE IMAX CREVASSE, so called because it was used as a shooting location for an IMAX film several years ago. Erik Barnes, a mountaineer, Dawn Needham, the field support coordinator, and I set off from a snowmobile parking area near Scott Base. We all dress for cold with balaclavas, hats, goggles, bear-paw mittens over fleece liners, and our parkas. Again, I put hand warmers in my mittens, knowing it's an hour's drive. Although I've been on snowmobiles a number of times, I've never actually driven one.

We set off in single file, following the flat track to Windless Bight on the south side of Ross Island. Snowmobile driving isn't difficult, since you have only one gear and a throttle, so I get the hang of it quickly. As we drive, the weather slowly closes down, from a light overcast to a milky soup. It's a fog that seems neither earth, nor air, nor sky, but a compound of all three. It's like driving inside a marshmallow. The route is flagged so we can see the next marker ahead of us, but the tracks on the ground blend perfectly into the surrounding ice and sky. We can't see bumps or potholes until we drive into them.

About an hour out, we stop near a rescue hut locally known as "room with a view," a description that doesn't apply today. We spread sandwiches out on the seat of one of the snowmobiles and drink hot cocoa. Erik says we're at the edge of a dangerous area. We need to rope up since we'll be crossing part of a major crevasse field. I wonder to myself whether it makes sense to head out when we can hardly see our own feet. We drive the snowmobiles several hundred yards farther to a pair of crossed black flags indicating the crevasse field boundary and shut the machines down.

We put on harnesses with locking metal karabiners and rope ourselves together. Since I have no mountaineering experience, I figure I should ask Erik, who is in the lead, what to do if he suddenly disappears from view. The Antarctic literature is full of descriptions of explorers, sleds, ponies, and dogs falling down crevasses, often with tragic consequences. Certainly, I'm likely to go tumbling along if Erik takes an unexpected fall, since he probably weighs twice what I do. If he falls down a crevasse, he warns us, we are to immediately hit the ground and dig in our boots and ice axe.

Peering into the crevasse

He shows us how to keep the rope taut and warns us to walk only in his footsteps. Apprehensively, Dawn and I set off in the whiteness behind him.

Slowly we pick our way through foot-deep snow to the beginnings of a slight rise. Below us is a blue ice hole, the size of a small car. When we get closer and look down, we can see that it is the slanted mouth of a crevasse. The passage down is covered with blocks of ice that have fallen from an overhanging snow bridge. We descend gingerly, unsure of our footing since our ice axes reveal areas of little substance between the enormous snow-covered blocks of ice. Delicate hoarfrost crystals encrust the sides of the snow blocks. I look up nervously and don't tarry under the long overhanging icicle-like formations. When we eventually reach the floor of the crevasse, I pause to listen. It's like being in the silence of a deep cave. If I listen long enough, I can hear the blood moving through my body.

Unlike a cave, however, the crevasse is lit by a neon blue light that filters through the ice. From its floor, I can see behind us the bright light of the opening from which we have descended and then a long passage with an oval of blue light at the end. More than a hundred feet overhead is a snow bridge that covers the crack, making it invisible at the ground surface. We follow this narrow passage several hundred yards through the crevasse. The straight sides are rippled and snow covered. At the far end is another opening that in years past allowed an exit but has now been sealed by falling ice rubble. It's the palace of Hans Christian Andersen's Snow Queen, eerily lit and fantastically ornamented.

After retracing our steps and clambering carefully back to the surface, we find that the overcast has lifted. We can see blue sky. In the distance are White Mountain, Black Mountain, and Mount Erebus puffing away. We rope back together and retrace our steps to the snowmobiles. We return via a rugged track along the Castle Rock ridge. The views go on forever. I love it. Unfortunately, this is probably my last outing onto the ice sheet.

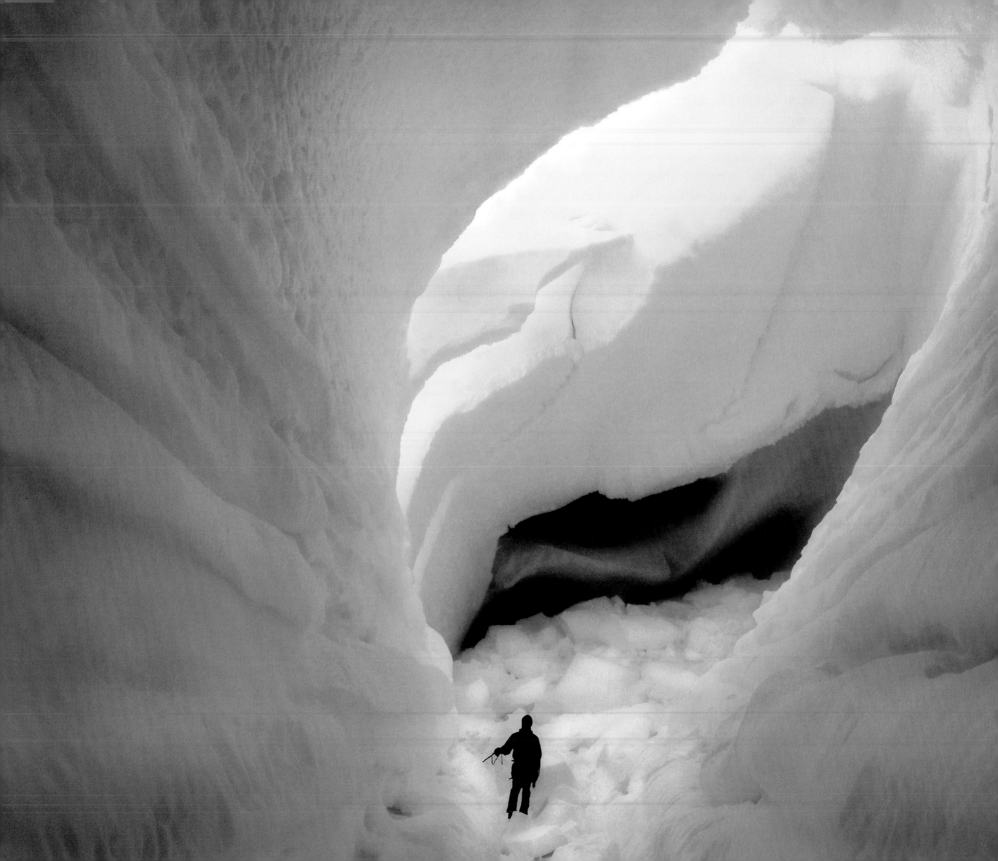

Inside the crevasse
Crevasse ceiling

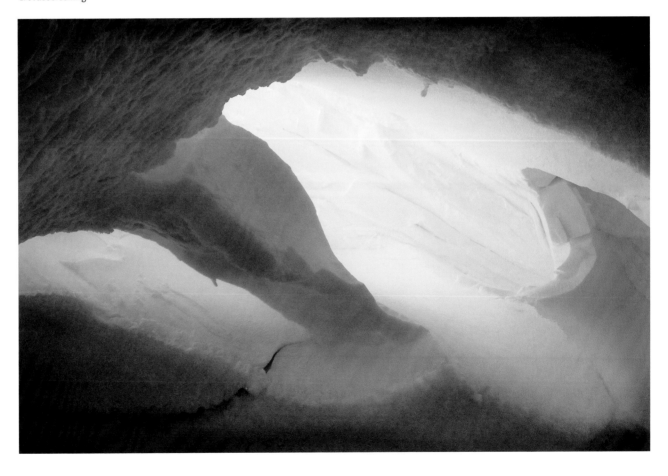

Men wanted for hazardous journey. Low wages, bitter cold, long hours of complete darkness. Safe return doubtful. Honour and recognition in event of success.

ERNEST SHACKLETON

*apocryphal but often reprinted newspaper ad
announcing his 'Endurance' expedition*

Accident

LOVE HELICOPTERS BECAUSE THEY FLY LOW to the ground and I can photograph out an open window. It's more dangerous than flying in a fixed-wing aircraft, but I try not to think about that. The pilots here are careful and very experienced, but a helicopter's margin of safety is not large if there are mechanical problems or errors in judgment.

A helicopter crashed about 3:30 yesterday afternoon at Lake Fryxell in the Dry Valleys. Details are still not clear, but evidently the men were removing camp equipment, probably with a sling load, and had mechanical problems. They fell from about 100 feet onto the frozen lake. The helicopter was destroyed, and the pilot and helicopter tech are badly injured. A search-and-rescue team was able to reach the helicopter, extricate the men with considerable difficulty, and fly them by helicopter to the McMurdo airfield at around 10 PM. Fortunately, the snowy weather lifted briefly so they could be flown by Hercules LC-130 to a hospital in Christchurch, where they arrived in stable condition this morning about 6. In this small community, you get to know most everybody. I have flown with both men.

Antarctica is an unforgiving place. The support staff plans carefully to minimize risk, but sometimes it's pure luck that keeps accidents from happening. Yesterday, that luck ran out.

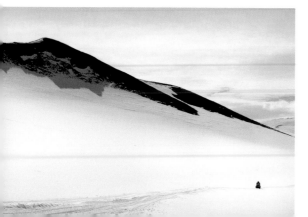

Snowmobile returning to McMurdo

Leaving Soon

EVERYONE IS TALKING ABOUT THEIR PLANS when they leave here in February. I chat with a group of janitors at dinner, all in their 20s and 30s, about where they're going to travel when they leave. One of the best perks of working here is that you're able to save up all the money you make since there's nothing besides liquor and sundries to spend it on. You can go almost anywhere in the world on your way home. One of the women tells me that she has decided to go to Alaska with a friend she met here. She owns her own literary agency and originally had planned to go straight home to California and take it up again. Now, she says, she doesn't want that much pressure in her life. She's going to travel a bit and then decide what to do next. "I've changed. I don't know if it's the wonderful people I've met here, or the stressless situation I work in, or the place itself," she tells me. "I want to savor life."

I say good-bye to friends at McMurdo. Computer technician Karen Joyce touches me by saying, "You've become one of us." That's how I feel. I can't believe I won't be coming back next year like everyone else. I give away all the ink-jet prints of my exhibition photographs that I brought along as well as postcards that I made here on my little HP postcard printer. Everywhere I go, in the galley or around Crary, friends ask me whether I'll get out that day. Everywhere I go I receive handshakes, hugs, and addresses with admonitions to "keep in touch." I work in my office answering e-mail and doing final packing.

For me, it's time to return to all the ordinary pleasures and responsibilities of marriage, family, and business. I find myself pausing more to enjoy the daily activities— looking out across the white expanse of sea ice toward Mount Discovery from my Crary office window, listening to the volcanic stones crunch beneath my shoes as I walk around the station, chatting with friends at meals, and smiling at the greetings that I give and receive. For most people here, leaving is part of a cycle. They know they'll return and see friends again. I am not returning.

Sea ice crack

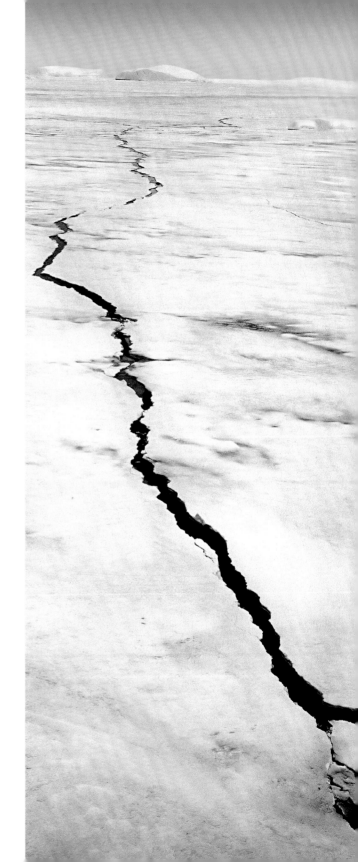

Saying Good-bye

ANTARCTICA HAS GIVEN ME a whale of a storm as a parting gift. The most powerful storm of the season, the blizzard has huffed and puffed and nearly blown us all down, blanketing us in wet snow. Foot-high drifts fill my boots if I step away from shoveled paths. Paths quickly disappear as the wind obliterates them. With much of my packing done, I begin to feel claustrophobic in this isolated world and ready to depart.

I walk up to the Heavy Shop at the Vehicle Maintenance Facility to photograph the large trucks being serviced inside. The snow blows sideways so I keep goggles on to protect my eyes. All season I've avoided falling on the ice, but it's very slippery. Coming down a hillside, I take a nasty tumble on my shoulder. Somehow, I protect the camera around my neck. Fortunately I don't break anything, but I'm black and blue and sore.

The good news for the station is that the wind is blowing out 20 miles of sea ice that is clogging McMurdo Sound. This is also welcome news for the *Polar Sea*, which has been struggling to keep the channel open for the incoming supply boats after one of its propeller blades broke a week ago. The bad news is that if the storm continues through tomorrow, I will have no way to helicopter out to the *Kapitan Khlebnikov*, an icebreaker cruise ship, which will transport me to Lyttleton, New Zealand. At this moment the ship is waiting out the 50-mph winds some 20 miles out of McMurdo, near Cape Royds.

I pack the stuff I won't need on the ship and drive it to Science Cargo for air shipment to Christchurch. It's snowing so hard that I can't get the truck close to the building entrance and have to carry the cases through drifts. In Antarctica you don't just feel insignificant, you feel superfluous. Buffeted by the blowing snow, I wonder if I'll ever be able to leave the station.

One of the paper scraps tacked to my bulletin board is a shooting list written months ago. As I mentally check off everything I've done, I see "Ross Chalice." Otherwise known as the *Erebus* Chalice, this is the silver Communion chalice carried by James Clark Ross's 1841 expedition to the Ross Sea. In 1986, it was engraved and dedicated for use at the Chapel of the Snows in McMurdo, in honor of the 75th anniversary of Scott's ill-fated *Terra Nova* expedition to the South Pole.

I grab my camera, flash, and tripod and walk through the snow to the chapel. Marti Reynolds, the military chaplain, sits in his office answering e-mail and watching

Erebus Chalice

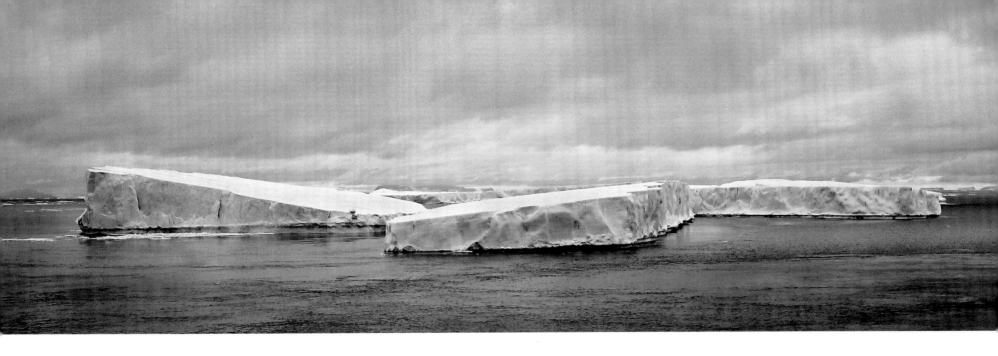

Icebergs

the snow drifting in front of his window. He opens a glass case and helps me position the chalice on the altar, as he does when he offers Communion. When I finish, I take a deep breath and sit in silence for a few moments in the chapel, giving thanks for the opportunity I've been given to spend this time in Antarctica and for the help so many people have offered me.

Back at Crary, a call finally comes about helicopter transport to the *Khlebnikov*. It's a good thing I've been preparing for the last couple of days because I only have about an hour to do final packing and catch a shuttle van. I have loved my office here and can hardly believe I'll never return. I take a last look at Mount Discovery from my window, turn the key in the lock, and walk alone out of Crary for the last time.

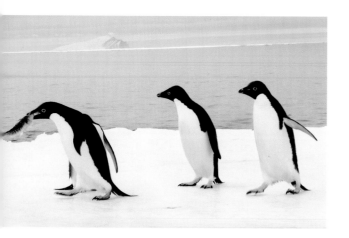

Adélie penguin eating emerald rockcod
(*Trematomus bernacchii*)

Mount Discovery, Royal Society Range

Kapitan Khlebnikov

JANUARY 25, *KAPITAN KHLEBNIKOV*, 31°F, OVERCAST WITH LIGHT SNOW

AS WE HELICOPTER TO THE SHIP, the sun's rays pierce the thinning clouds and illuminate McMurdo below and the Royal Society Range across the sound. Below us, the *Polar Sea* icebreaker lies comfortably docked near the *Discovery* hut at Hut Point. As we fly past Scott's quarters at Cape Evans, the shimmering light gilds the sea ice and the snowy slopes of Mount Erebus, while the distant peaks have a violet cast. How I'll miss the clarity and beauty of Antarctica. Its scale has remained beyond my comprehension, much less a picture frame.

We land on the sea ice near Cape Royds. The *Khlebnikov,* waiting at the edge of the ice near Cape Royds, is a former Soviet icebreaker that has been refitted for use as a cruise ship in the Arctic and Antarctic. It still has an enormous hammer and sickle on its prow. From the ice, it looks like a rusty tub with an apartment building up top. After we load our bags onto sleds for transport over the ice, I climb up a ladder to the deck of the ship. Inside, it has comfortable cabins, a pleasant dining area, and a well-appointed lecture hall. The atmosphere is informal. Passengers, about half of whom have just completed a very expensive circumnavigation of the entire continent, are hardy folks from all over the world. My roommate, Pauline, is from Perth, Australia. How very odd to return so abruptly to the social interactions of the outside world while still seeing the familiar landscape out the windows.

The adjustment away from the McMurdo-family culture is jarring. I miss being greeted by name. The experiences I have had are impossible to share with someone who has not been there. Many of the passengers have been to the Antarctic before, and they talk about their previous visits with an annoying possessiveness. Only a tourist or newcomer can pretend an identification with Antarctica; a McMurdo electrician would never dare. The gap between tourist and those who live and work in a tightly knit community is enormous. So I take my camera and tripod out on to the sea ice and sit down near the edge to photograph penguins passing by.

After dinner we finally leave Ross Island. I dash out on deck and watch the familiar shoreline slip by. Mount Erebus is shrouded by low clouds, but all of Cape Bird glides slowly past our starboard side. I feel quite desperate as we pass the tip of the cape, knowing I will not see it again. McMurdo is hidden by the shadowy outline of Hut Point. Tears dribble down my cheeks. In the distance, Beaufort Island rises, half-obscured, from the open water that now surrounds it, reminding me of the enchanted day I spent at the Adélie colony. What places I've seen!

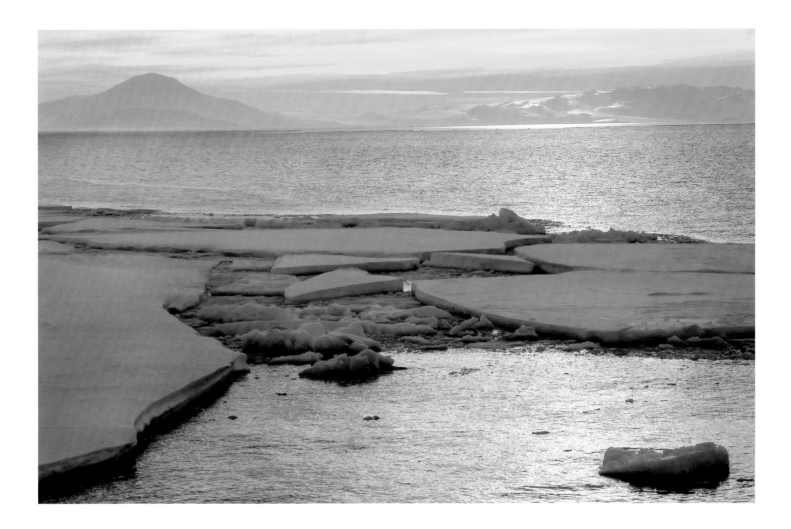

These four months have changed me. I've experienced a part of the world that few have seen. I've had the opportunity to photograph and walk a continent that humans have been unable to tame or exploit. I've held meteorites that are as old as our planet. The cold emptiness of the larger solar system has been ever-present and often frightening. I have seen the home of the Snow Queen and come to know her. I have always been aware that I'm at the mercy of forces I don't understand and certainly can't control. I've done many things I didn't want to do or was afraid to do, things that were uncomfortable, dangerous, and uncertain.

I've seen how beautiful and how fragile our planet is. I've spoken with scientists about global warming, air quality, and climate change, and I fear for our life-sustaining environment. I appreciate as never before the loveliness of growing plants, the fragrance of rain in the desert, the trill of songbirds, soft evening walks, and the change from light to darkness because I've lived without them. This heightened appreciation of familiar surroundings may be Antarctica's most lasting gift to me.

Louis Bernacchi, a scientist and member of Norwegian explorer Carsten Borchgrevink's 1898–1900 British Antarctic expedition, wrote of arriving at Cape Adare.

Approaching this sinister coast for the first time, on such a boisterous, cold and gloomy day, our decks covered with drift snow and frozen sea water, the rigging encased in ice, the heavens as black as death, was like approaching some unknown land of punishment, and struck into our hearts a feeling preciously akin to fear. . . . It was a scene, terrible in its austerity, that can only be witnessed at that extremity of the globe; truly, a land of unsurpassed desolation.

LOUIS BERNACCHI
To the South Polar Regions, 1901

Cape Hallett and Cape Adare

JANUARY 27, *KAPITAN KHLEBNIKOV*, 45°F AND OVERCAST

FOR MUCH OF THE DAY YESTERDAY, we sailed along C19, one of the two large icebergs in McMurdo Sound, hoping that the pack will not close up and trap us. The sea was calm and relatively free of ice until we reached Cape Hallett, where we found our way blocked by thick ice. Fortunately, even though the Zodiac inflatable boats couldn't be used in these conditions, the ship's helicopters could still ferry passengers to a small landing site near the Adélie colony.

By the time we landed, it was late evening and the light was several f-stops dimmer than I had seen in months. Depth of field was minimal. I used my tripod to photograph mother Adélies feeding their chicks and then the remains of a joint U.S.–New Zealand station built during the 1957–58 International Geophysical Year.

The station and penguin colony occupy the edge of a pretty bay with dramatic headlands and the northern tip of the Transantarctic Mountains in the distance. A large fuel tank still holds gallons of sludge that nobody is certain how to remove without spilling into the surrounding penguin colony. Little else remains of the station other than a very small hut with a few bunks and a radar dome.

This morning we reach Cape Adare. Its headland, a dark rocky outcrop with glaciers nearby, was the first landmark for many of the early Antarctic explorers who came to this side of the continent. The dramatic promontory overlooks a small flat spit with the largest Adélie colony on the continent, some 400,000 birds. The nests stretch nearly a thousand feet up the side of the mountain.

Unfortunately, once again we encounter ice. Normally this area, on the edge of the continent, is ice-free this time of year. The *Khlebnikov* pulls in slowly past long lines of stranded icebergs and thick pack. It finally stops about 300 feet from shore with a clear view of the huts and the penguins. Zodiacs cannot maneuver through the fast ice. Helicopters cannot land in the penguin colony. So near and yet so far. A brave visitor might imagine leaping from floe to floe. I have to content myself with shooting from the deck. Slowly the ship backs out of the ice and turns north. In less than an hour we leave icebergs behind. After four months of ice, I am finally seeing open water. We are truly leaving Antarctica.

Nesting skuas, Cape Hallett

Borchgrevink's hut, Cape Adare. Borchgrevink's expedition was the first to winter-over on the Antarctic continent. Living in a small wooden hut, they proved that humans could survive the dark, bitterly cold winter.

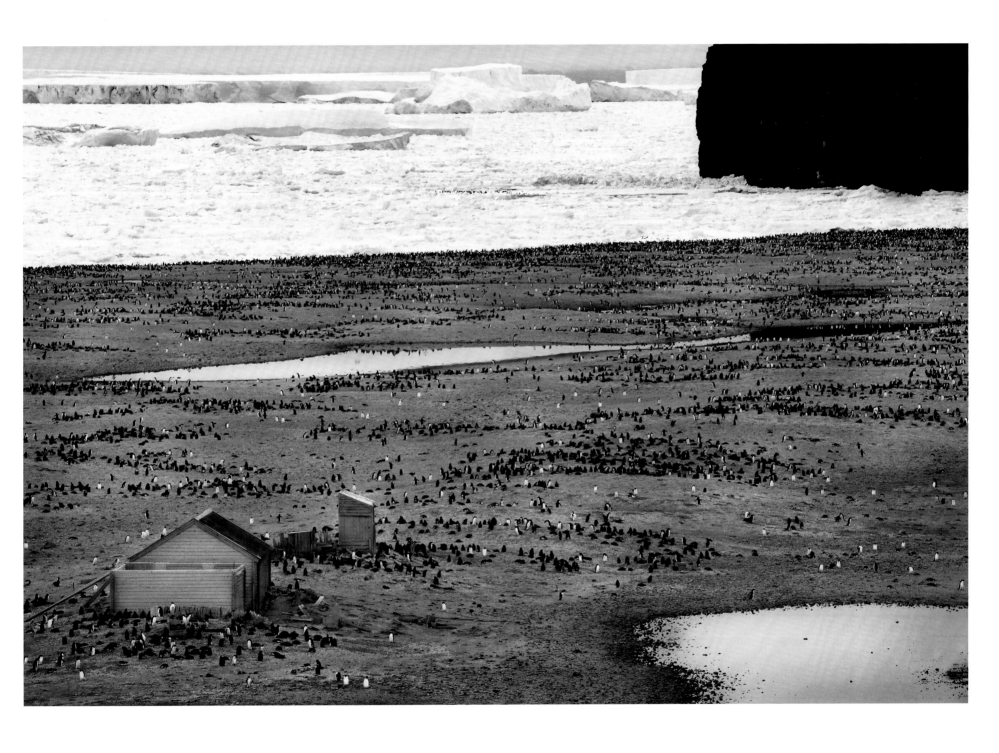

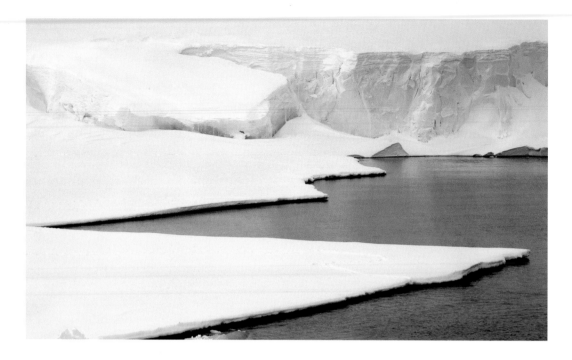

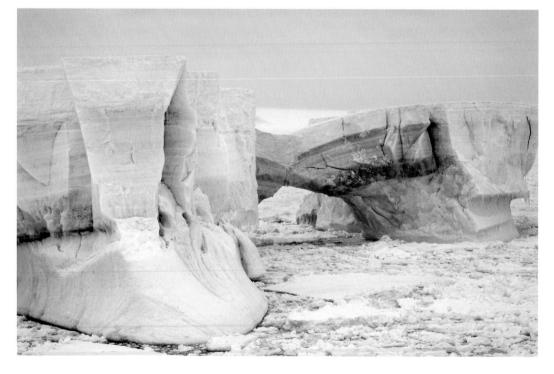

Drygalski Ice Tongue

Blue iceberg, near Cape Adare

C19 iceberg. This iceberg, along with B15, floated in McMurdo Sound. The icebergs were large enough to affect currents in the sound and prevent sea ice from drifting out of the Ross Sea.

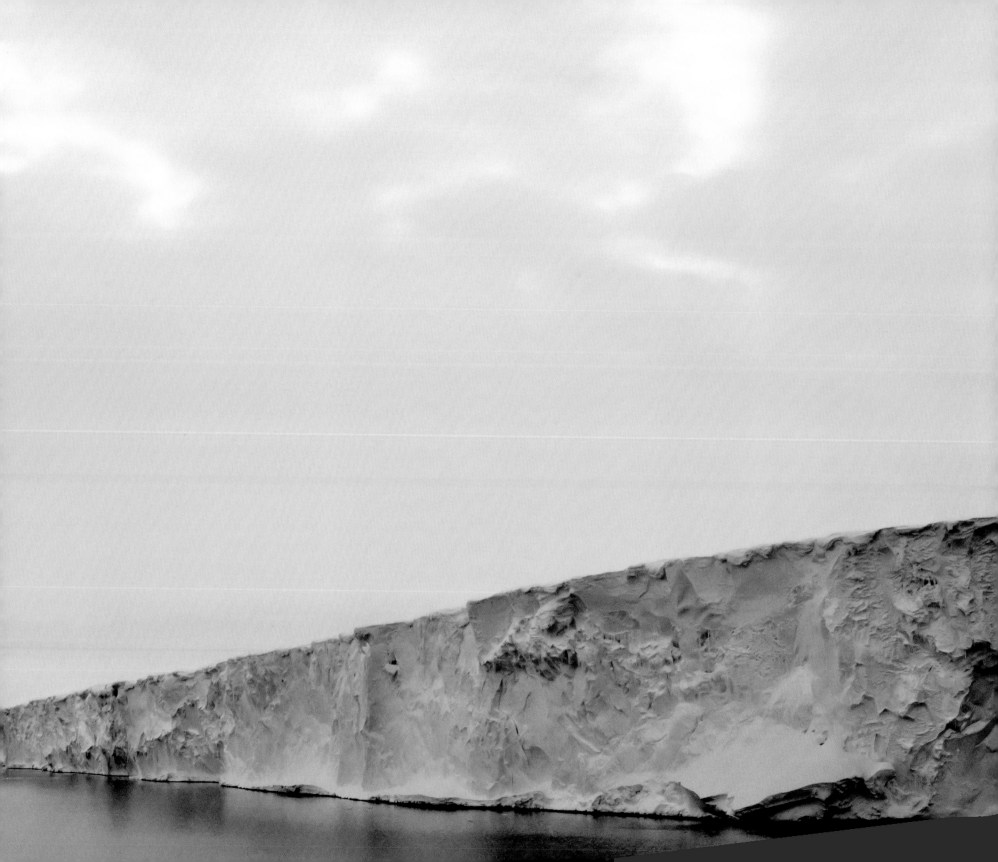

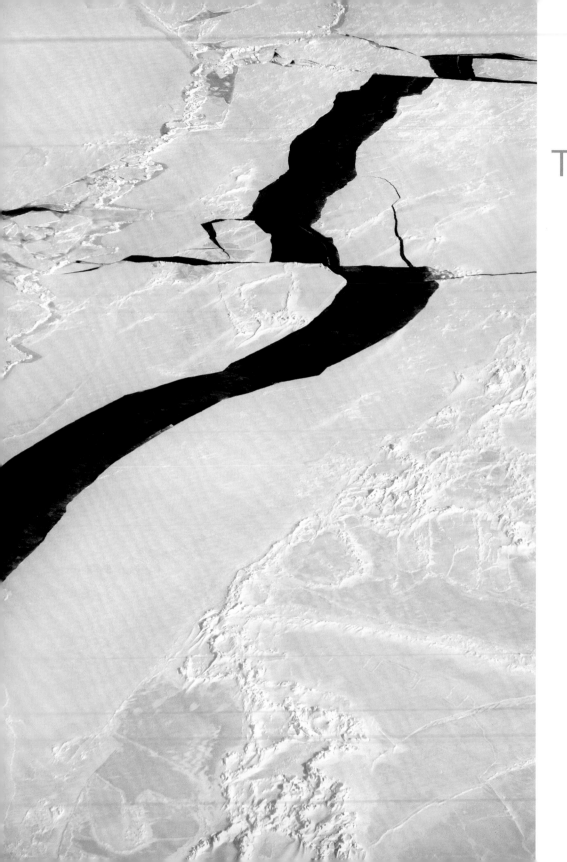

Sea ice

North of the Convergence

JANUARY 29, *KAPITAN KHLEBNIKOV*, 52°F

THIS AFTERNOON WE CROSS the Antarctic Convergence, where the cold Antarctic waters meet the much warmer waters of the northern oceans. The air is no longer cold, and you can smell the sea. Different birds follow the ship. Our sea crossing has been mild, and we make up much of the time we lost in detouring around the ice at the northern part of the Ross Sea. The sun sets for the first time in three and a half months. I can feel darkness as I sleep, as welcome as a lover after a long separation.

I wake refreshed and, as we anchor near Campbell Island, am astonished at the smells and sights of a familiar yet almost forgotten world. The island is a pretty place, full of ferns, mosses, lichens, and tussock grass. After living so long without smell or color, I find it a fragrant fantasy of greenery and flowers. The island is a caldera with a narrow opening, and it rains almost daily. Only 500 visitors are allowed here each year. Our group walks in a light drizzle up through the rainforest vegetation to see the nests of the royal albatross. Campbell Island is also home to Hooker's sea lions. Like the fur seals on South Georgia and the Antarctic Peninsula, they resent any intrusion into their space and will come at you with teeth bared. (A woman on the cruise before ours had a bite taken from her posterior.)

The final passage to New Zealand is less felicitous. A storm comes up and lasts about a day, reminding me why I swore off boat travel in the Southern Ocean after the storm last year. With 50-mph winds and 25-foot swells, the *Khlebnikov*

rolls heavily side-to-side. One woman falls and breaks her wrist. Several people tumble out of bed, including one man from his top bunk.

On one of the roughest nights, I'm invited to a cocktail party in the captain's cabin. For a short time, everyone tries to pretend everything's normal. But it's so rough that, except for the captain and a couple of other diehards, we soon sit down on the floor and sip our sloshing drinks while firmly anchored to a wall or piece of furniture.

About 30 miles from the New Zealand coast the winds weaken, and the waves, which have been steadily diminishing, drop to bathtub size. I grab hold of railings and walk out on deck. I smell the sweetness of land.

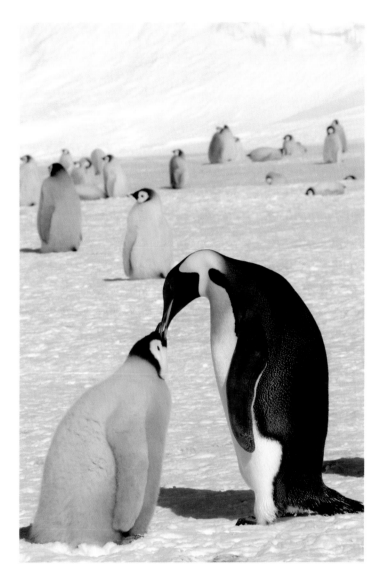

Hooker's sea lion, Campbell Island

Emperor penguin feeding chick

We'd rather have the iceberg than the ship,
although it meant the end of travel.

ELIZABETH BISHOP
"The Imaginary Iceberg"

Adjustment

Back in New Mexico, I am distraught for several months. I have left too soon. I feel like the man who finds a magic lantern and is given three wishes. When I first arrived at McMurdo I could photograph my surroundings in whatever way I chose. My possibilities were limited only by my imagination and stamina. But by the time I figured out what I really wished to photograph and how, my time was up.

I return after four months to family and friends, to my home, and see them as an alien from another planet might. Bernie tells me that even after several weeks I still look disoriented. Certainly I don't feel present much of the time. The change in circadian rhythms from all daylight to night and day, the slowdown in metabolism, and the sensory overload contribute to my dislocation. Everything moves too fast. I can hardly stand car travel; it upsets my stomach. I don't want to go to the supermarket or shopping center. I don't want food. I crave a white room, empty and silent. And I miss my friends on the Ice. I find I don't really know many of the people around me. The truth is I'm depressed. Bernie tells me I have an Antarctic virus. I've become a stranger to my old life.

Of course, I return, though not to McMurdo. In 2004, I again sail on the *Kapitan Khlebnikov* to the Weddell Sea on the opposite side of the continent from McMurdo and the Ross Sea.

After a calm passage from the Falklands to South Georgia, we sail to the South Sandwich Islands. This small line of inhospitable icy islands was discovered and named by Captain James Cook in 1775. They bear little resemblance to their northern counterparts, the Hawaiian Islands. South Thule, a dark, windy, icy island where we briefly put ashore, has the burned remains of an Argentine base used as a staging station during the Falklands War.

It is a charmed journey with fine weather and calm seas. The landscape is as beautiful as any I saw in my four months at McMurdo. I am deeply happy to be back in this world of air and ice.

We sail south, nearly 1,000 miles through pack ice into the Weddell Sea to reach the shore of the Antarctic continent. Only a full-fledged icebreaker like the *Khlebnikov* can make such a journey since the constantly moving pack is an ever-present threat.

Iceberg, Crystal Sound

We are only a few miles from where Shackleton's *Endurance* was first beset by ice and eventually crushed by the pack.

We reach the shore of the Antarctic continent, the edge of the ice shelf, where we visit emperor penguin rookeries and Neumayer (German) and Halley (British) stations. With the comfort of the ship as a home base, I use my panorama camera to photograph the seemingly infinite variety of pack ice, the wildlife, and the architecture of the stations against the Antarctic landscape.

However, I miss talking to scientists and learning about their struggles to unravel the secrets of the harshest landscape on the planet. I miss living on the Ice and the grounding sensation of walking, eating, and sleeping on land rather than on a tourist boat. Most of all I miss the unique human construct of McMurdo, a society made possible by the conjunction of harsh landscape and human determination.

This time I return home without longing for another visit. It is time to move on. I have promised Bernie that my next project will include palm trees. When I leave my house and take a deep breath of juniper, piñon, and moist earth, I think of Antarctica and am grateful for the scents of home.

PAGES 152–153

Grounded iceberg, Atka Bay

PAGES 154–155

Emperor penguins approaching their
rookery, Drescher Inlet

Chinstrap penguin at the burned remains
of an Argentine military base, South Thule,
South Sandwich Islands

Halley rookery

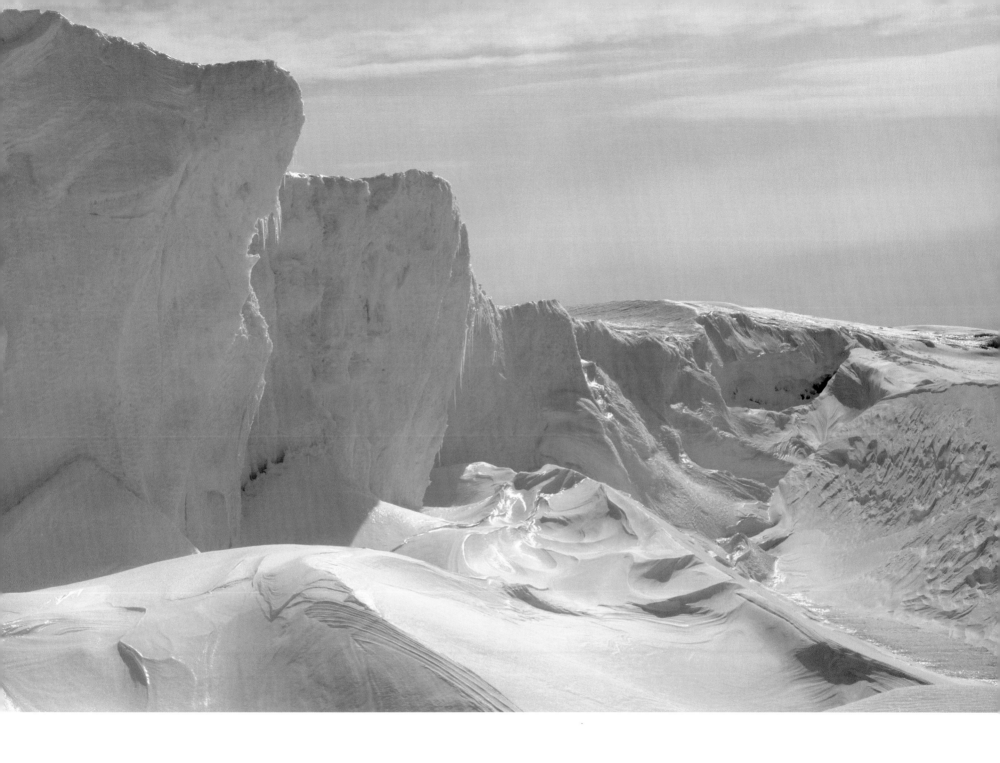

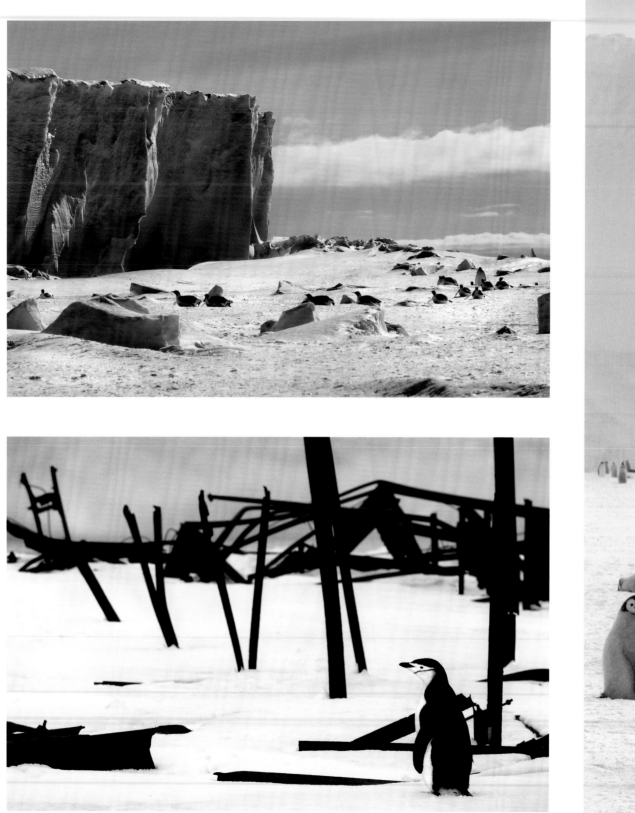
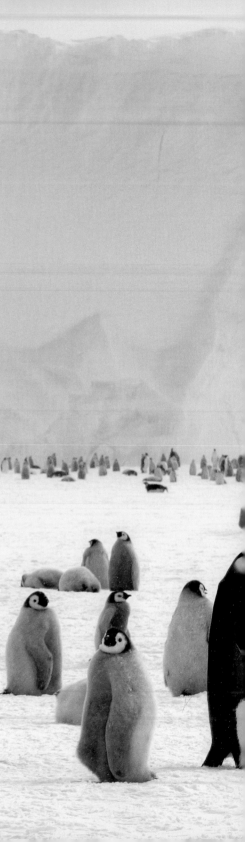

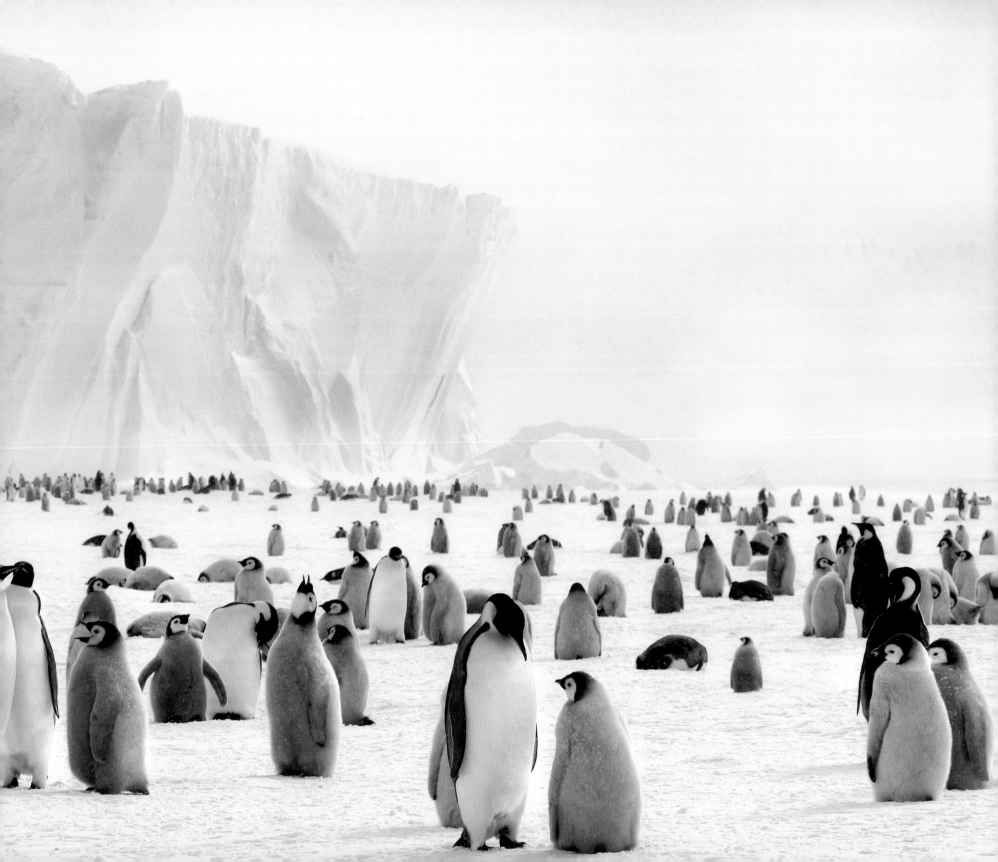

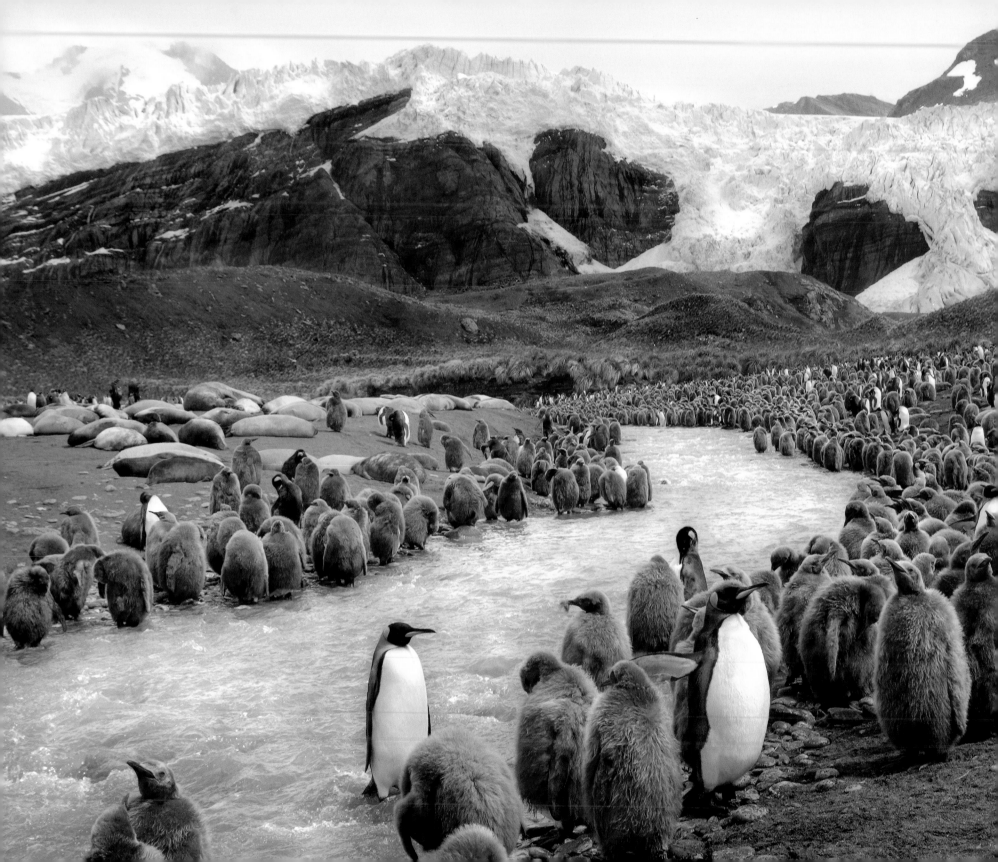

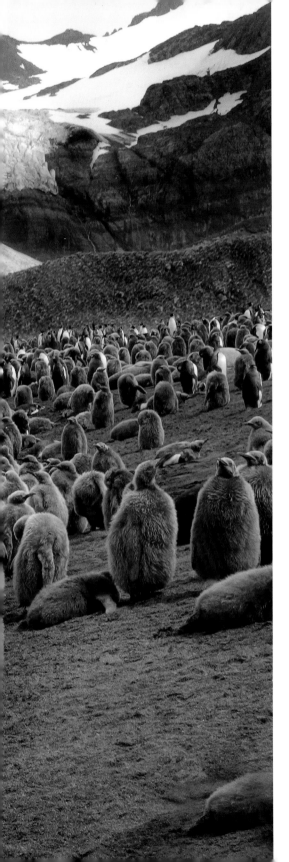

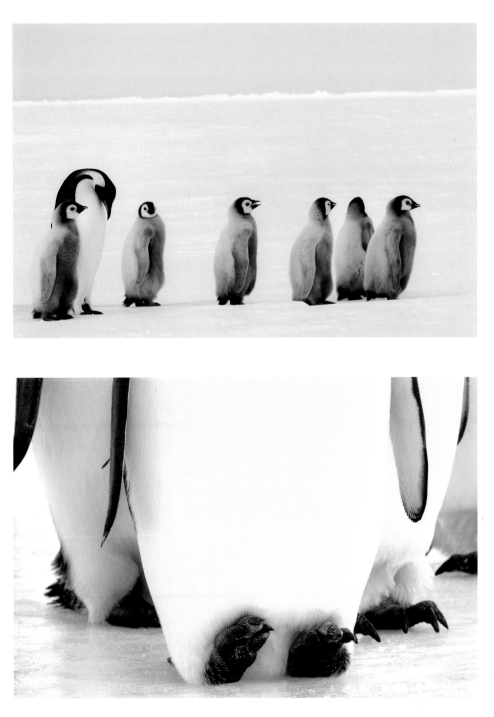

King penguins and chicks, South Georgia
Emperor penguin and chicks, Atka Bay
Emperor penguin feet

Skiing, Hut Point

Acknowledgments

ANTARCTICA IS NOT A CONTINENT FOR LONERS. Its obvious dangers discourage anyone from traveling and working alone. To photograph there requires substantial logistical support. I am therefore grateful for the assistance of many more people than I can mention.

Foremost is the National Science Foundation, which awarded me a 2002–03 Antarctic Artists and Writers Program grant. At the end of my four-month stay on the continent, I was free to publish and use my images as I felt appropriate. Guy Guthridge, my primary contact at NSF's Office of Polar Programs, was a passionate advocate for the Artists and Writers Program and made certain that I had the support necessary to accomplish my grant's goals. Brian Stone and Dave Bresnahan helped smooth my time at McMurdo.

Raytheon Polar Services provided most of the support while I was on the continent. Elaine Hood at Raytheon was a comforting and most helpful mother hen, shepherding me through the preparation for my trip and answering innumerable questions both before I left and after I returned. She told me I would never be the same after living at McMurdo; she was right. Val Carroll also helped. I'd like to offer a warm thanks to everyone at McMurdo, the South Pole, and out in the field, who kept me safe and helped me in countless ways: helicopter and fixed-wing aircraft pilots, field-hut managers, scientists, maintenance staff, construction crews, heavy-machinery staff, mountaineers, office personnel, and IT staff. A special thanks to the officers and crew of the *Polar Sea* for making me feel welcome on board. McMurdo will always seem like home because of all of you.

In addition, I have traveled to the Antarctic Peninsula with Aurora Expeditions, Quark Expeditions, and Zeghram Expeditions. All of their staff were professional, knowledgeable, and helpful in assisting me to get the photographs I wanted. A special thanks to Quark, which has helped support both the book and the Smithsonian traveling exhibition of *Wondrous Cold*. Their trip to visit emperor

penguin rookeries in the Weddell Sea was an awesomely beautiful way of ending my Antarctic journeys.

Many people have assisted in the development of this book and the exhibition. Brendan Bullock, my studio assistant, helped in many ways. My son and graphic designer, Raymond Buetens, was very helpful in original design concepts. Lee More helped with early text editing, and her husband, Michael, provided much-needed advice and encouragement. Jon Emmanuel, Joni English, David Panzera, Sridhar Anandakrishnan, David Marchant, Rob Robbins, Sara Wheeler, Kelly Tyler, Kathleen R. Reedy, Carlton Walker, Darryn Schneider, David Harrowfield, Dave Burkitt, Jan Piggott, and Robert Headland all helped answer questions. At SITES, I'd like to thank Jennifer Bine, Andrea Stevens, and my superb editor, Ann Carper. At Marquand Books, Ed Marquand, Andrea Thomas, and the rest of the staff worked very hard under tight deadlines to make a beautiful book. Julie Bennett and Dawn Manges designed the exhibition, the accompanying poster, and the marketing materials. Jessica Walker drafted the beautiful maps used in the book and exhibition. Many thanks to Barney McCulloch for framing and R.J. Bailie of Untitled Fine Arts Service Inc. for crating. My gallery owner, Andrew Smith, was encouraging and there for me in ways large and small throughout the several-year project. Thanks also to the New Mexico Council on Photography, Morton Meyerson, James Enyeart, and William Fox.

Sandra Blakeslee, science writer for the *New York Times*, joined me for three weeks of my McMurdo stay on an NSF press grant. She has been most generous in writing the science captions that appear as sidebars throughout the book and in reviewing various drafts of the book and exhibition text.

A very special thanks to my mother (who was always enthusiastic), to my sons, Raymond and Julian, and to my father (who believed I was crazy but supported me anyway). Without the unstinting support of my husband, Bernie López (who also accompanied me on several of the trips to the Antarctic Peninsula and helped carry camera gear), I couldn't and wouldn't have done it.

Seen from Cape Crozier, the B15 iceberg is
100 feet high by 120 miles long by 24 miles wide

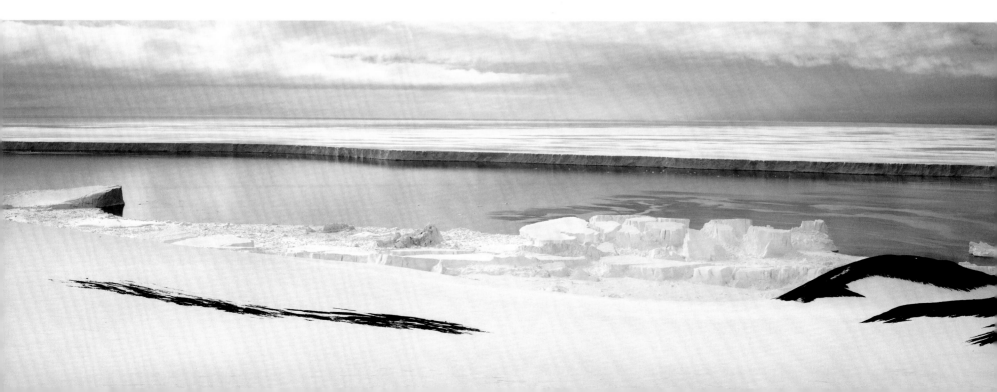

wondrous cold

Directed by Andrea Stevens
Edited by Ann Carper
Science contributions written by Sandra Blakeslee
Proofread by Sharon Rose Vonasch and Carrie Wicks
Designed by Susan E. Kelly with assistance by Andrea Thomas
Typeset in Adobe Caslon and ScalaSans by Marissa Meyer
Color separations by iocolor, Seattle
Produced by Marquand Books, Inc., Seattle
 www.marquand.com
Printed and bound by CS Graphics Pte., Ltd., Singapore

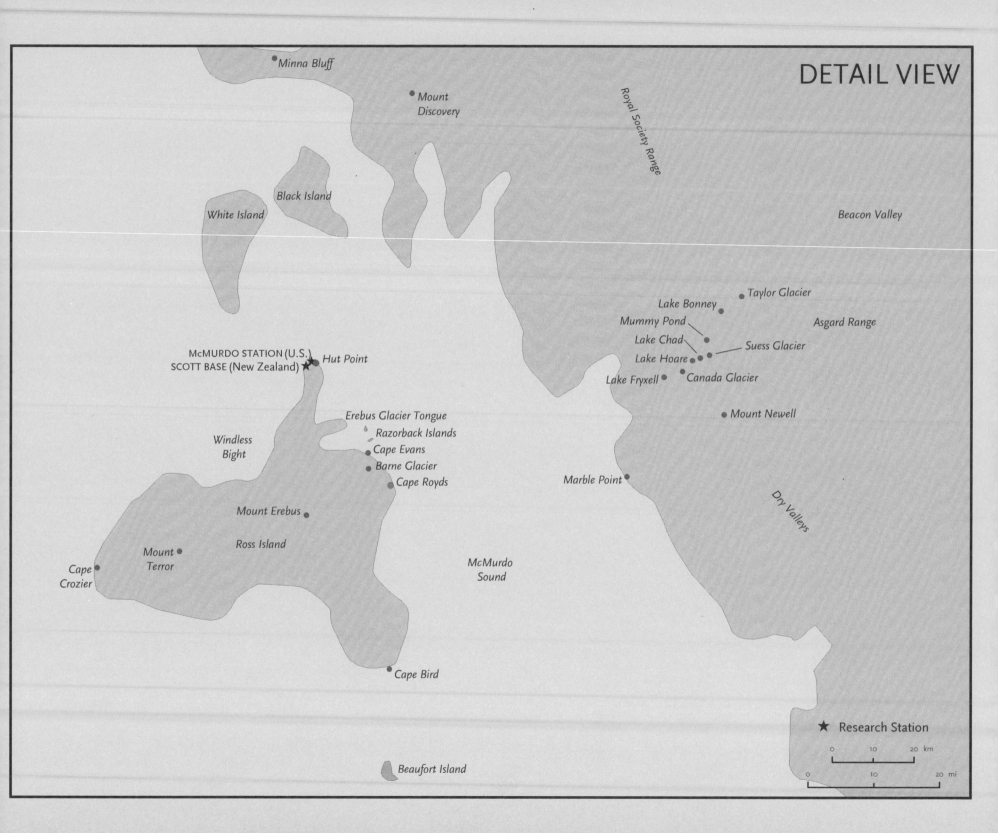

DETAIL VIEW

Minna Bluff

Mount
Discovery

Royal Society Range

Black Island

White Island

Beacon Valley

Taylor Glacier

Lake Bonney

Mummy Pond

Asgard Range

Lake Chad

Suess Glacier

McMURDO STATION (U.S.)
SCOTT BASE (New Zealand)

Hut Point

Lake Hoare

Lake Fryxell

Canada Glacier

Erebus Glacier Tongue

Mount Newell

Razorback Islands

Windless
Bight

Cape Evans

Barne Glacier

Cape Royds

Marble Point

Mount Erebus

Dry Valleys

Ross Island

Mount
Terror

Cape
Crozier

McMurdo
Sound

Cape Bird

★ Research Station

0 10 20 km

0 10 20 mi

Beaufort Island